Rochester City Ballet

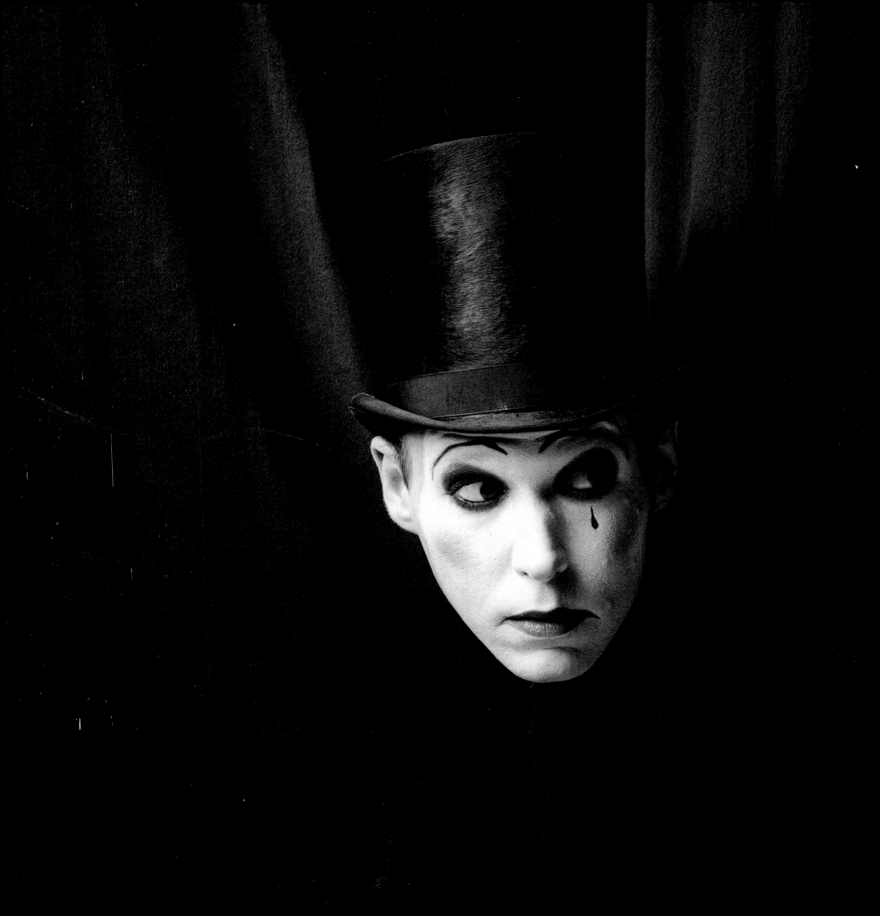

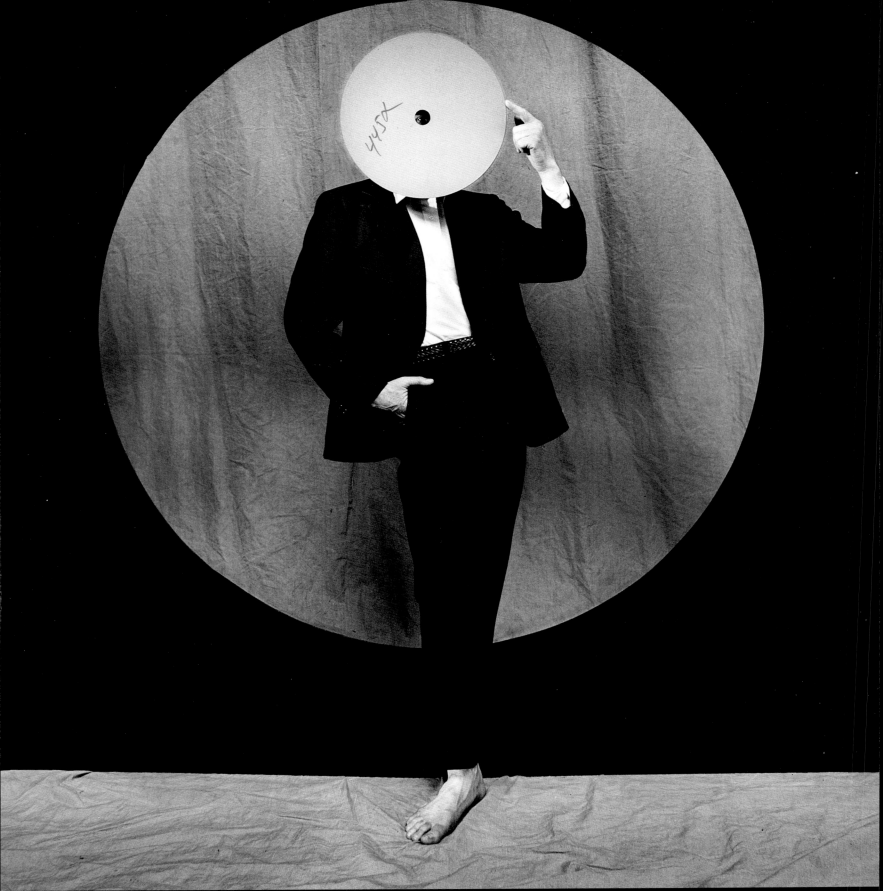

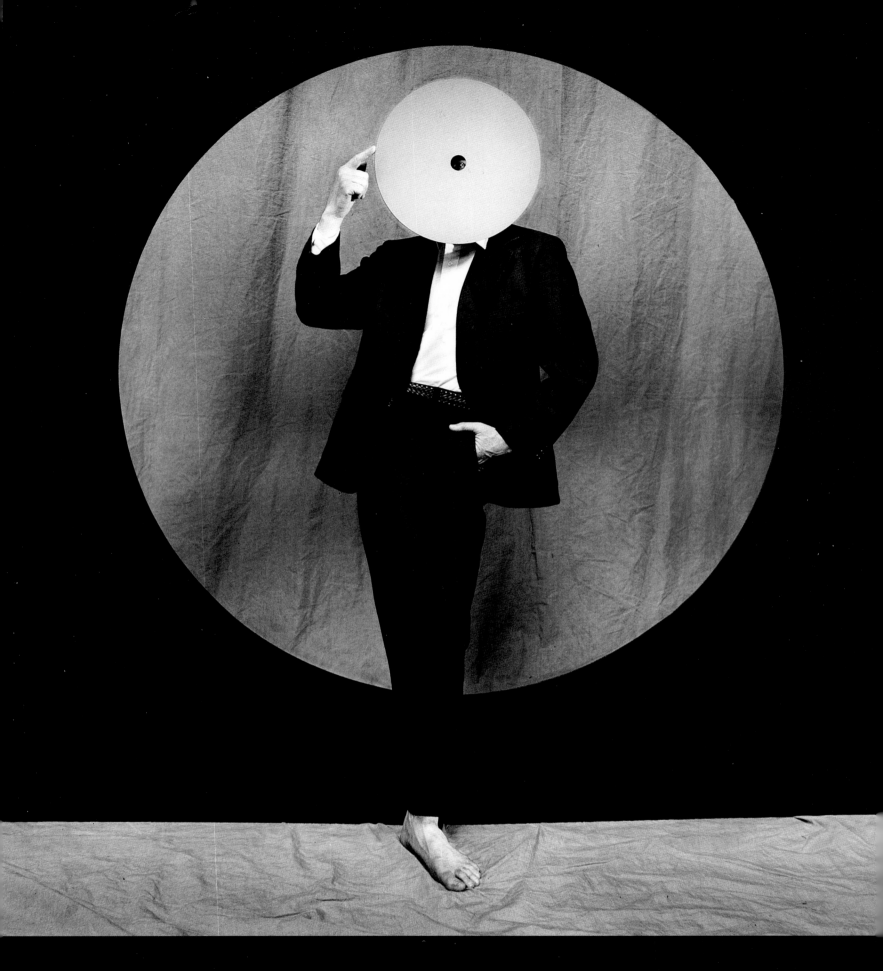

DOUGLAS DUNN
JOSEF ASTOR

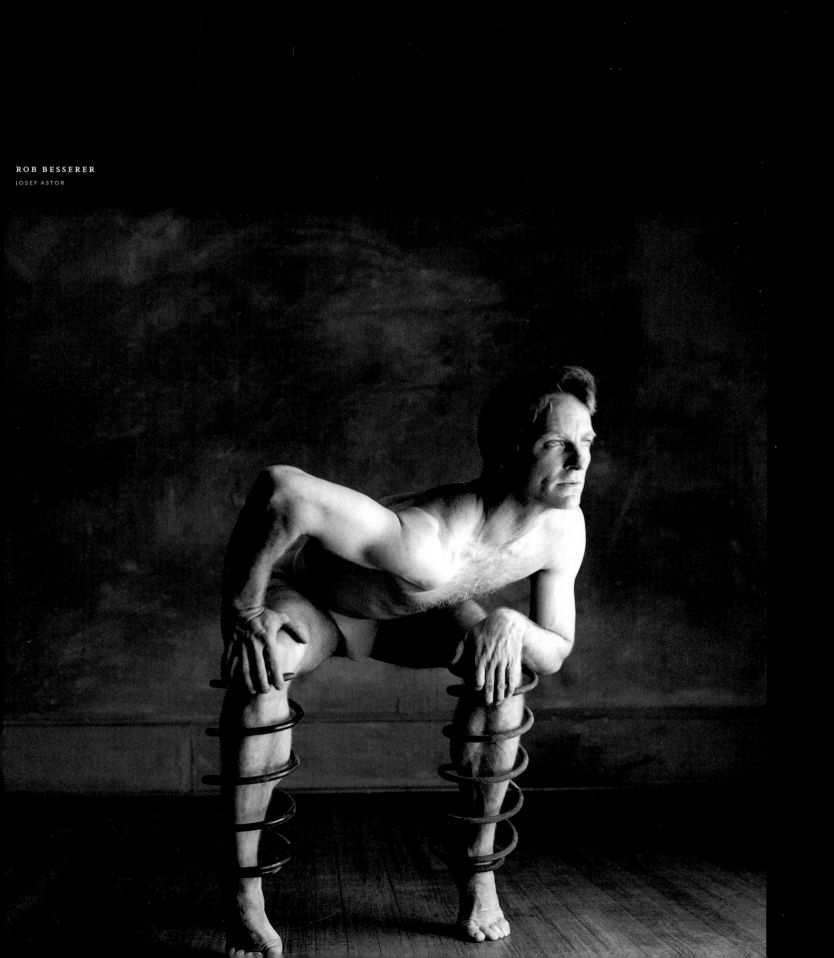

ROB BESSERER

JOSEF ASTOR

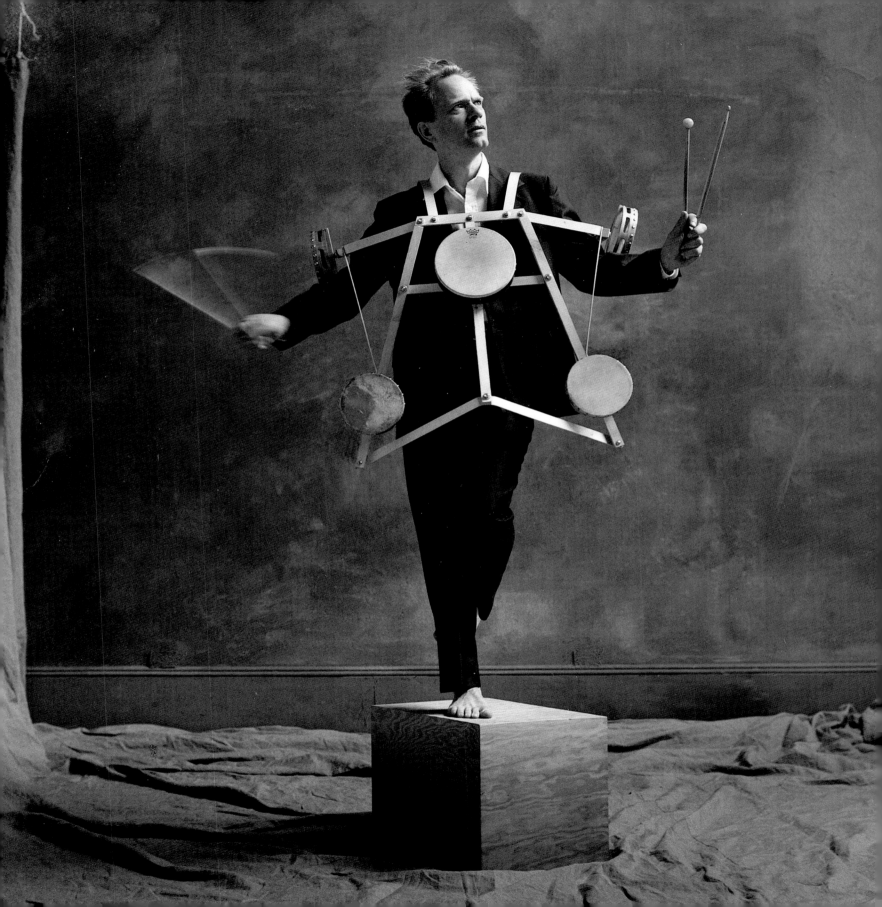

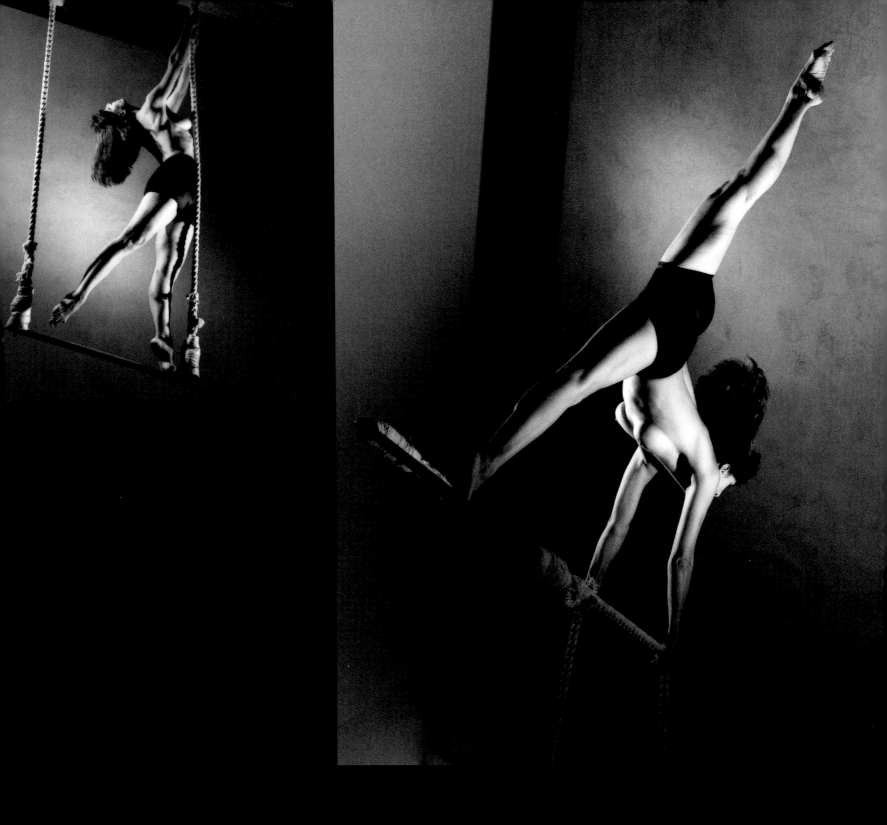

JUDY FLEX

6

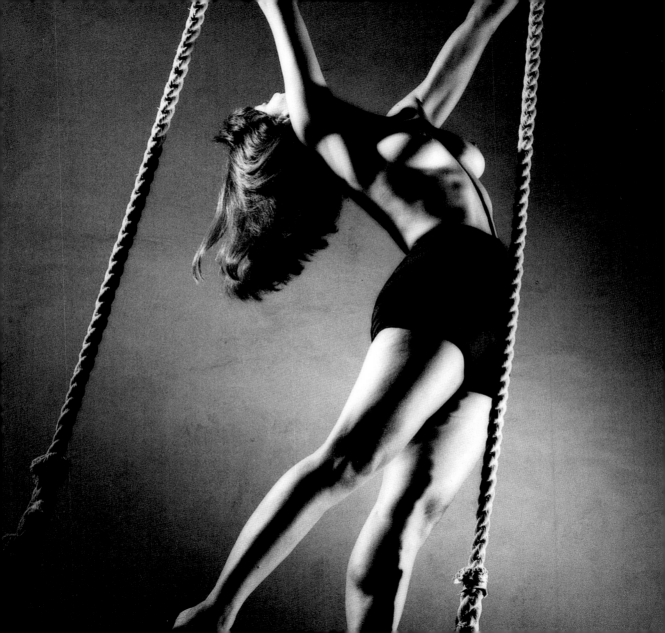

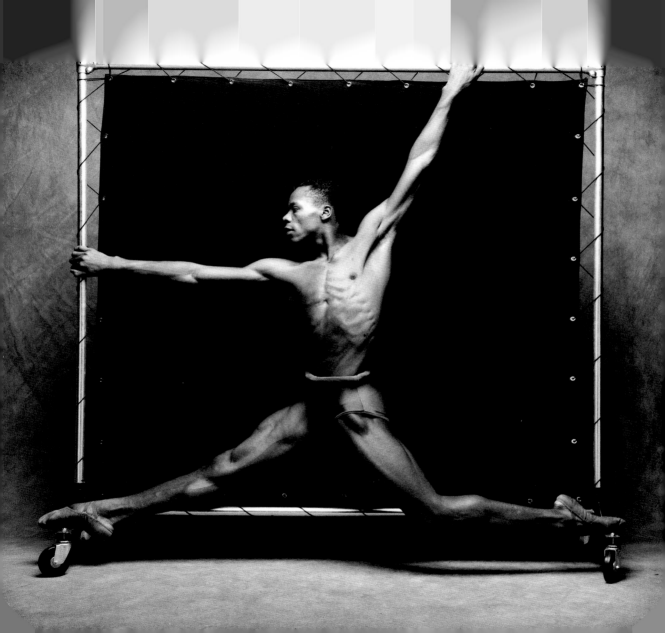

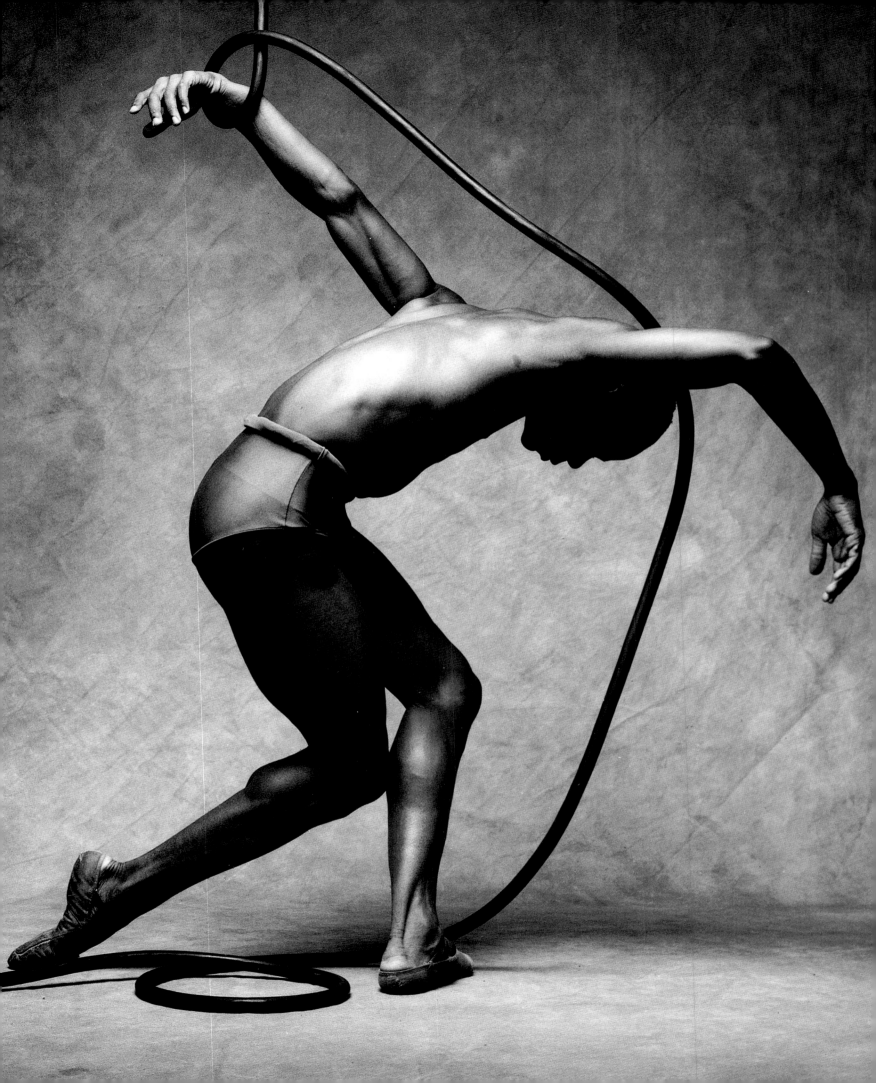

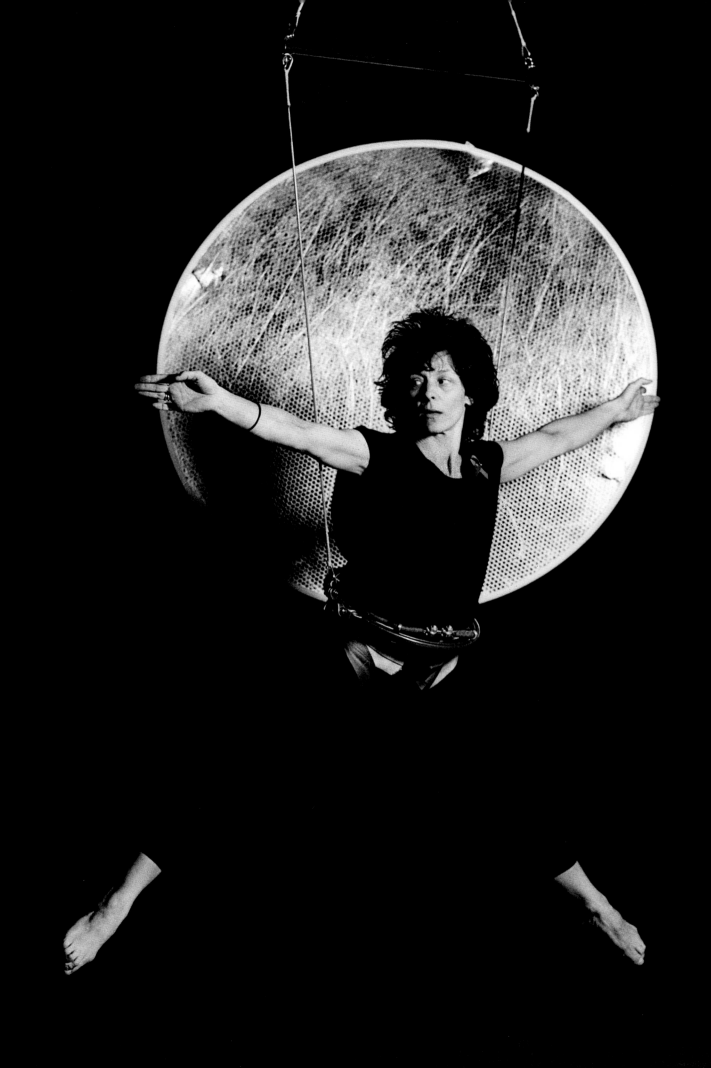

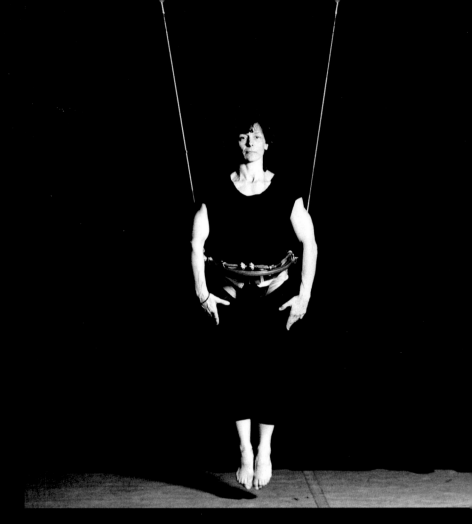

I WORK FORMALLY,
AND I APPROACH
WORK IN THE
ATTEMPT TO DIVEST
MYSELF OF IMMEDIATE
WHIMSICAL OR
PERSONAL REACTIONS.
MY SUBJECT IS
MOVEMENT AND
NOT MYSELF.
ELIZABETH STREB

ELIZABETH STREB
JOANNE SAVIO

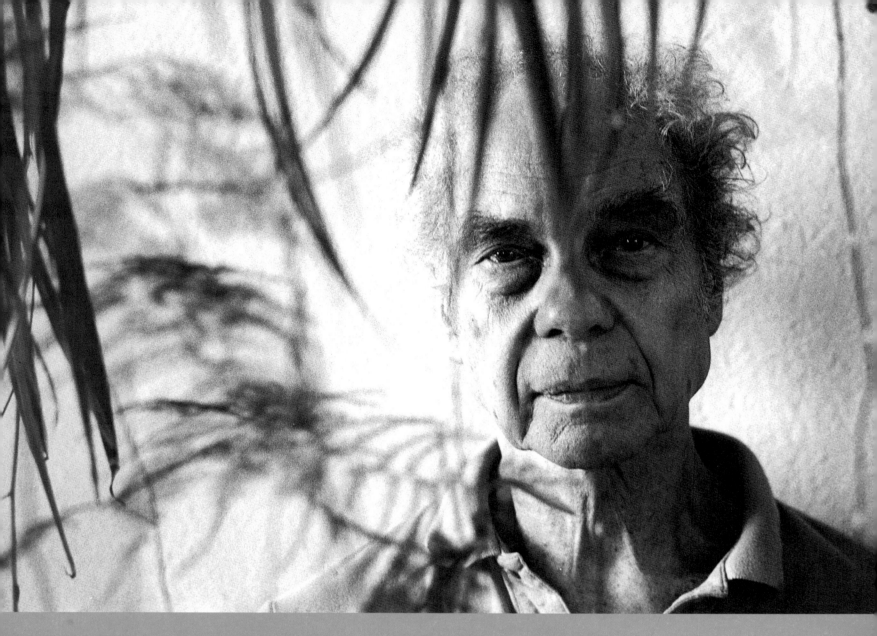

MERCE CUNNINGHAM
DUANE MICHALS

MERCE CUNNINGHAM

Starting nearly fifty years ago, Merce Cunningham began to change the way people danced and the way people see dancing in the same way that Picasso and the cubists changed the way people painted and the way people saw painting. He took dance apart and put it back together again, leaving out all but the most essential elements. He stripped dance of conventional narrative; he ordered it by chance procedures; he conceived it without music and without decor. He took it out of the proscenium (but later put it back), exploding the stage picture into fragments. He made the viewer the auteur. The great irony of all this is that only a great storyteller possessed of extraordinary and intrinsic

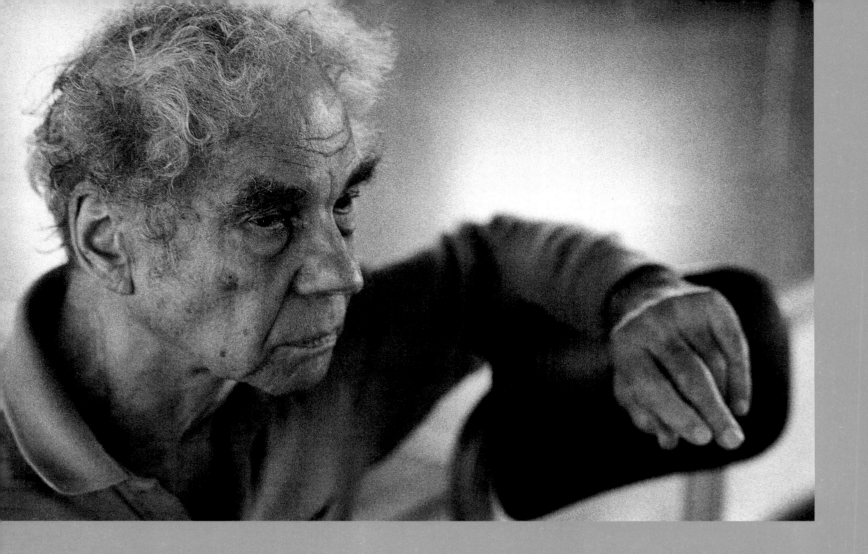

musicality could have stripped away so much and be left with more. Cunningham is able to separate dance from its traditional trappings not because dance does not need them, but because dance—at least in his hands—already has them.

Christened Mercier Philip Cunningham; known as Merce. Why? Because the name so suits him, suggesting, as it does, both the element mercury—quicksilver, changeable, unpredictable— and the god Mercury, fleet-footed messenger from Olympus. But that is not all. Merce is called Merce because his manner is unaffected and direct; because he is held in great affection, as well as esteem; and because he is so clearly our contemporary— if we can catch up with him. This man who has kept dance apace

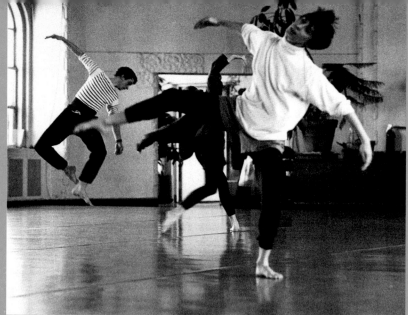

GLEN RUMSEY
DUANE MICHALS

JEANNIE STEELE

JEAN FREEBURY

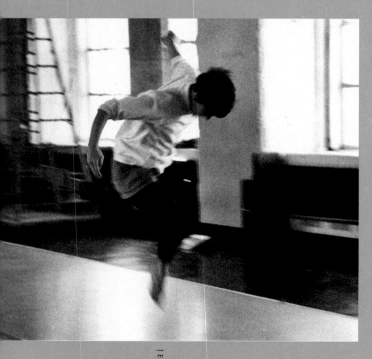

JEAN FREEBURY

GLEN RUMSEY

JEANNIE STEELE

JEAN FREEBURY

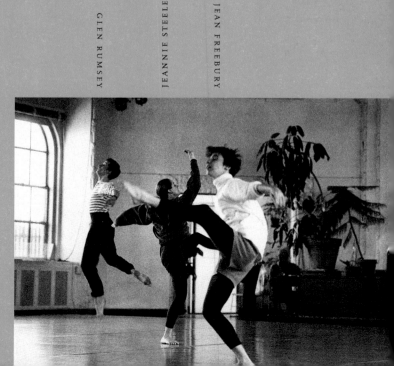

with the other arts of the twentieth century—music, painting and sculpture, literature—is now busy whisking it into the twenty-first via a romance with technology. His work is not merely reflective, it is predictive. He is the least dated person imaginable, and the most acute observer of natural phenomena.

There is no greater choreographer, no braver or more truthful performer. There is no one more innovative. Merce's dances encompass a technique and a philosophy, yet are full of the everyday. They are commanding and rigorous, yet sometimes deeply blissful. Recollected in tranquility, they absorb all thought, all conjecture—a strange and wonderful power common to all great works of imagination. They offer a proposition about the function of dance and a suggestion for how to go about looking at it. One might even come to think that these dances offer a proposition about the nature of life and how to go through it, but none of this matters at the moment of seeing the dance.

In the theater, all you have to do is open your eyes and your mind and let the dance in. Everything you need to know is in it. There is no secret. You can enjoy figuring out the dance, or, when the time is ripe, you can let the dance transfigure you. This is not something that happens with every dance or at every performance, and yet, there is this possibility, this necessity: You will find yourself in the dance. Where are we in it? We are with Merce. There is no better company, and there's no need to worry about where we are going. We learn by going where we have to go. As Merce says, "The only way to do it is to do it."

All we have to do is look.

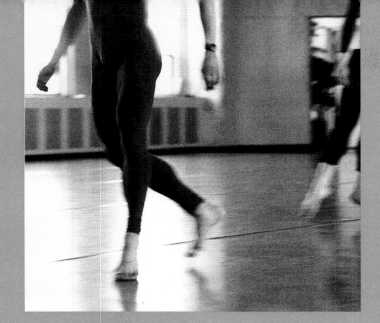

FRÉDÉRIC GAFNER

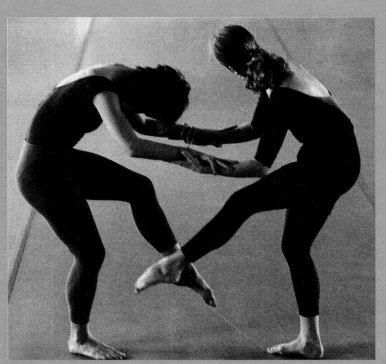

EMMA DIAMOND

JEANNIE STEELE

WITH A CERTAIN RIGOR AND
DISCIPLINE, WHAT COMES OUT
IS FREEDOM.
FRÉDÉRIC GAFNER
JOSEF ASTOR

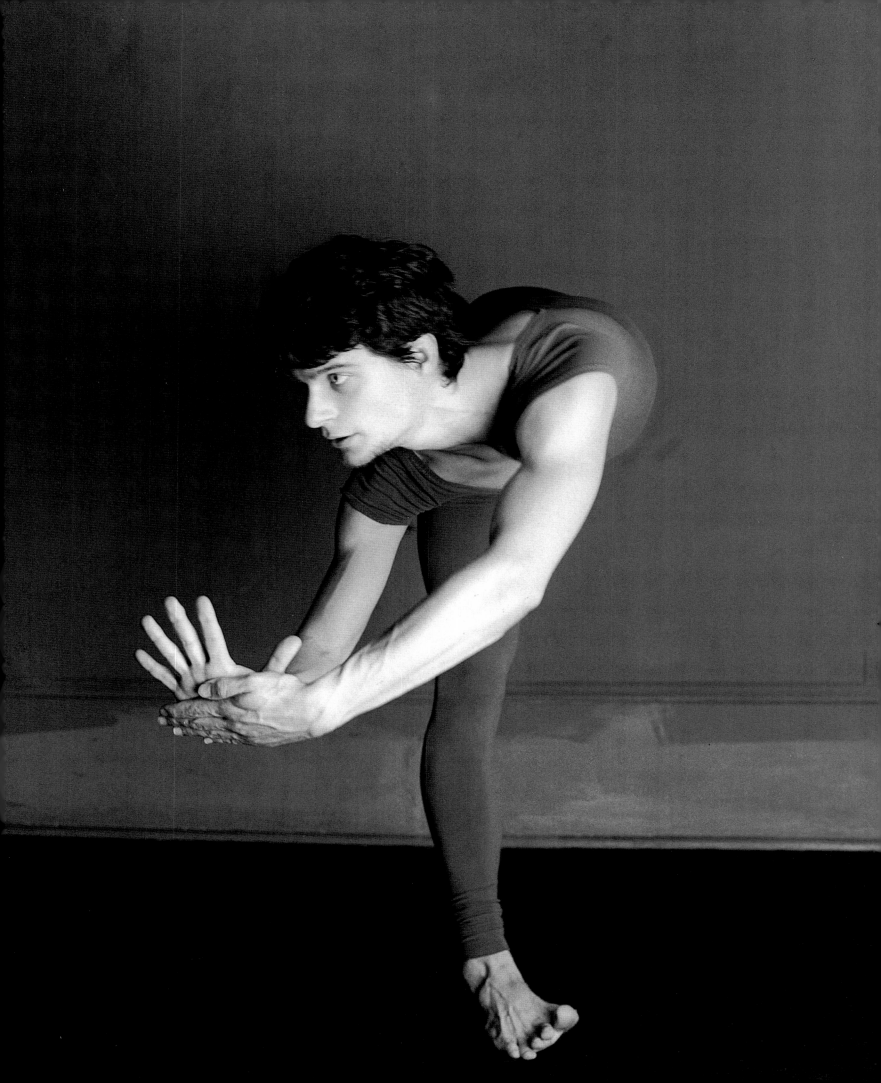

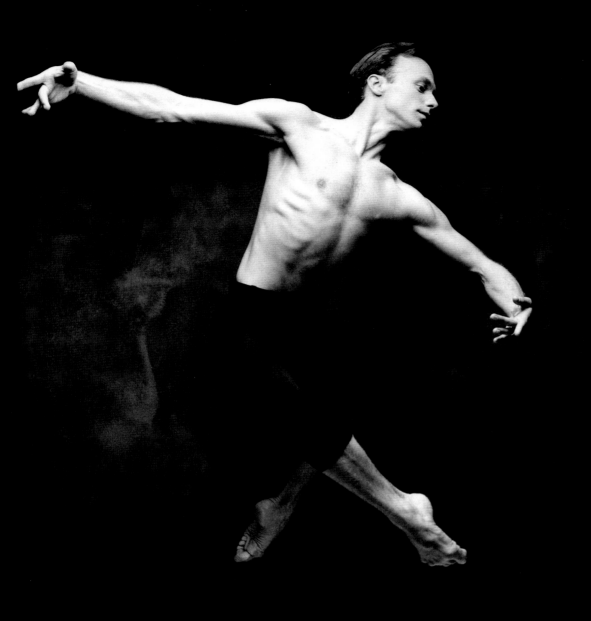

PETER BOAL
FRÉDÉRIC GAFNER
ANDREW ECCLES

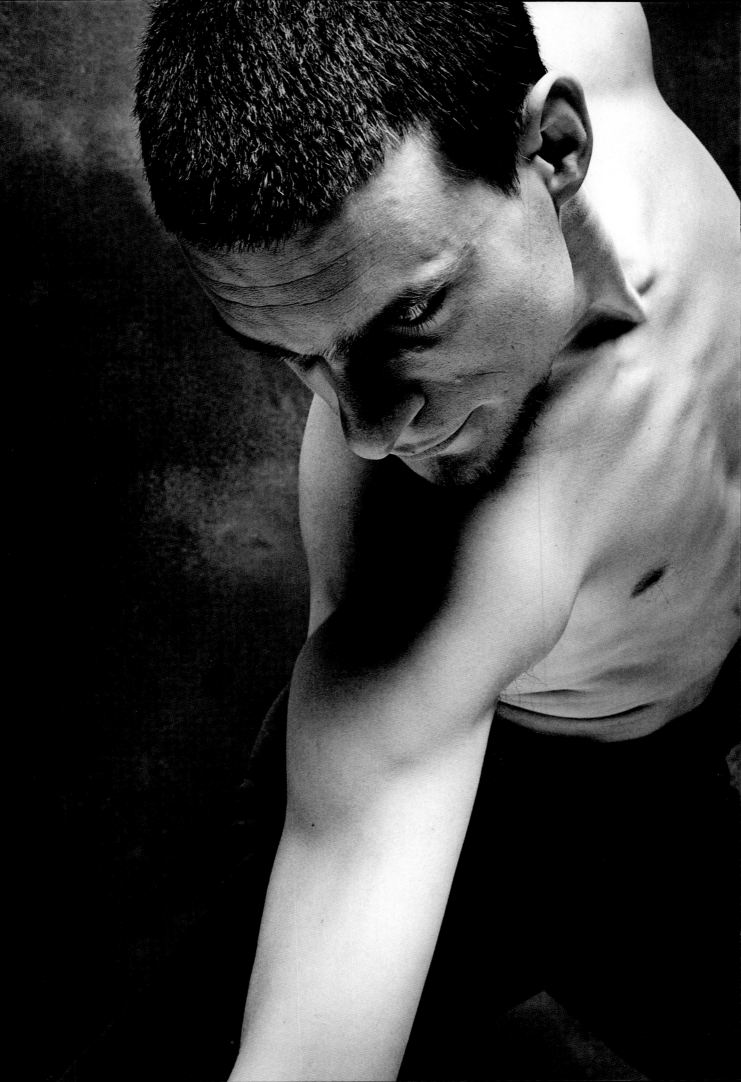

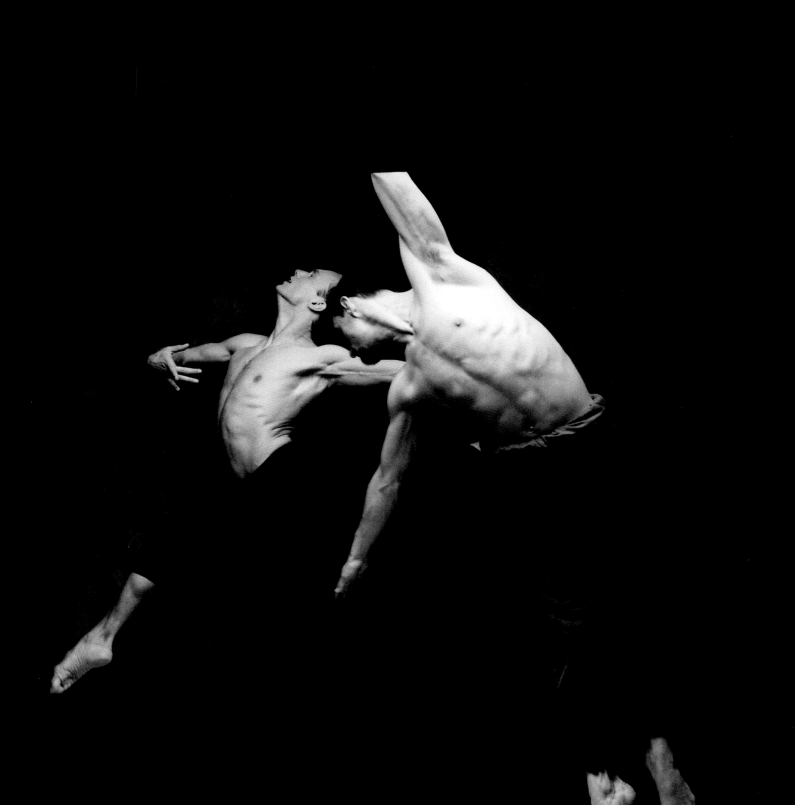

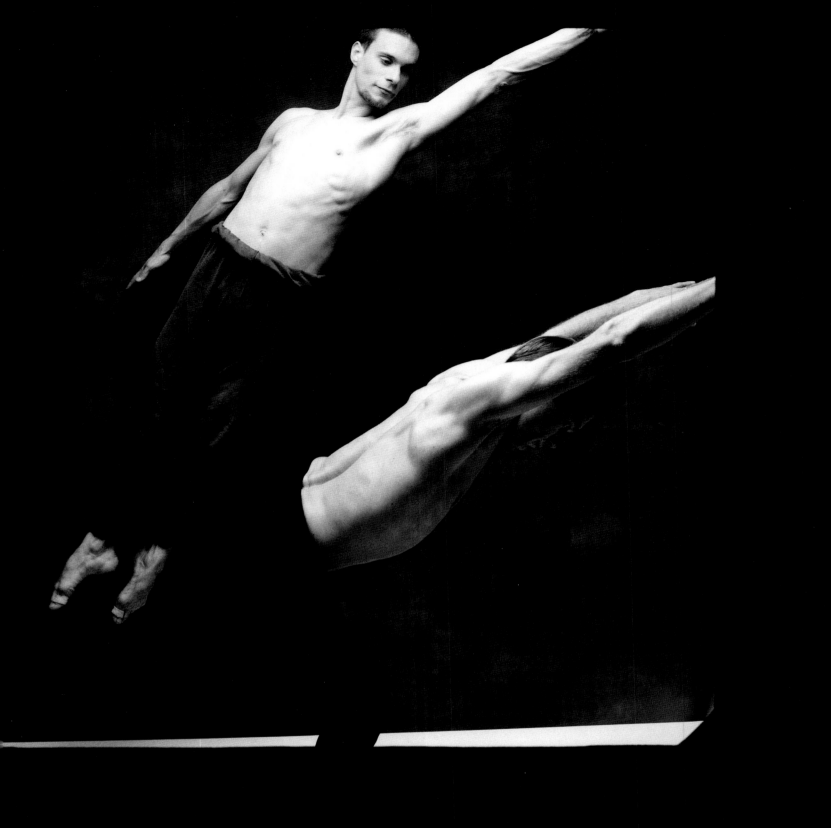

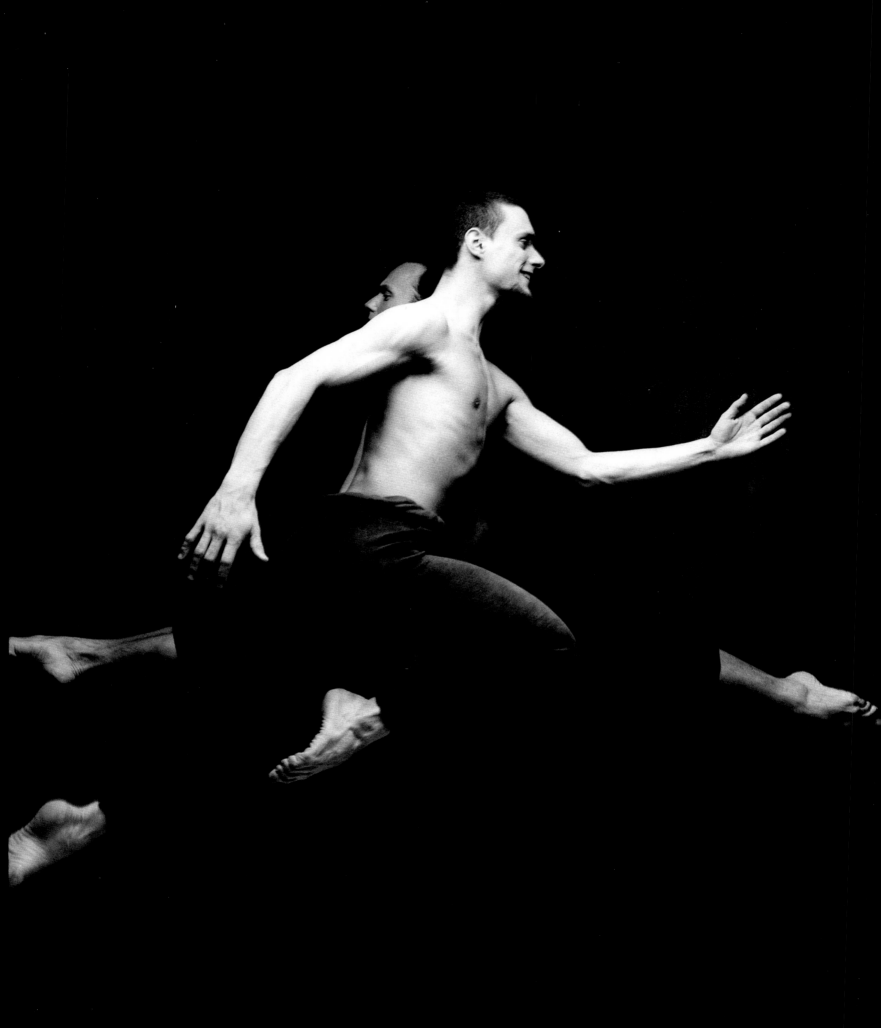

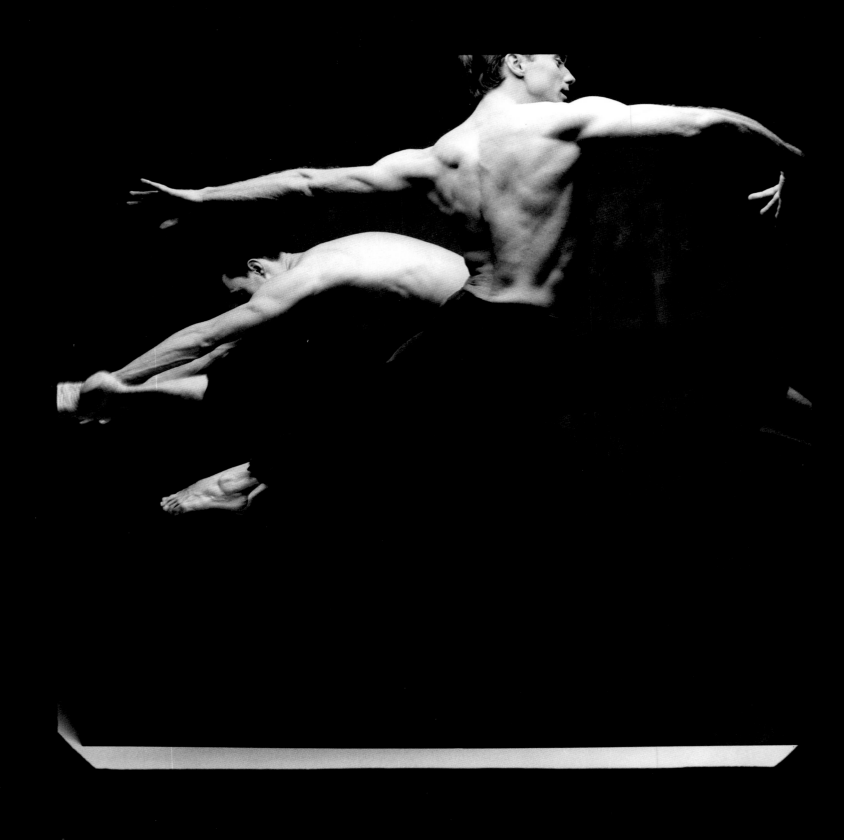

THE METAMORPHOSIS OF MY MOVEMENT HAS
INVOLVED MY LEARNING A LOT MORE ABOUT
GRAVITY, WHICH TRANSLATES WELL INTO THE
ISSUE OF MORTALITY. GRAVITY IS A SUBMISSION
TO FATE; IT IS SOMETHING PRESENT IN OUR
LIVES, WHETHER WE WANT IT TO BE OR NOT.
NEIL GREENBERG

ALICE GARICK

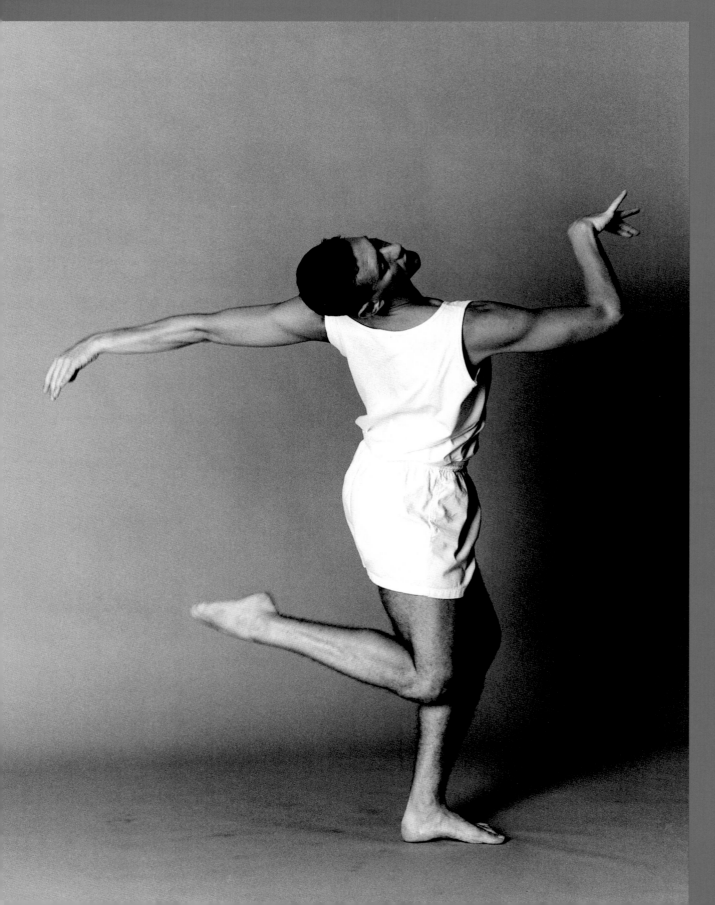

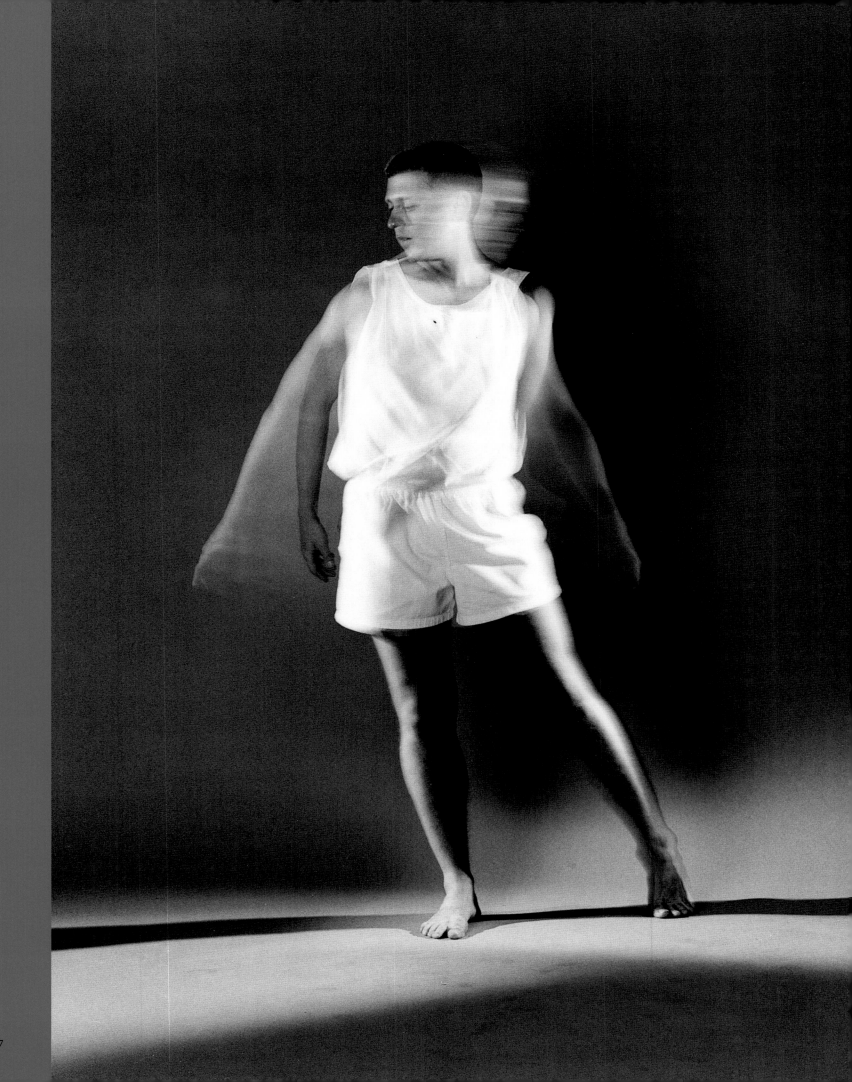

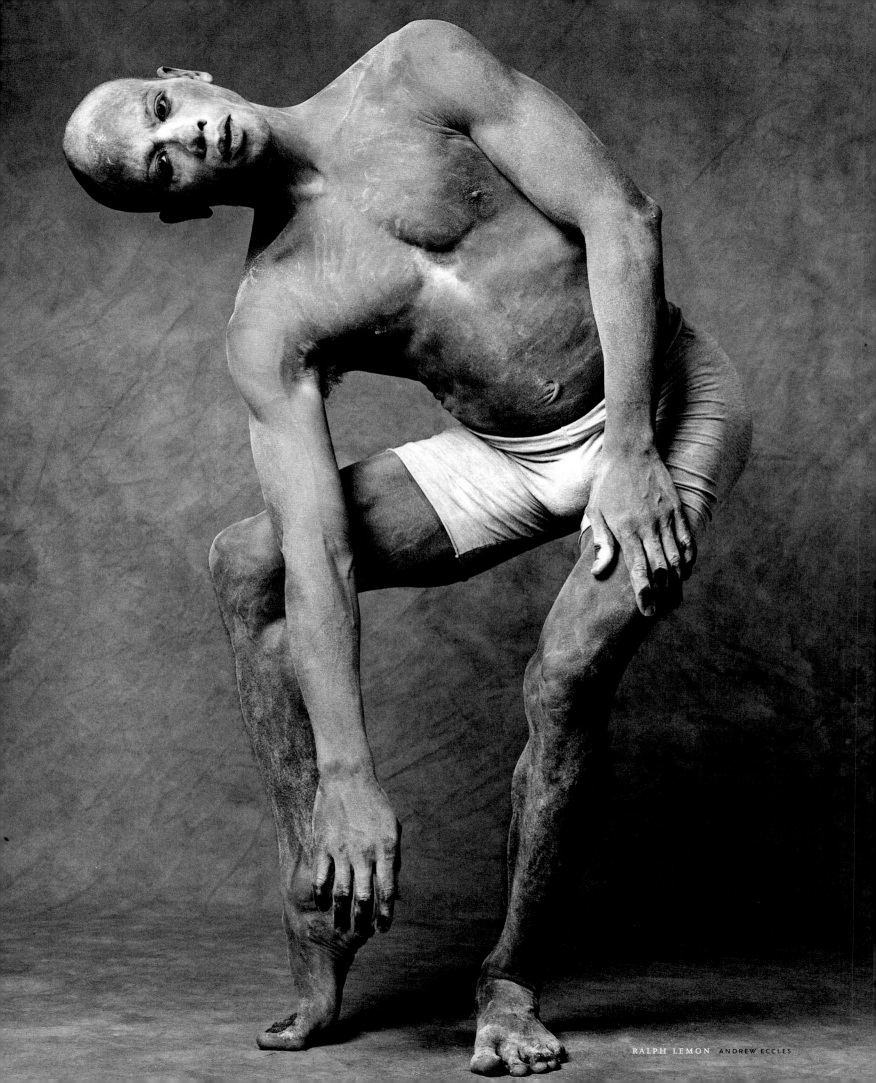

RALPH LEMON ANDREW ECCLES

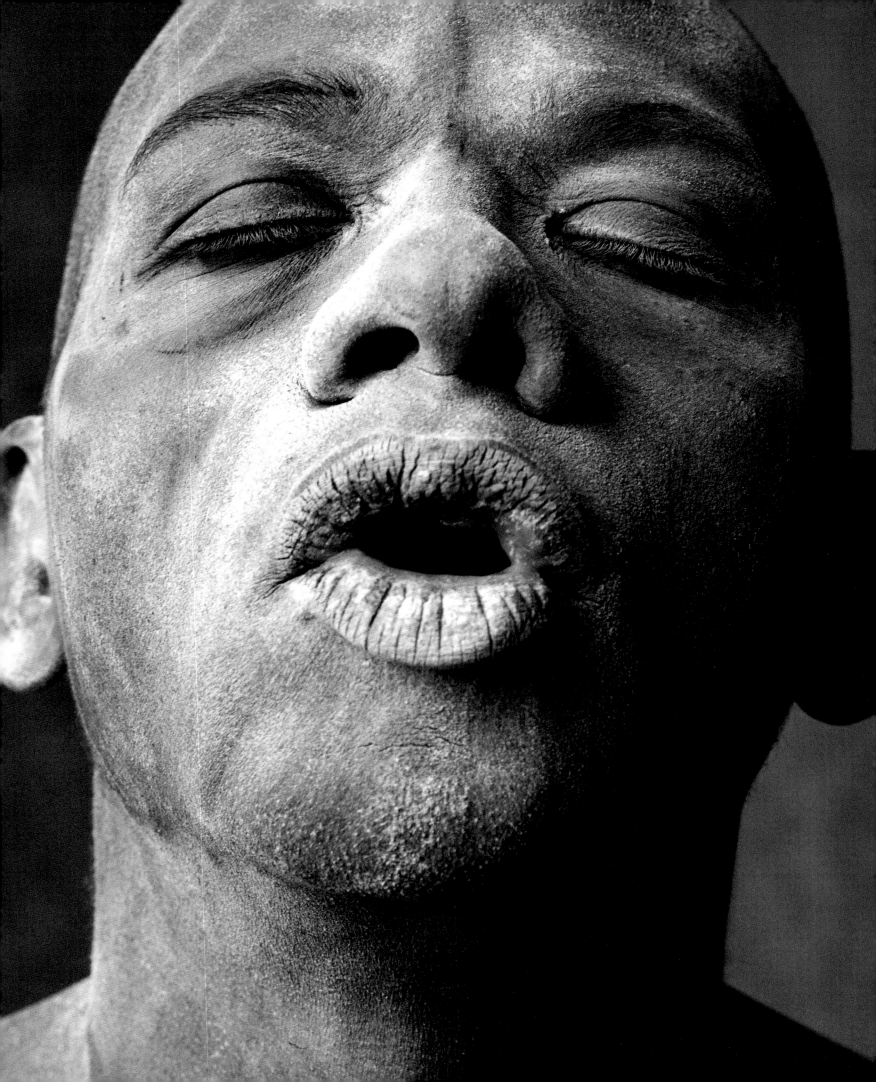

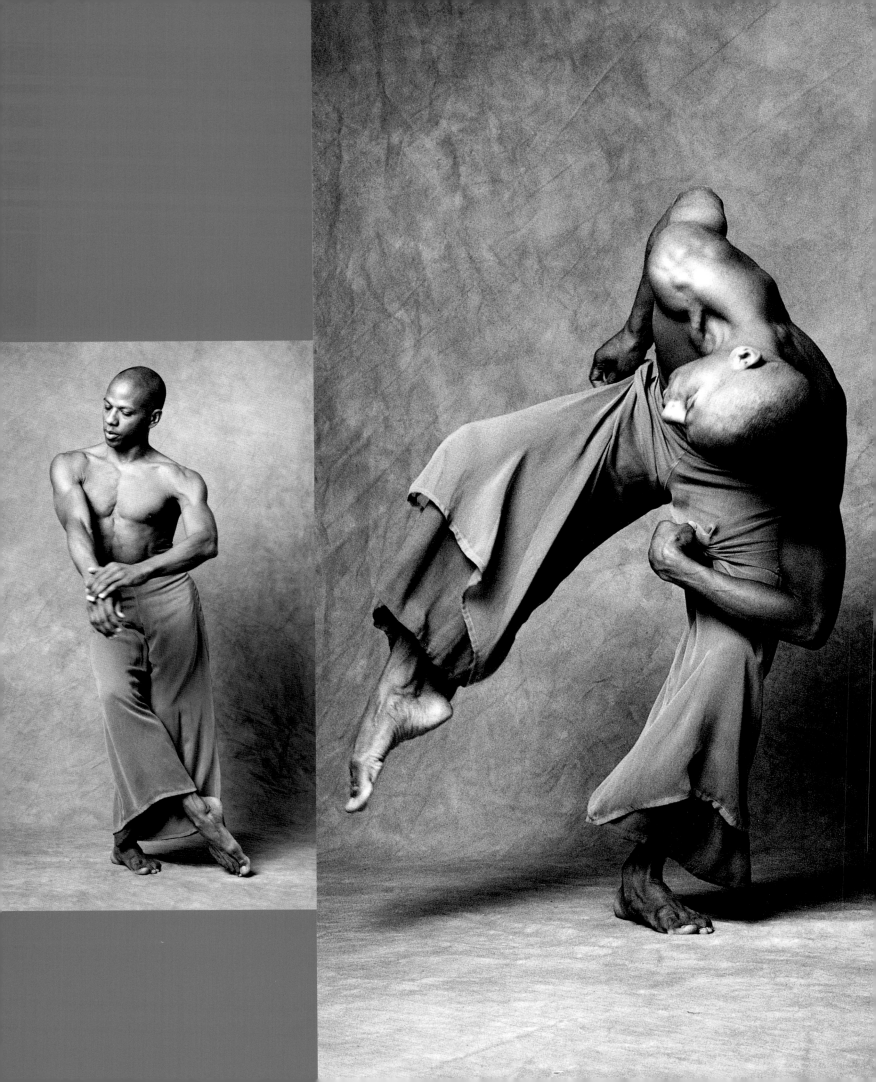

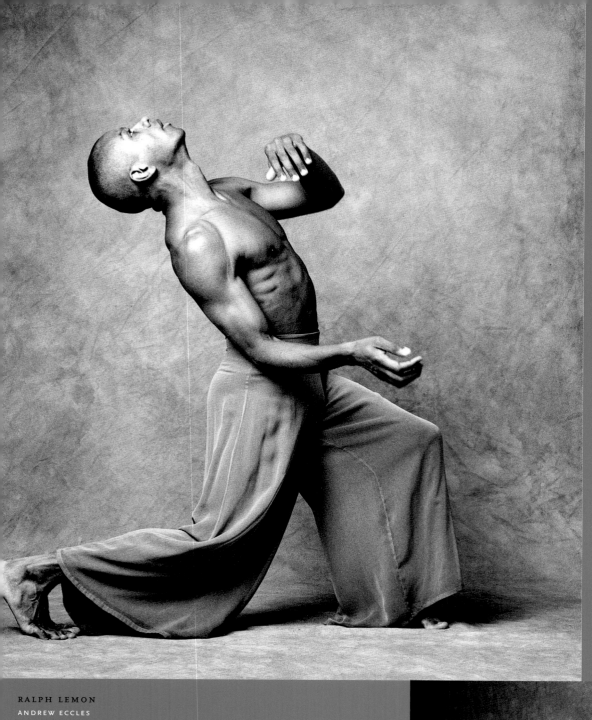

RALPH LEMON
ANDREW ECCLES

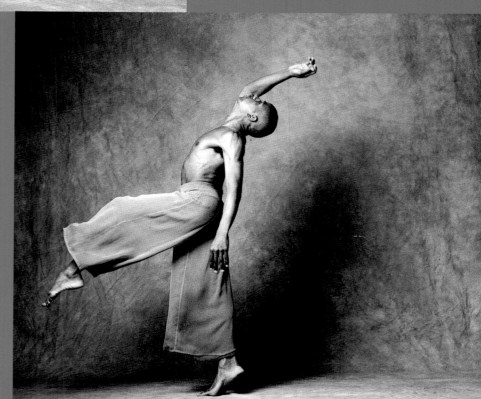

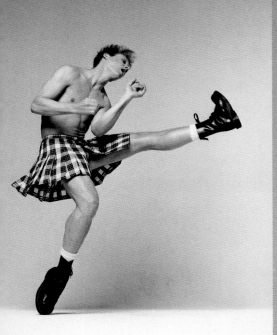
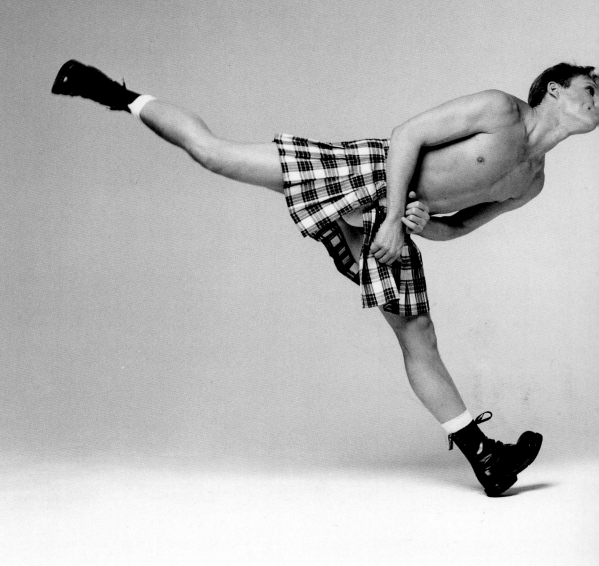

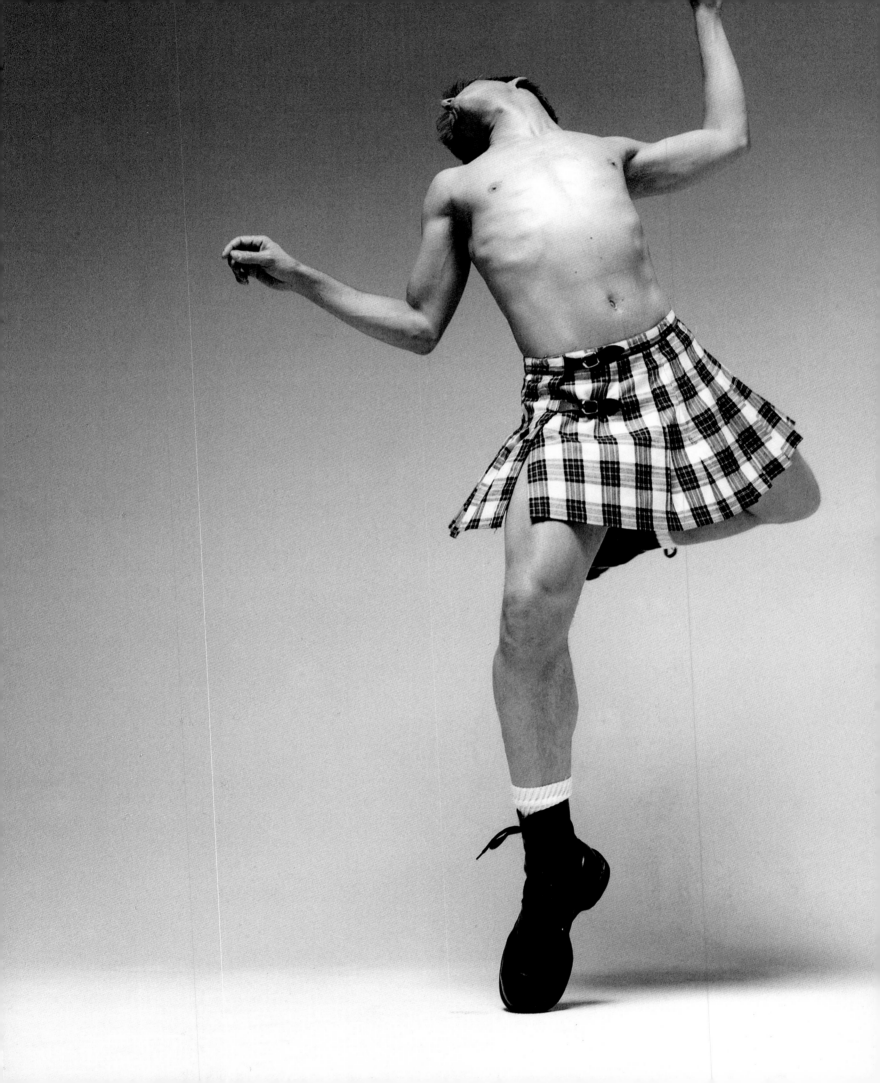

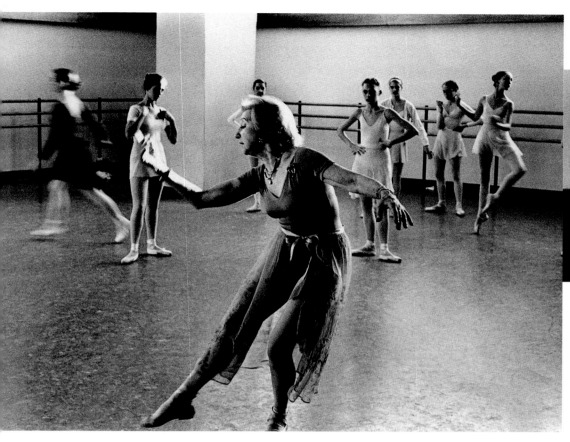

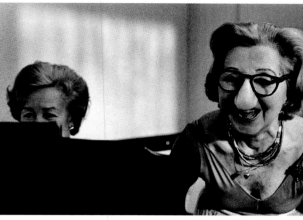

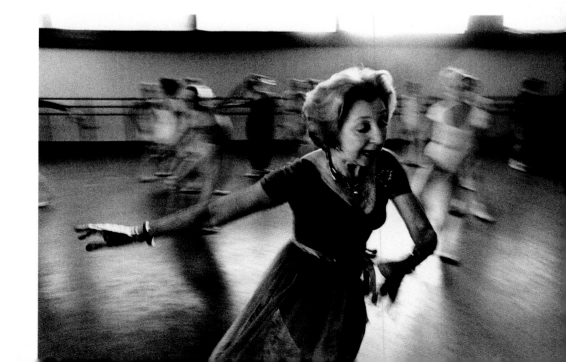

ALEXANDRA DANILOVA
DUANE MICHALS

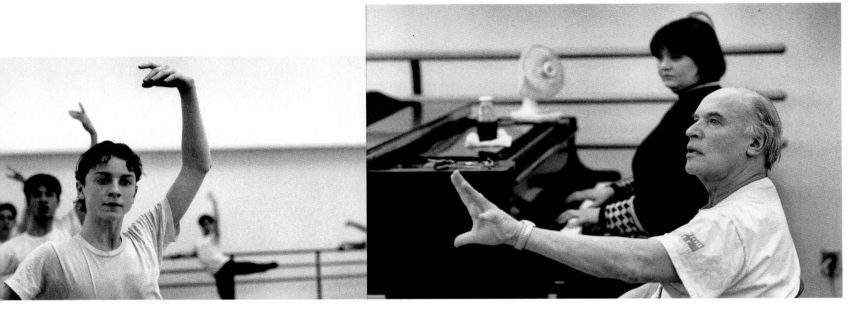

ANDREI KRAMAREVSKY

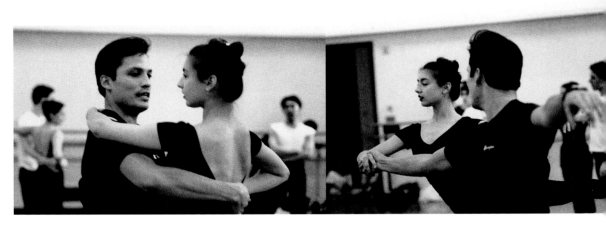

JOCK SOTO

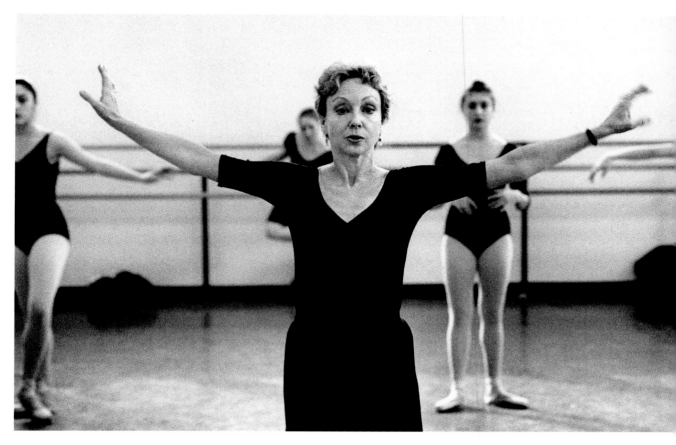

SUKI SCHORER

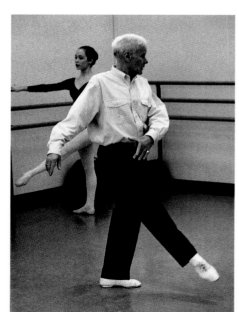

STANLEY WILLIAMS

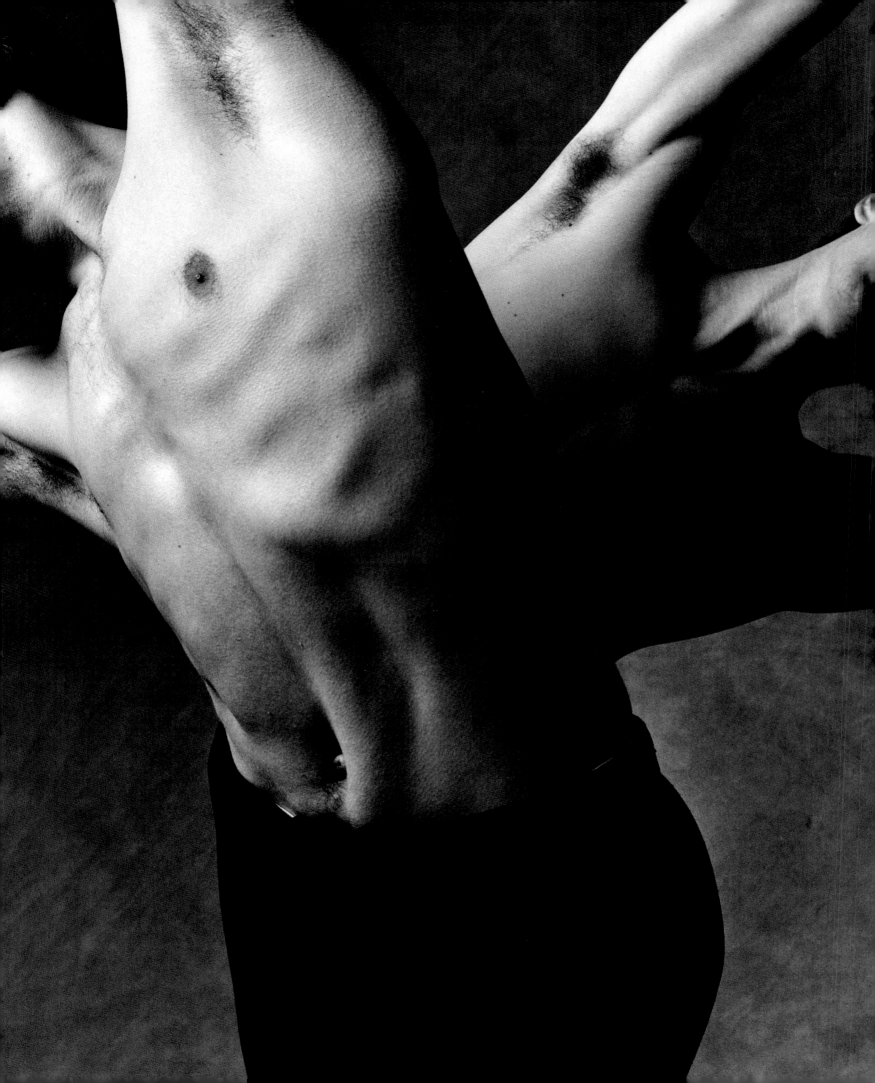

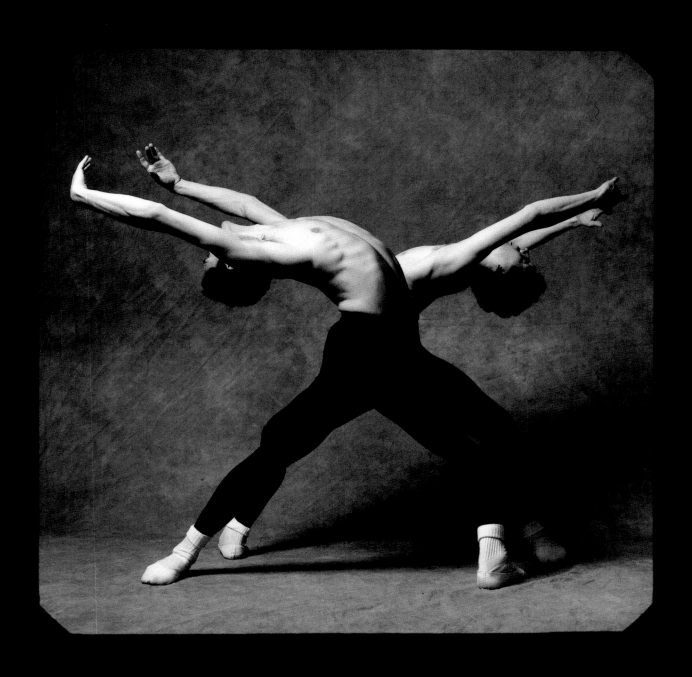

ARCH HIGGINS ALEXANDER RITTER ANDREW ECCLES

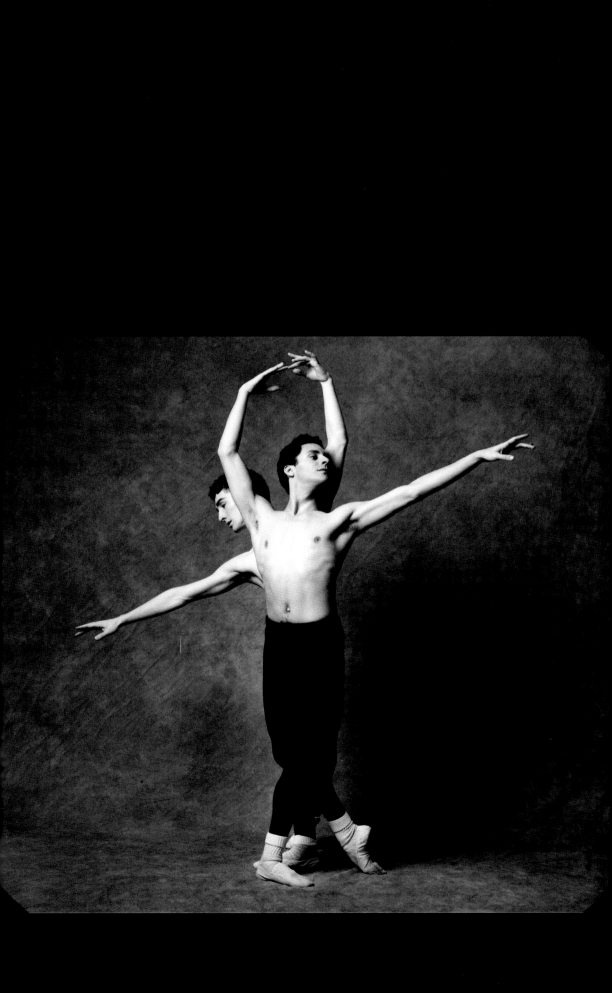

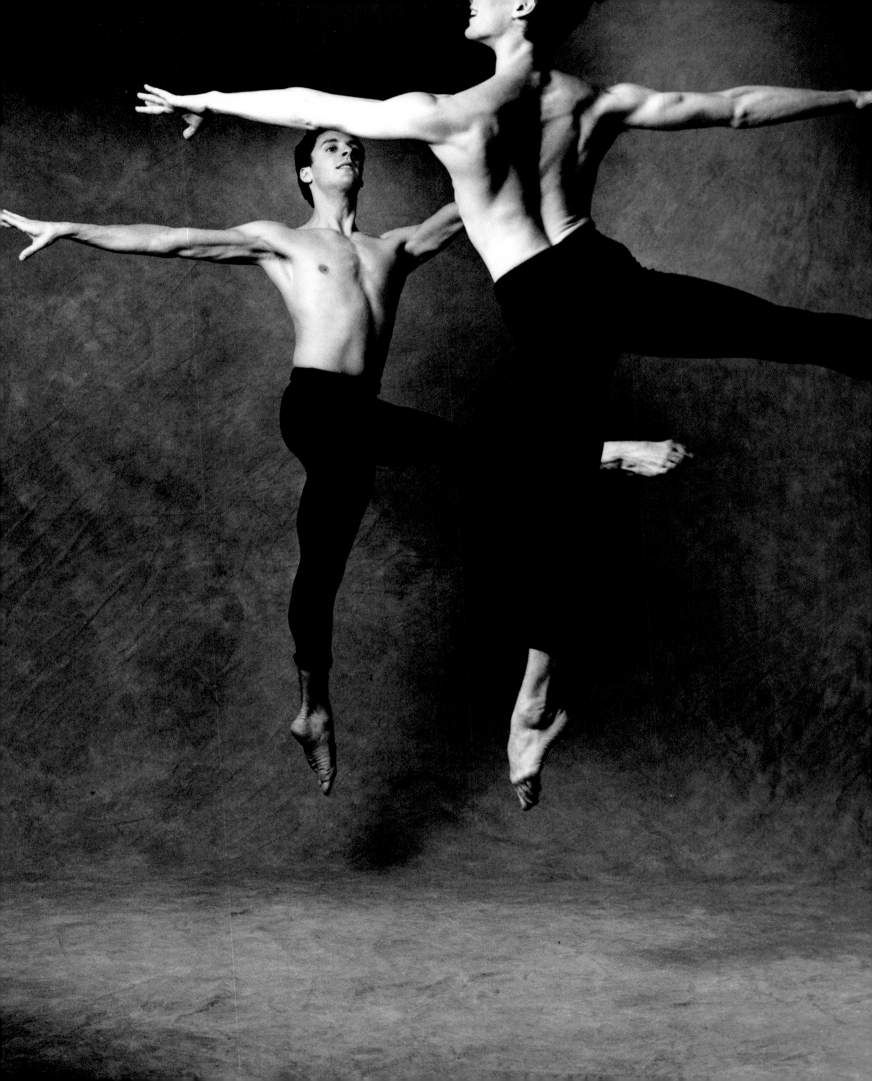

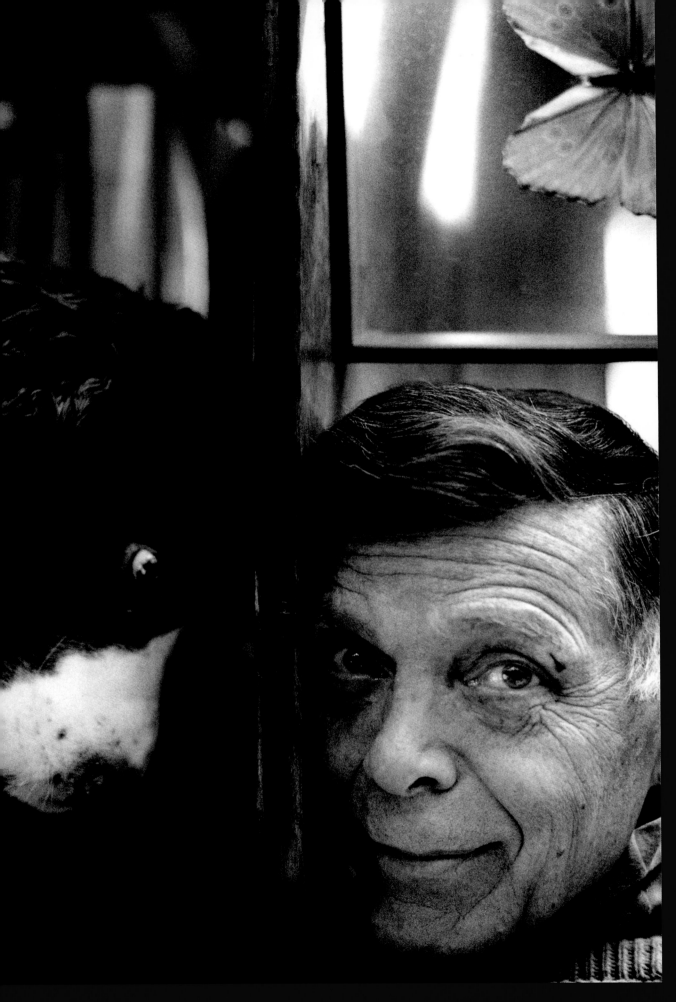

PAUL TAYLOR
DUANE MICHALS

[ACT 2]

PAUL TAYLOR

Some say that pets resemble their owners, and vice versa. In the city and in the country, Paul Taylor is announced by a bounding springer spaniel. Mischievous harbinger and soulful herald, Budd is handsome and quick of fang; he can jump like nobody's business, but his dark eyes are moody. Taylor's eyes are clear and light; but he is handsome, fabulously articulate in his own deceptively laconic way. Once upon a time, he, too, was a jumper. He looks like the great dancer that he was and, in his studio, still is—shaping a phrase, showing a step, soft-shoeing around with inescapable grace. This is where all those ardent and buoyant and sorrowing and terrifying works began, where all the ladders start: with this man dreaming and dancing. Dark-minded, light-footed.

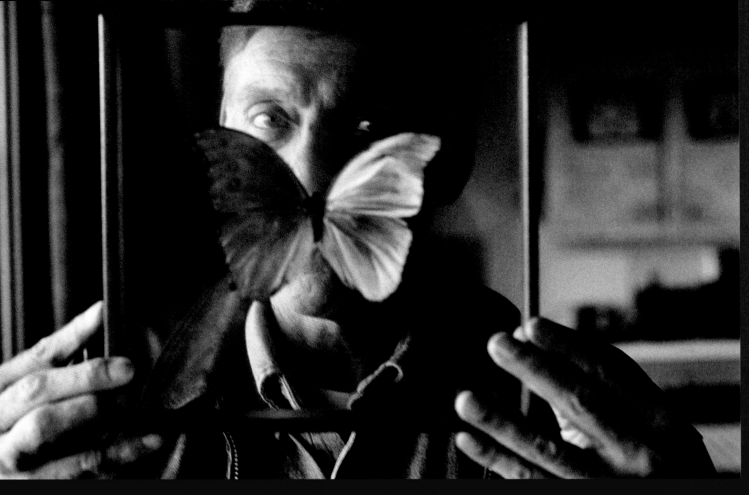

As with master and spaniel, choreographers look like their dances—or rather, their dances look like them; projections not only of the physical, but also of the psychic. Every time the curtain goes up on the Paul Taylor Dance Company, there might as well be a banner across the stage proclaiming PAUL TAYLOR MADE THIS. There is a whole Taylor world, instantly recognizable, whether a ravening, Dionysian upheaval or an idyllic pastoral greening. Here, for some forty years, the choreographer has presented us with dances of innocence and dances of experience. Work after work, the Taylor scheme unfolds in a pictorial dreamscape that alternates between joy and horror, delight and loathing, heaven and hell. Taylor sets us down someplace where there is no border between real and

surreal, fact and fancy, id or super ego. Here are the glorious Taylor consistencies: his structural firmaments—the alleys formed by two lines of dancers, the curving arms, the loping runs, the cartwheels, the somersaults—and the ebb and sweep of the Taylor tide.

And here are the glorious Taylor dancers, their master all over again. In a sense, all choreographers are visual artists, their medium people instead of paint or marble. Taylor fills his stages hierarchically and volumetrically. Stop a dance anywhere, and you see a stage as composed as a canvas by Poussin, but with figures out of Michelangelo and Bernini. And the poses! When not Taylor's signature homages to the archaic, or to Nijinsky, or to Graham, the poses are pure Blake. (You cannot open a book of Blake's illustrations without seeing Taylor everywhere.)

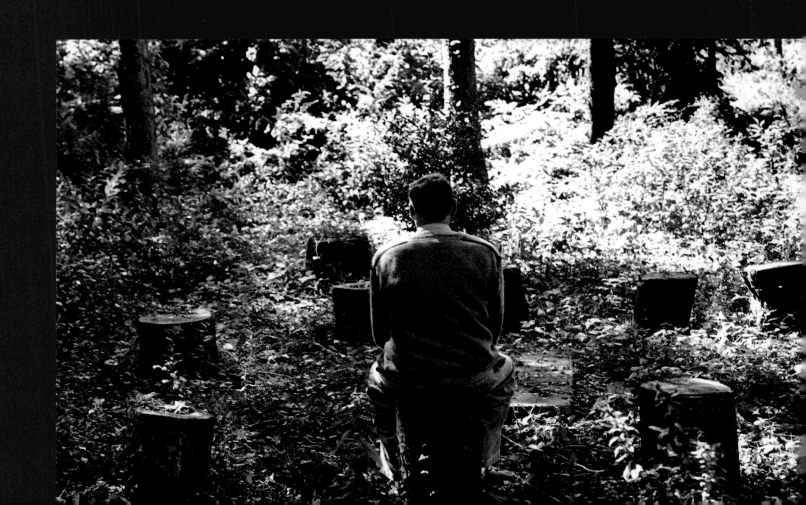

In Taylor's world there is always music. Music becomes him, for once he has choreographed a score, it belongs to him. Hear those measures on the radio, even hear them in a different theater with different dancers and a different choreographer, and instantly the spirit of Taylor's dance will infuse it, and you.

Lately, even Taylor's lightest and most frolicsome dances have, for the susceptible, an undertone of wistfulness, of nostalgia, of *chagrin d'amour*—those mild, perfumey sorrows. A melancholy has crept in too, a terpsichorean pentimento, for in all but the newest dances, under each performance there lie others, by much loved dancers now departed from the stage. Taylor's world is ageless; we are not. Fast falls the eventide, where dark and light converge, opposites intertwine, gladness and sorrow well up at once, and Taylor springs eternal.

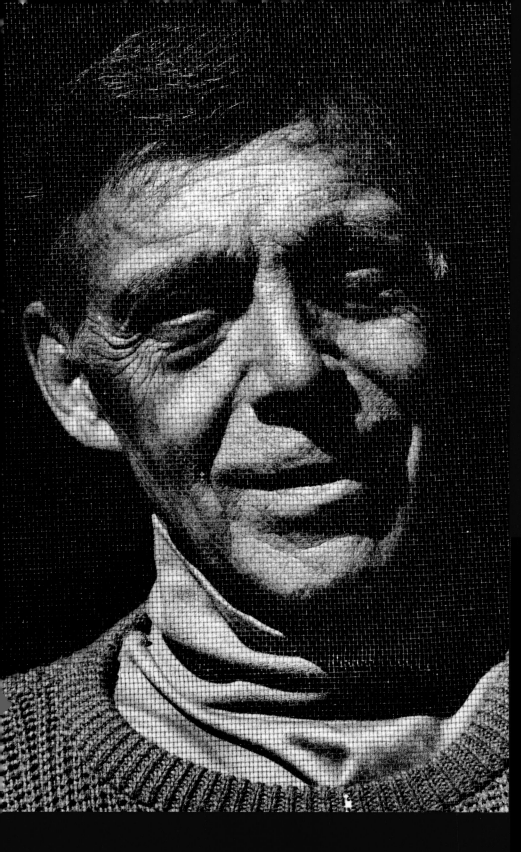

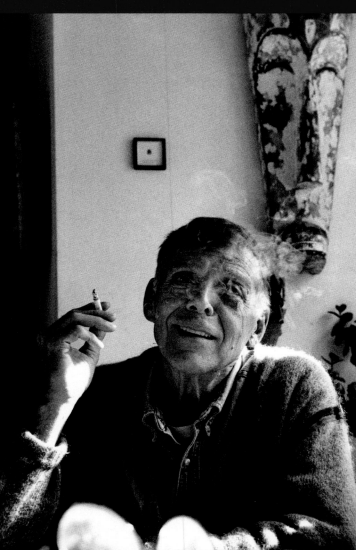

TOM GOLD
MARCIA LIPPMAN

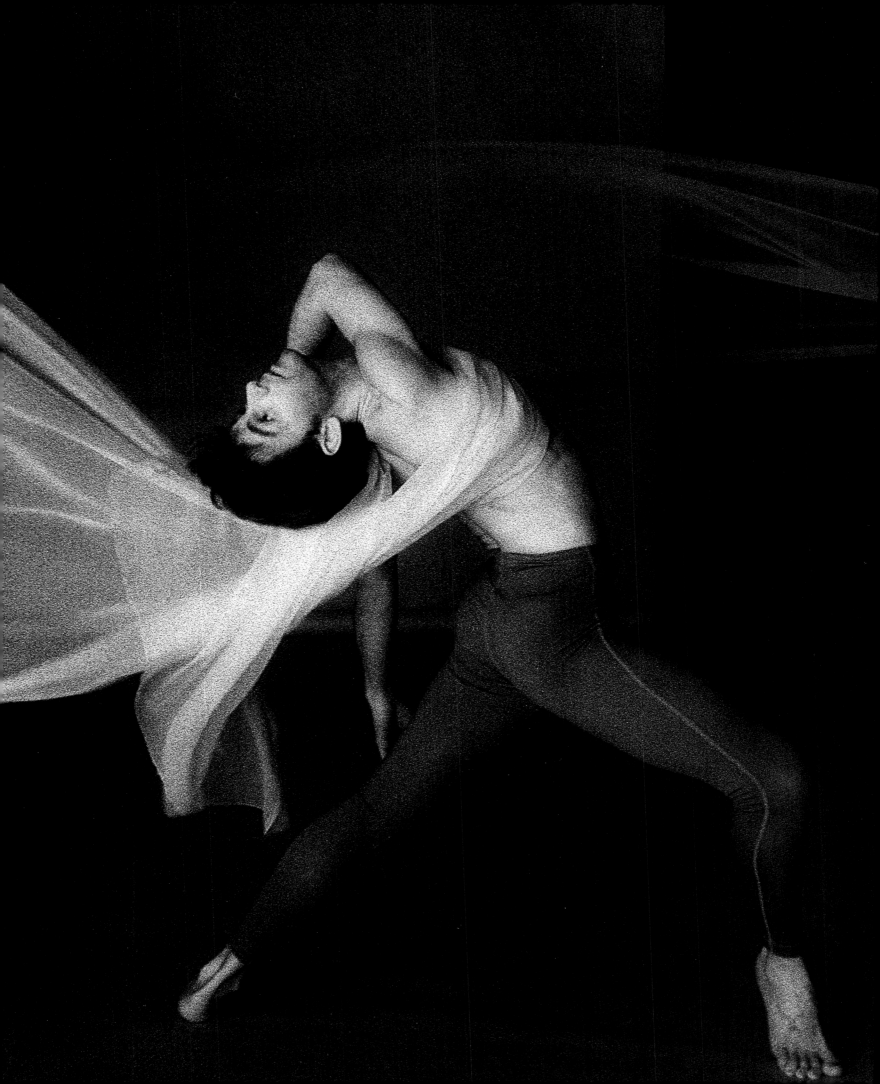

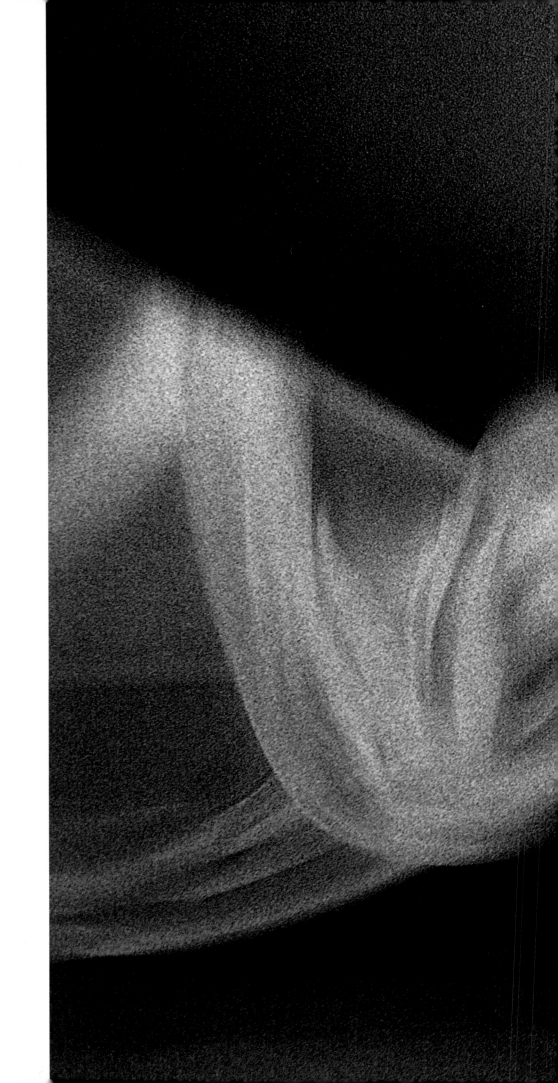

TOM GOLD

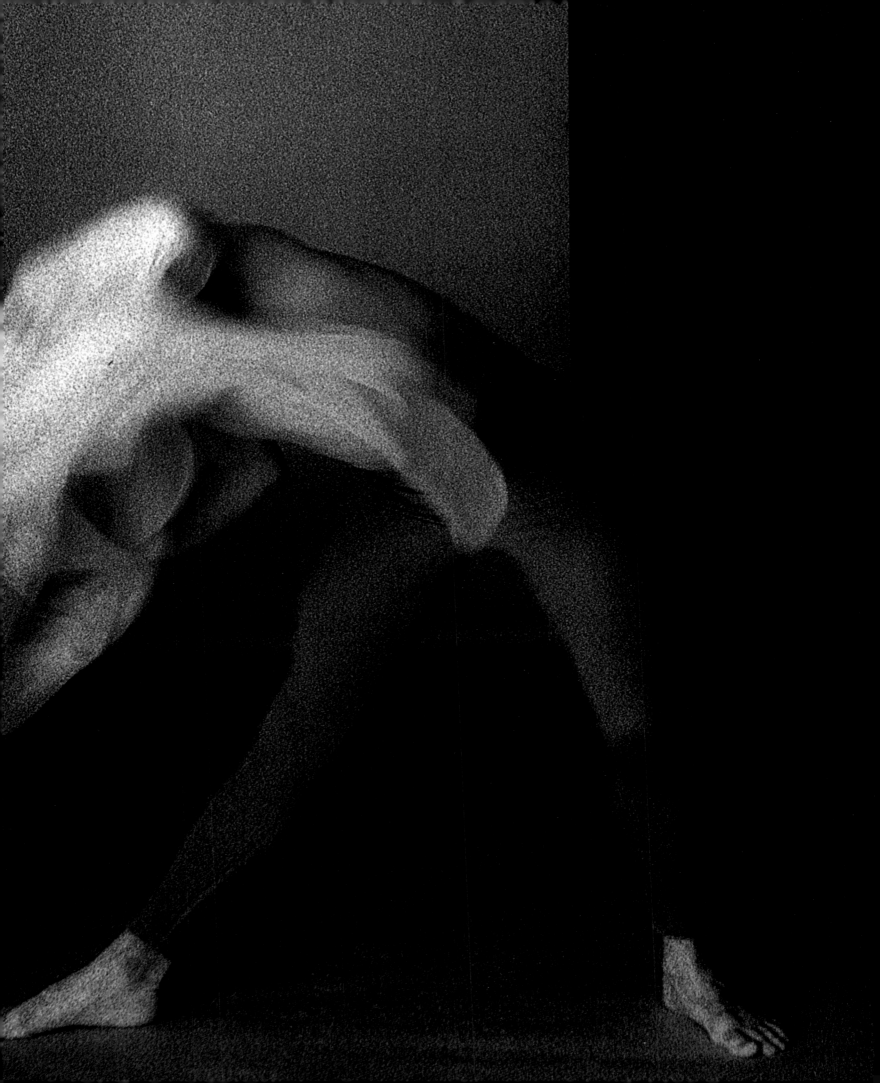

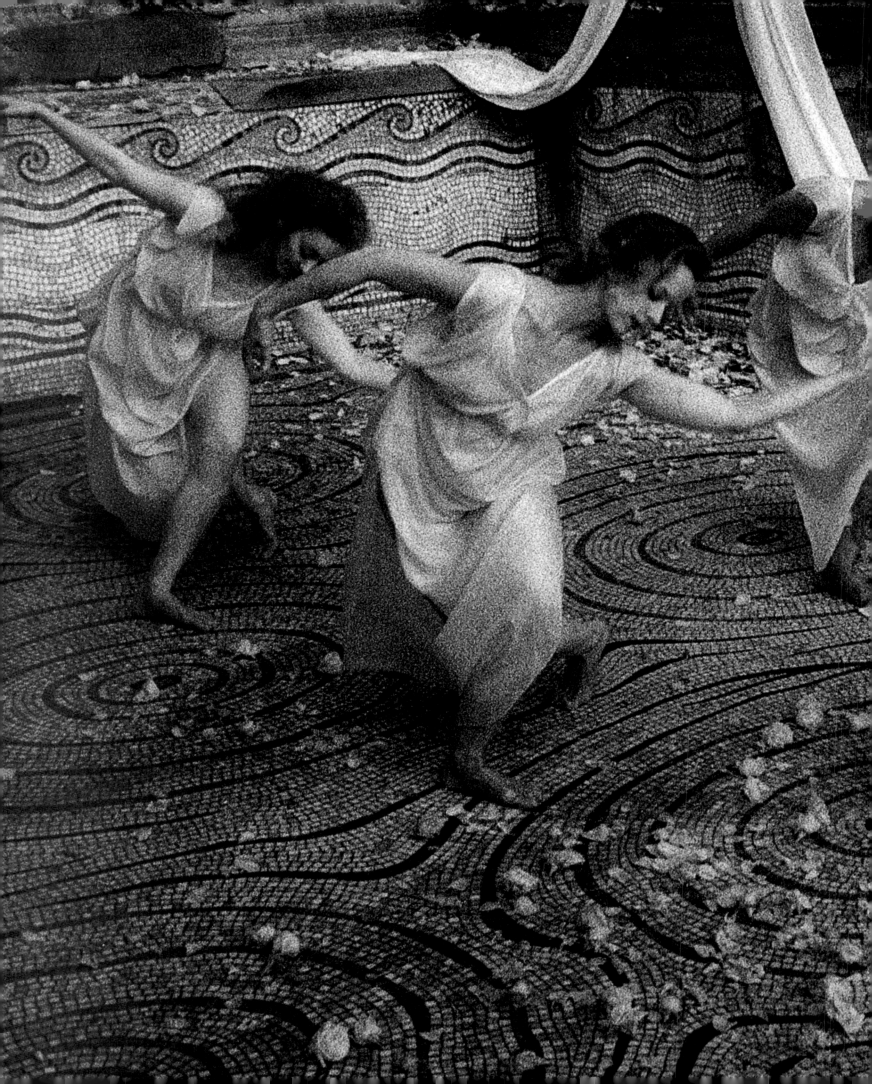

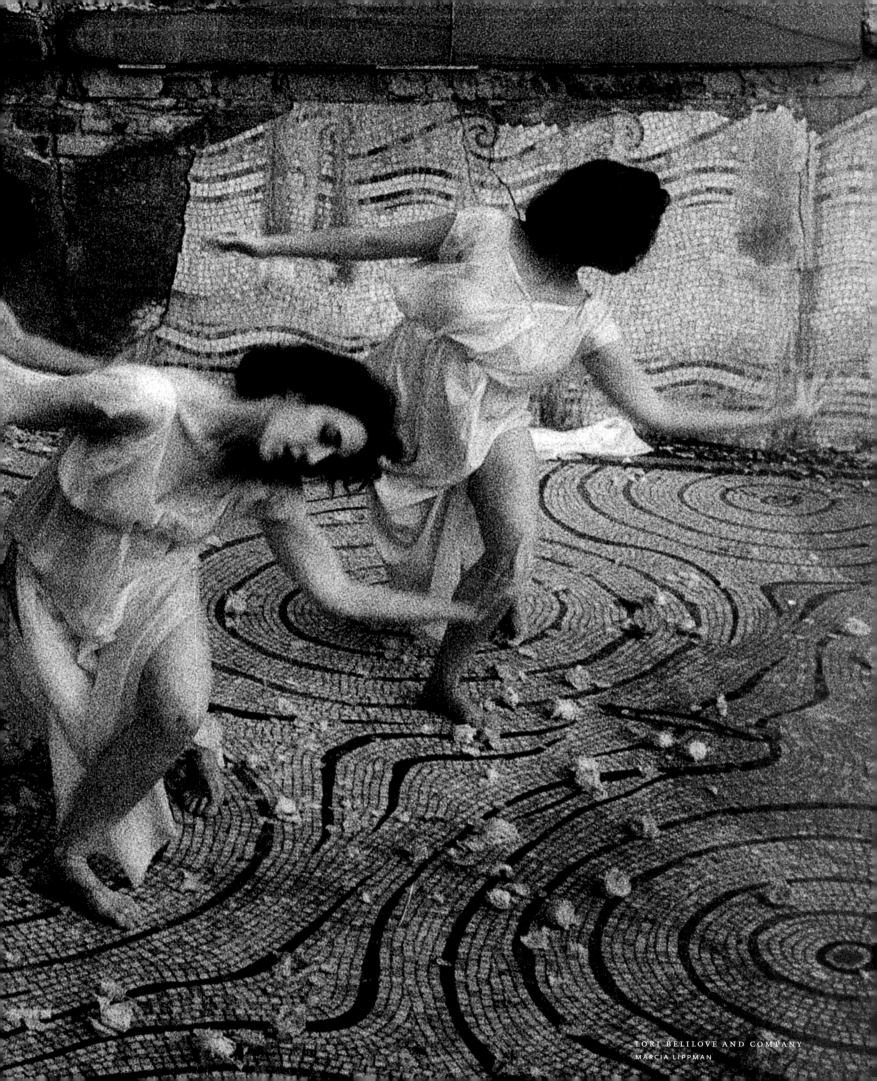

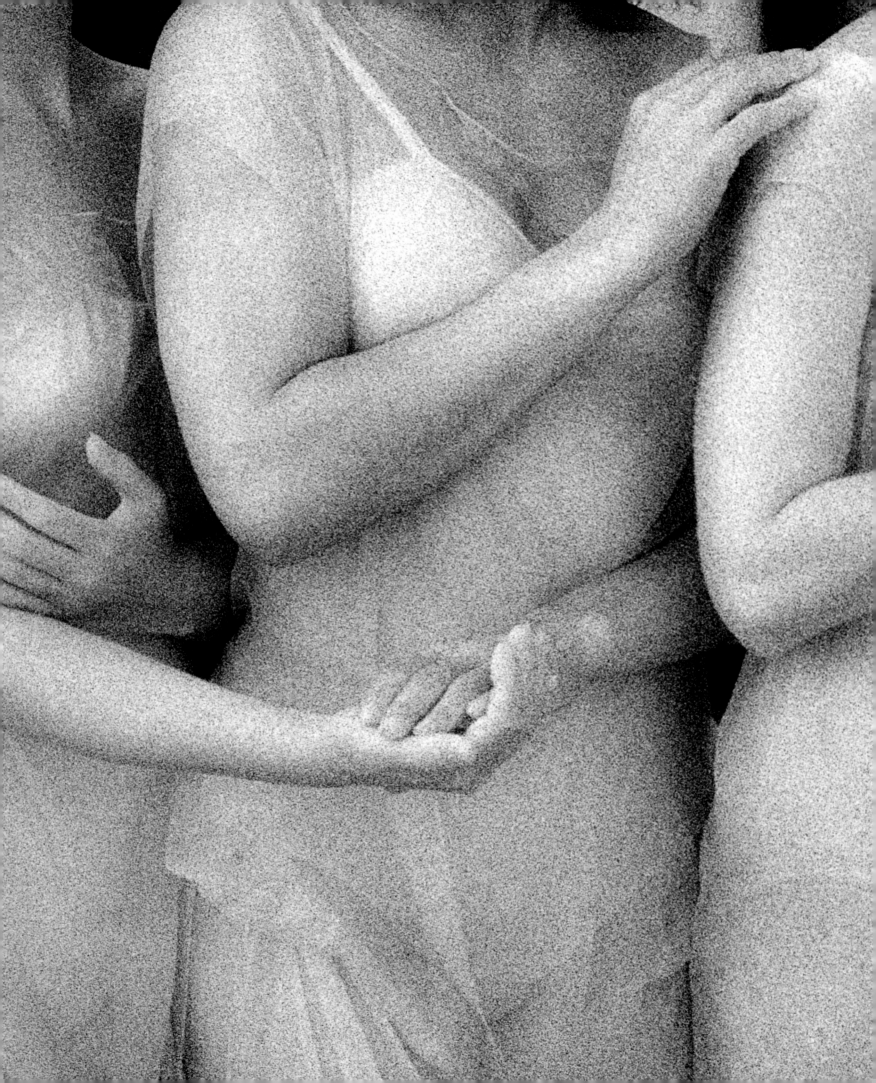

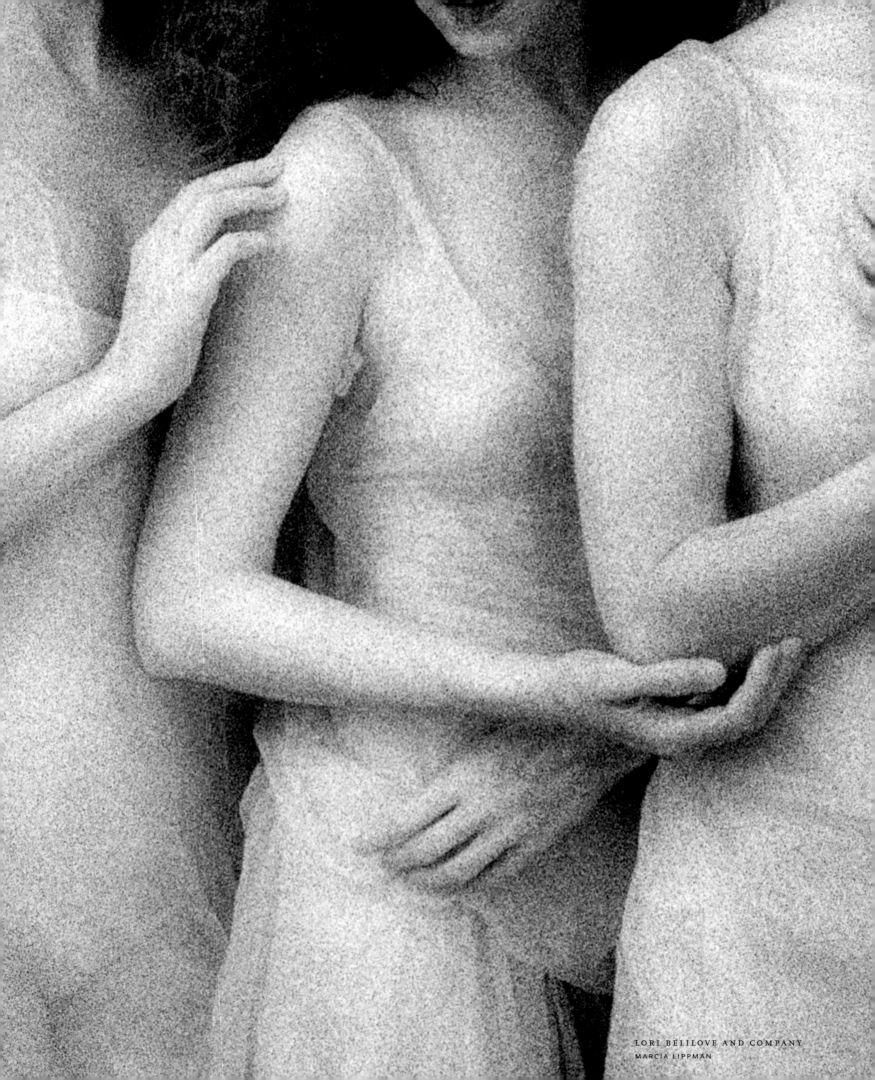

LORI BELILOVE AND COMPANY
MARCIA LIPPMAN

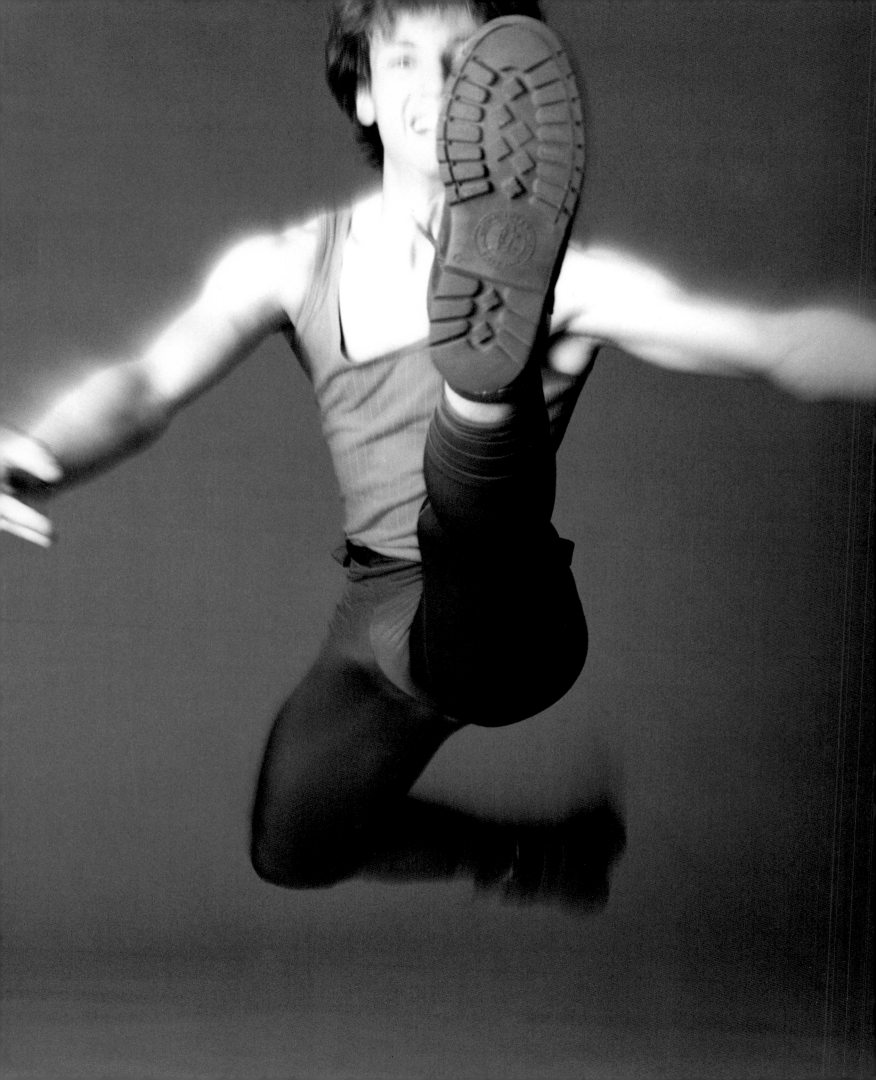

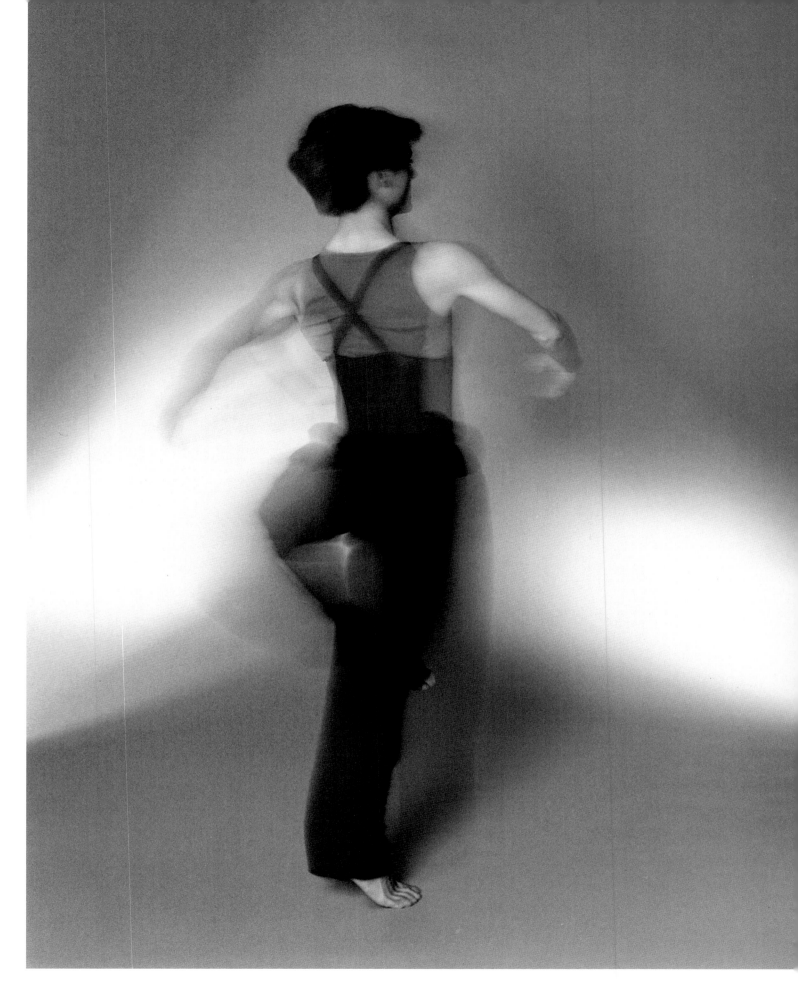

I DO NOT FEEL MY BODY. I DO NOT FEEL THE FLOOR.
IT SEEMS LIKE SOME OTHER DIMENSION.
ANGEL CORELLA

ALICE GARICK

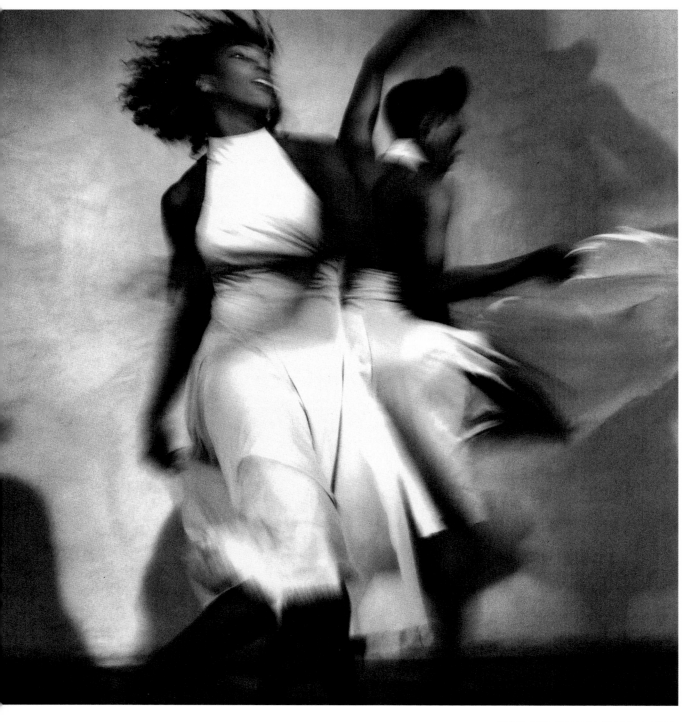

LULU AND TAMICA WASHINGTON
MARK HANAUER

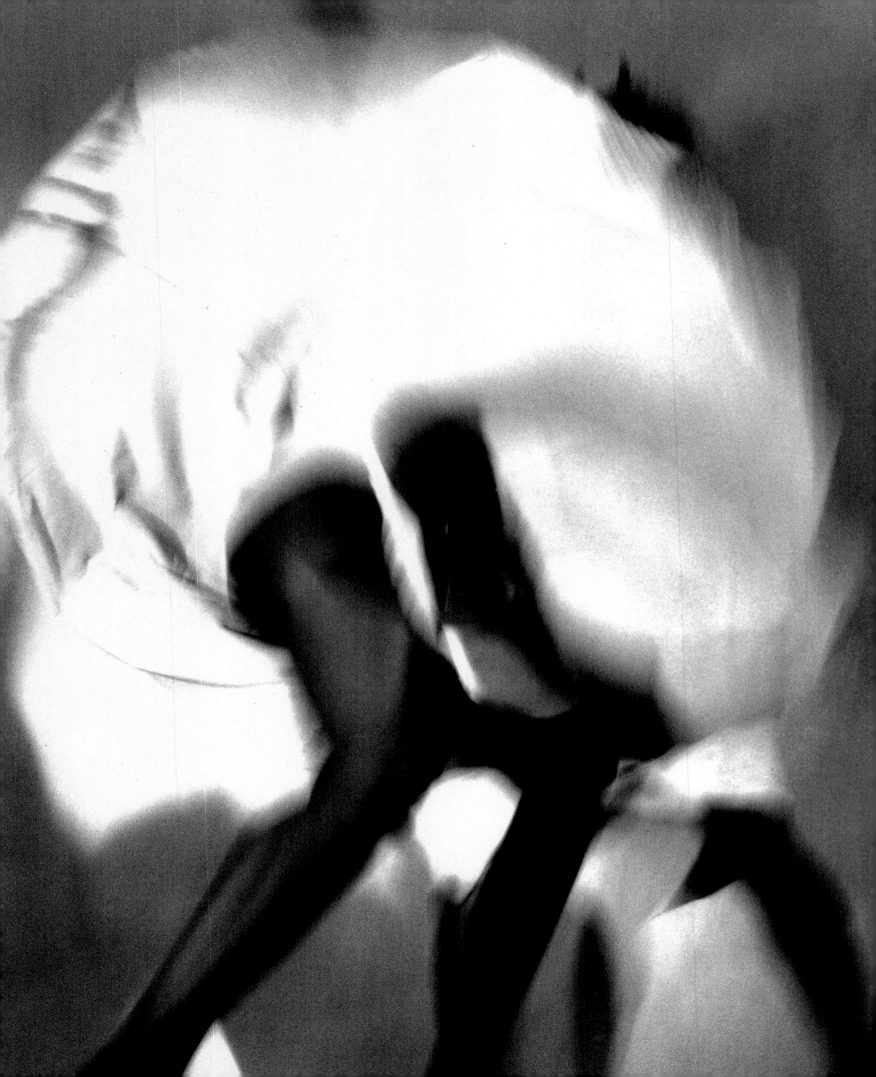

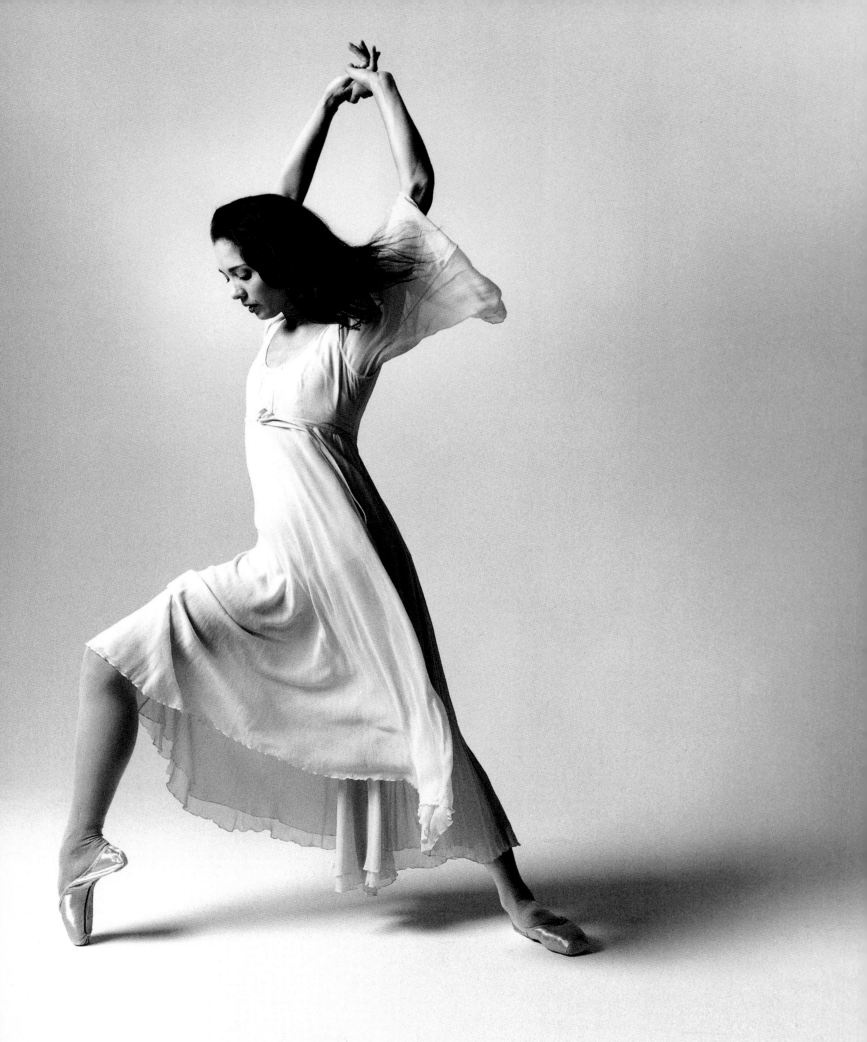

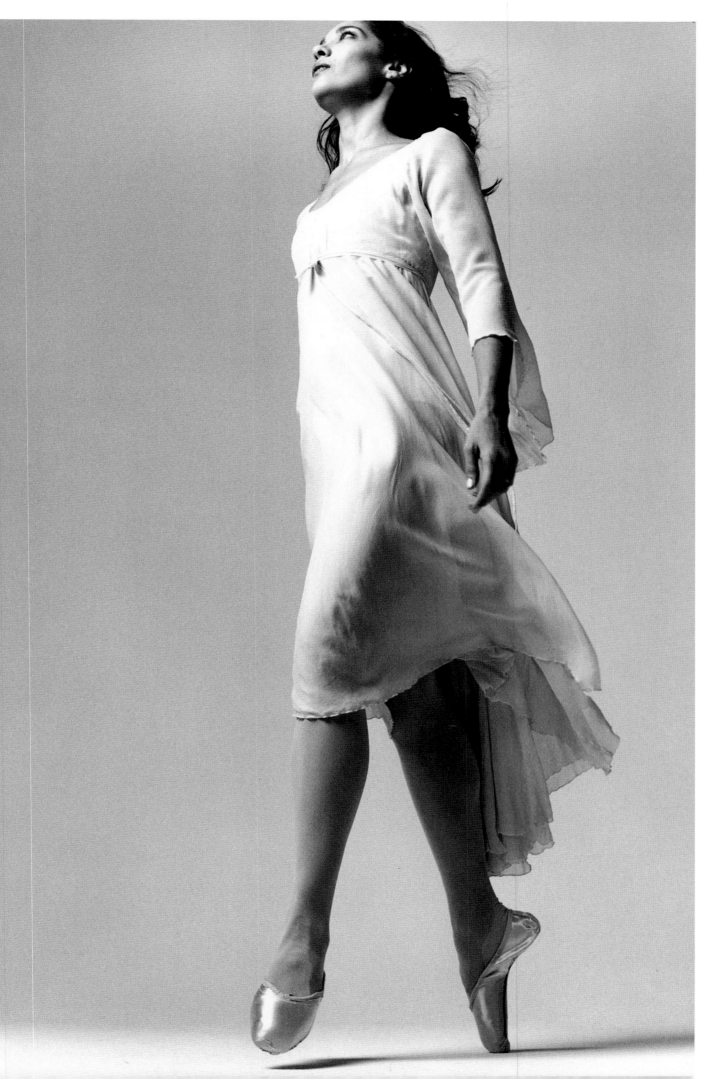

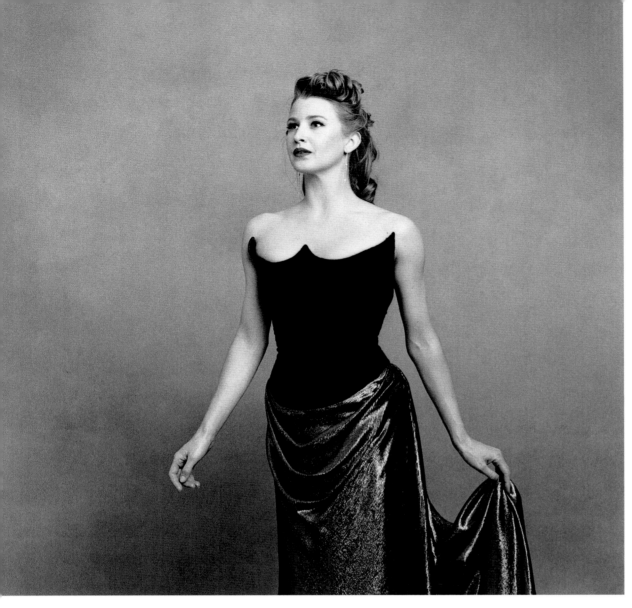

DARCI KISTLER
ANNIE LEIBOVITZ

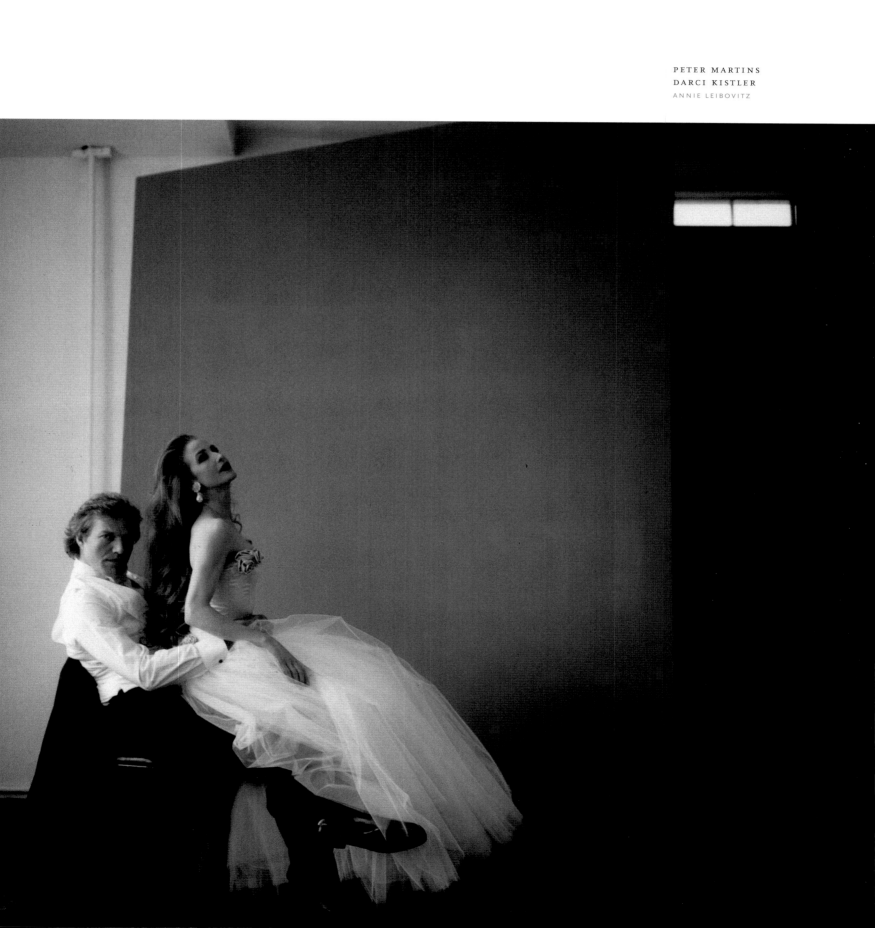

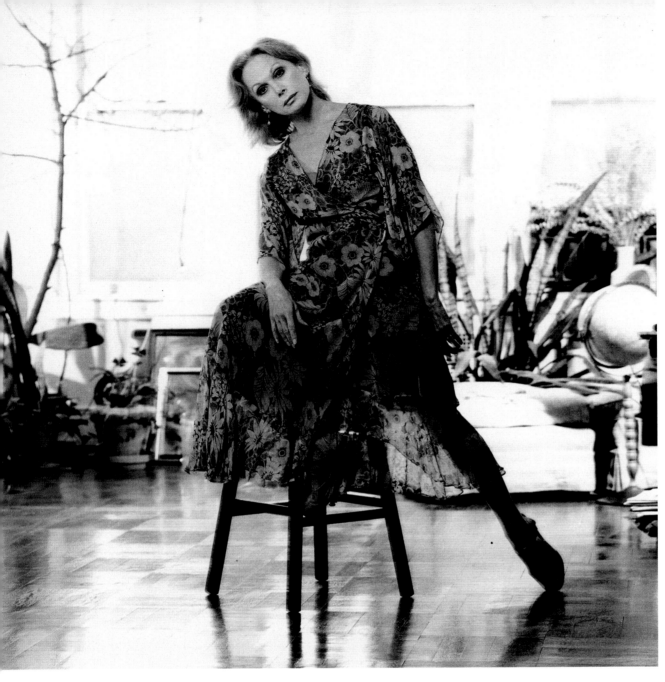

ALLEGRA KENT

JOANNE SAVIO

64

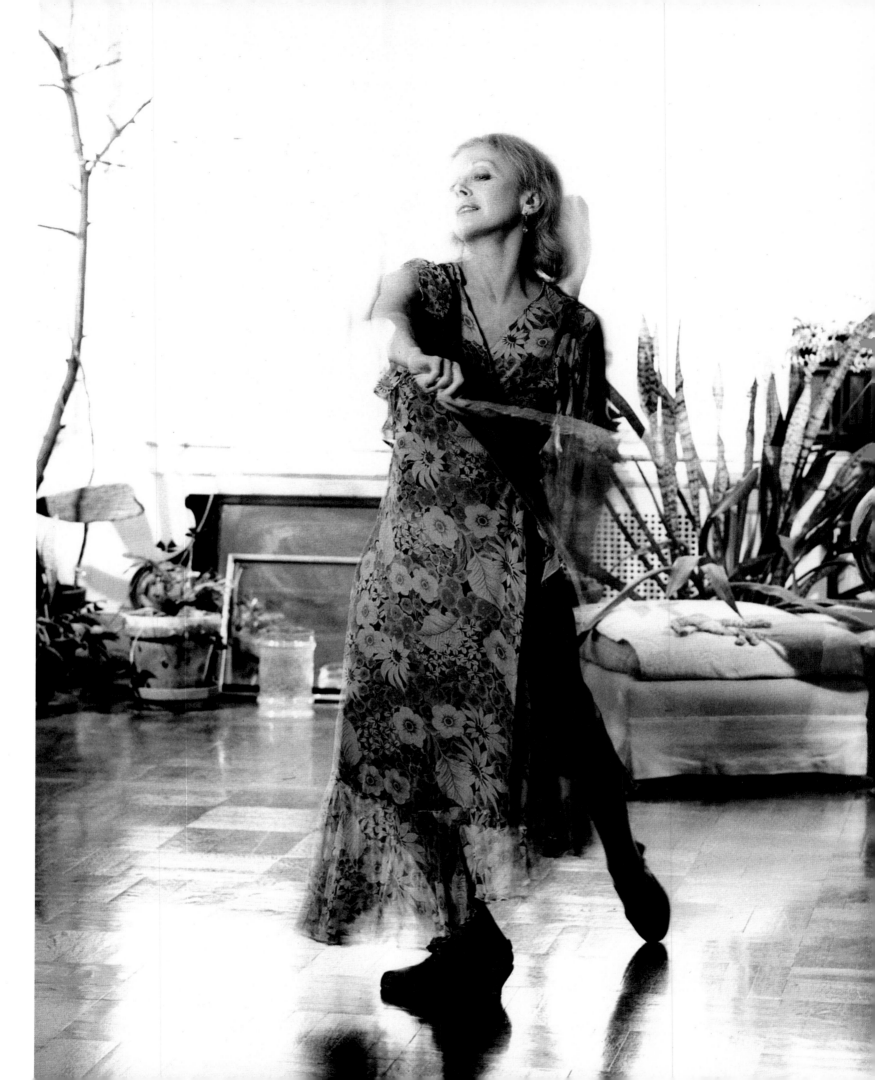

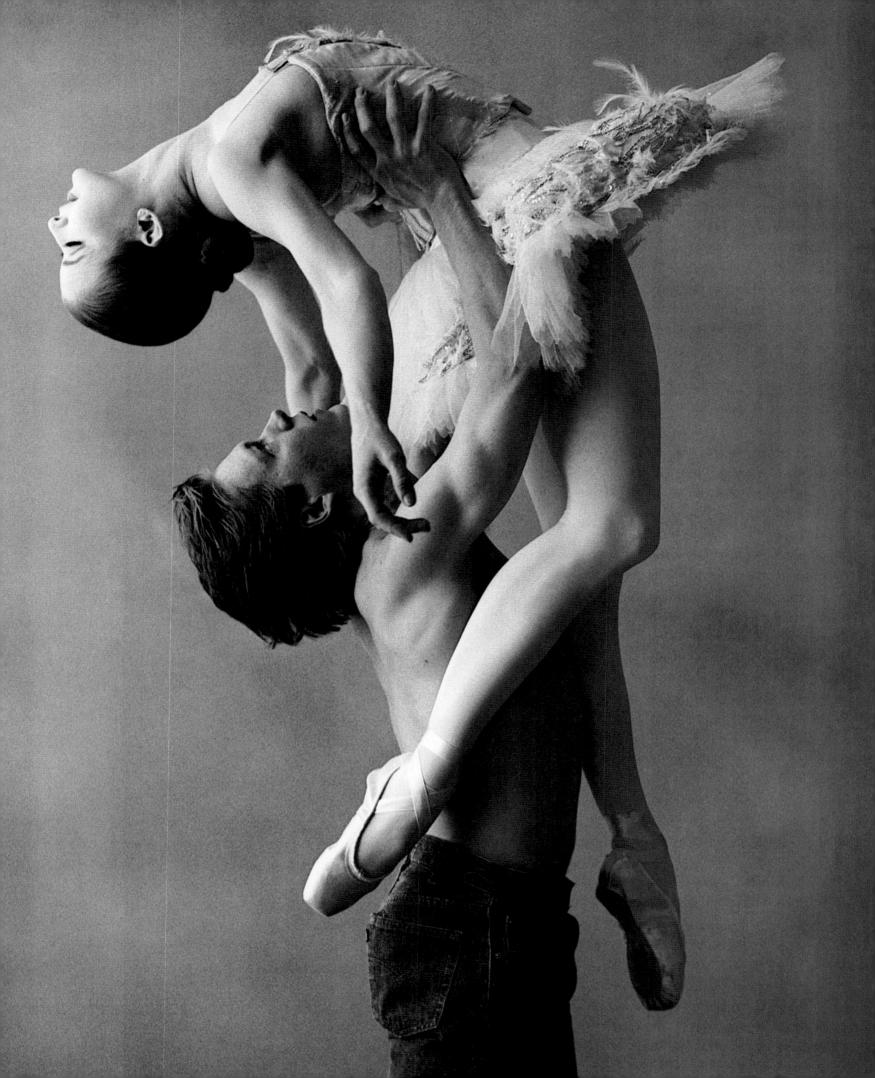

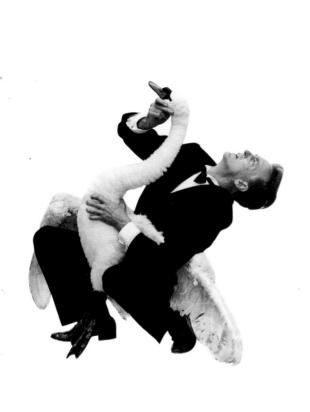
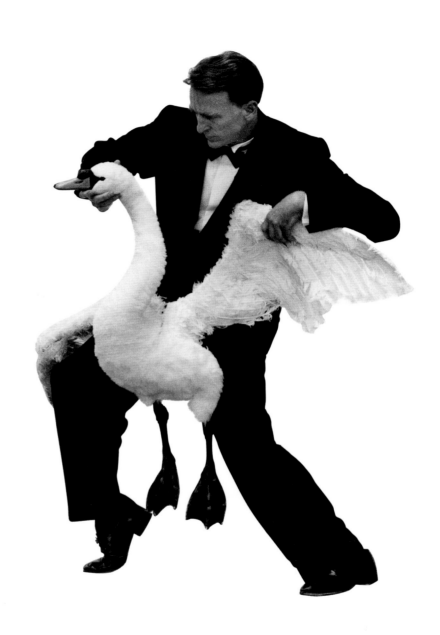

ROB BESSERER
DUANE MICHALS

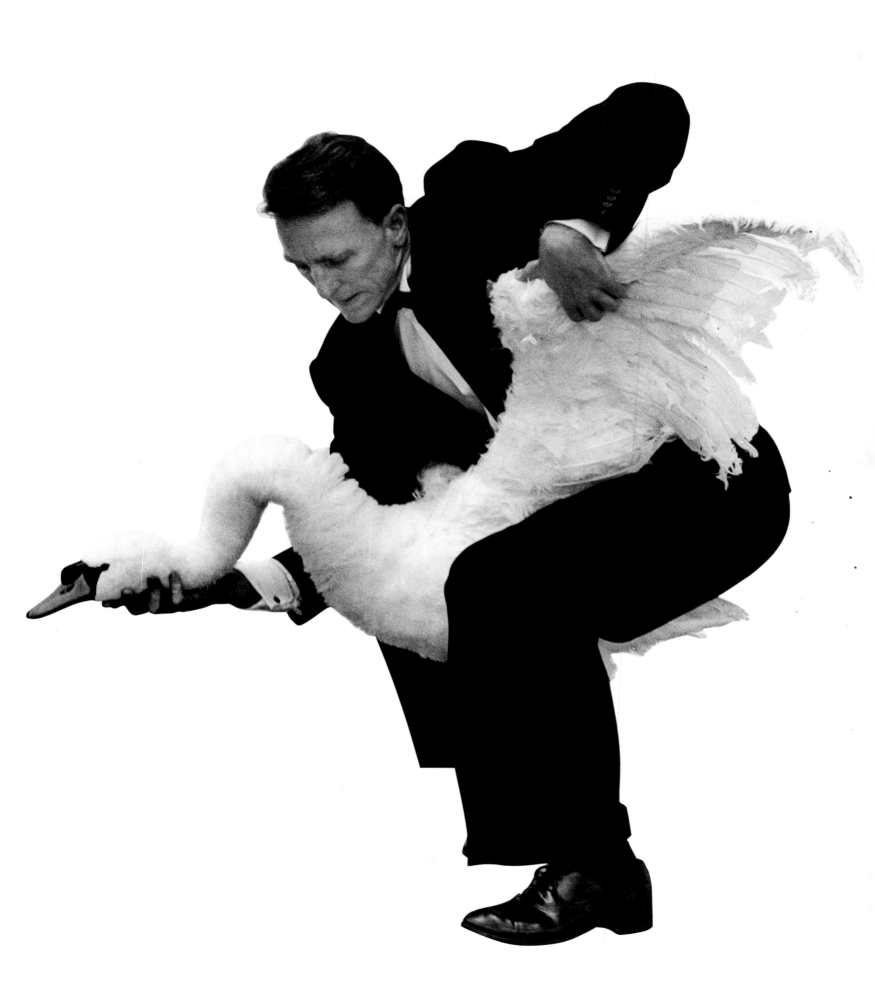

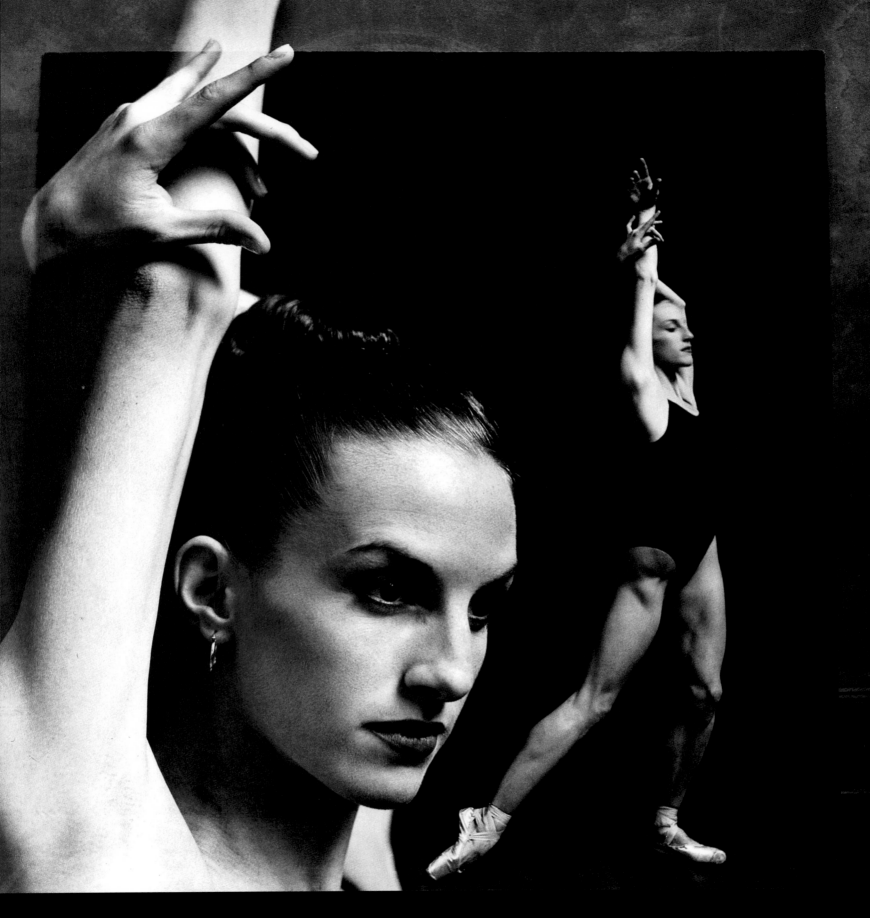

WENDY WHELAN
JOSEF ASTOR

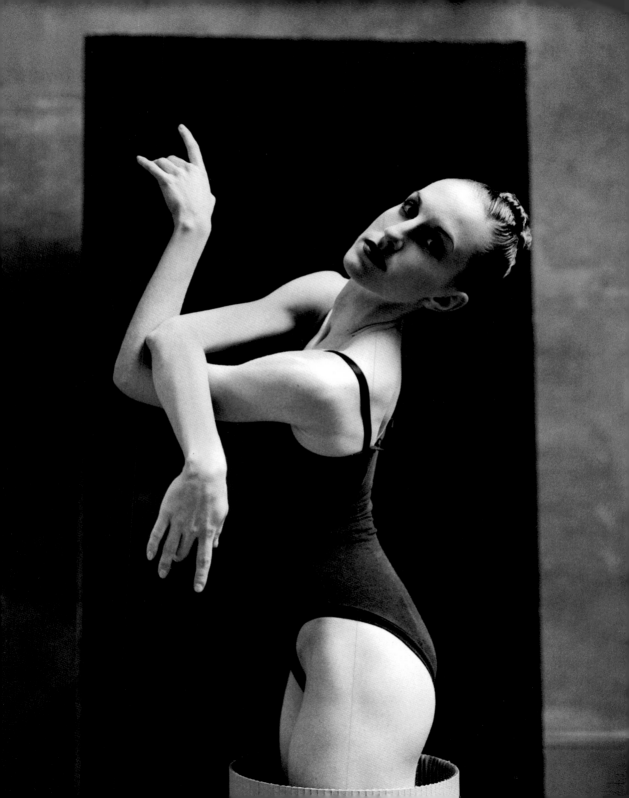

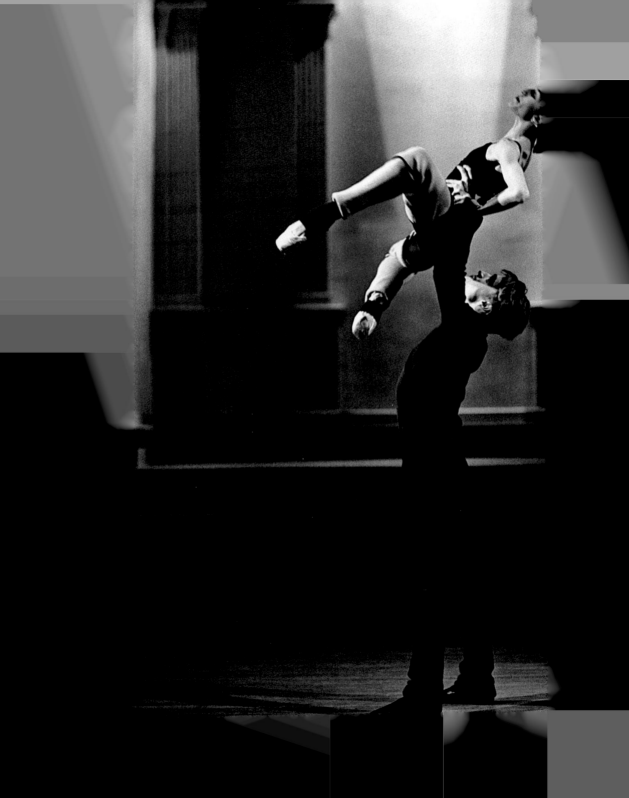

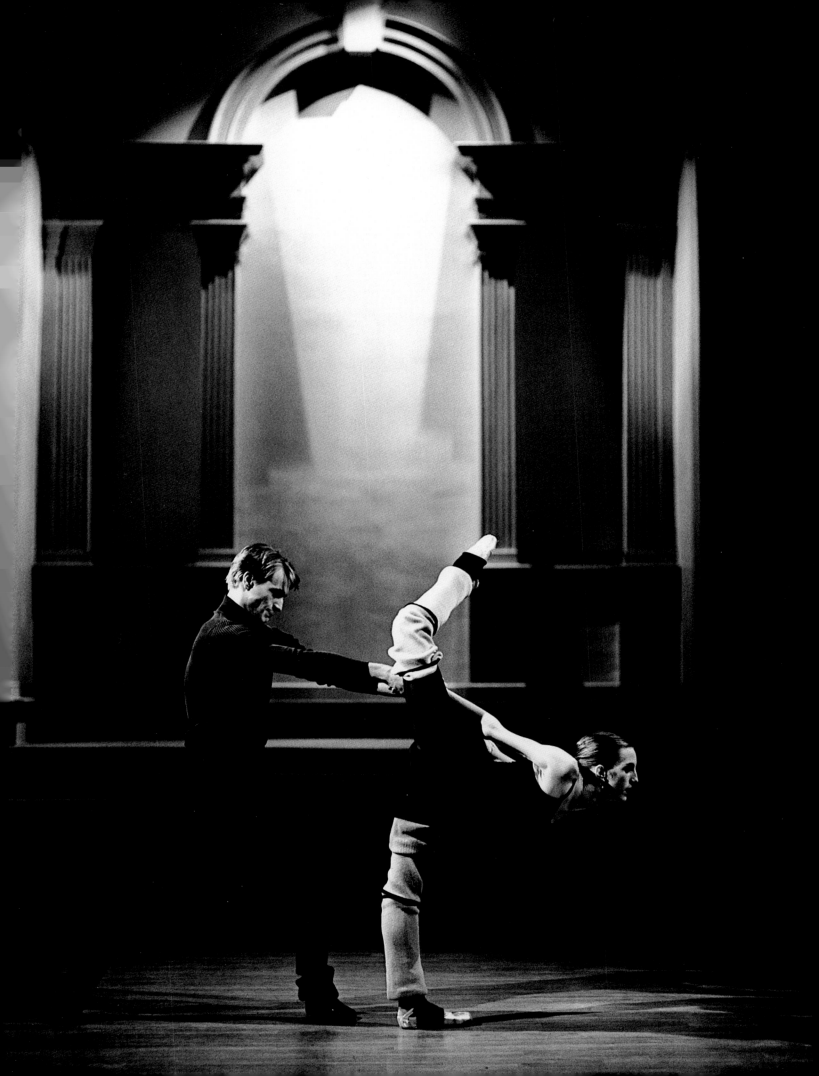

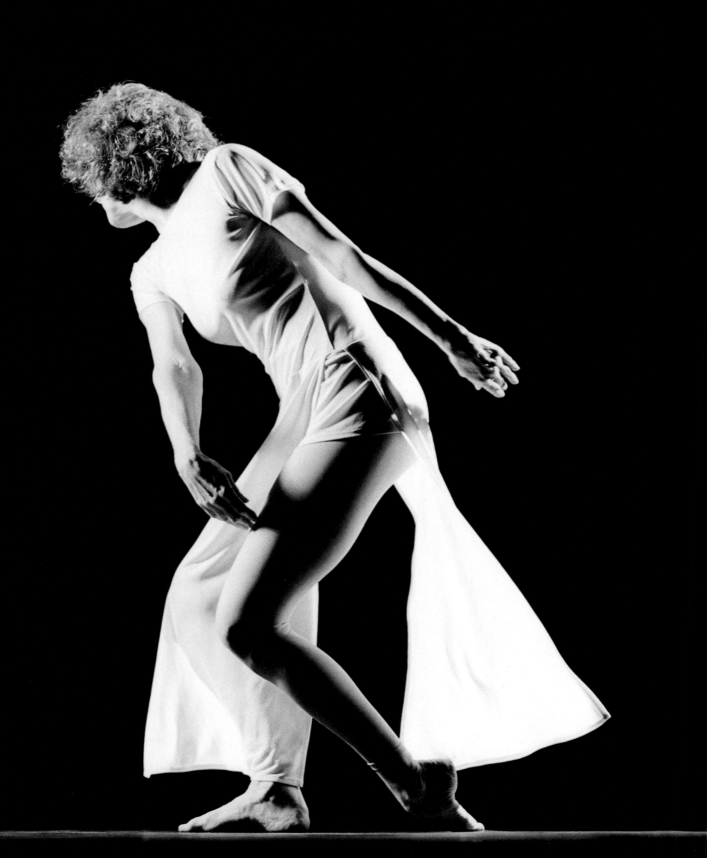

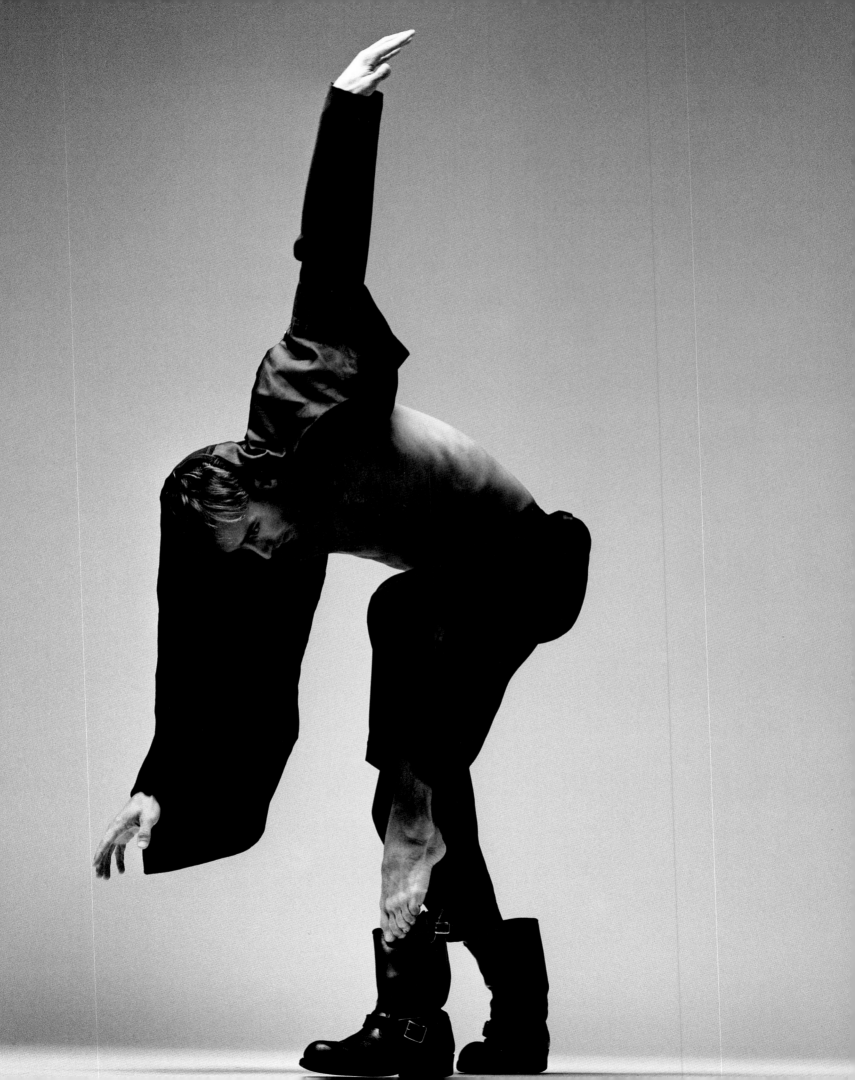

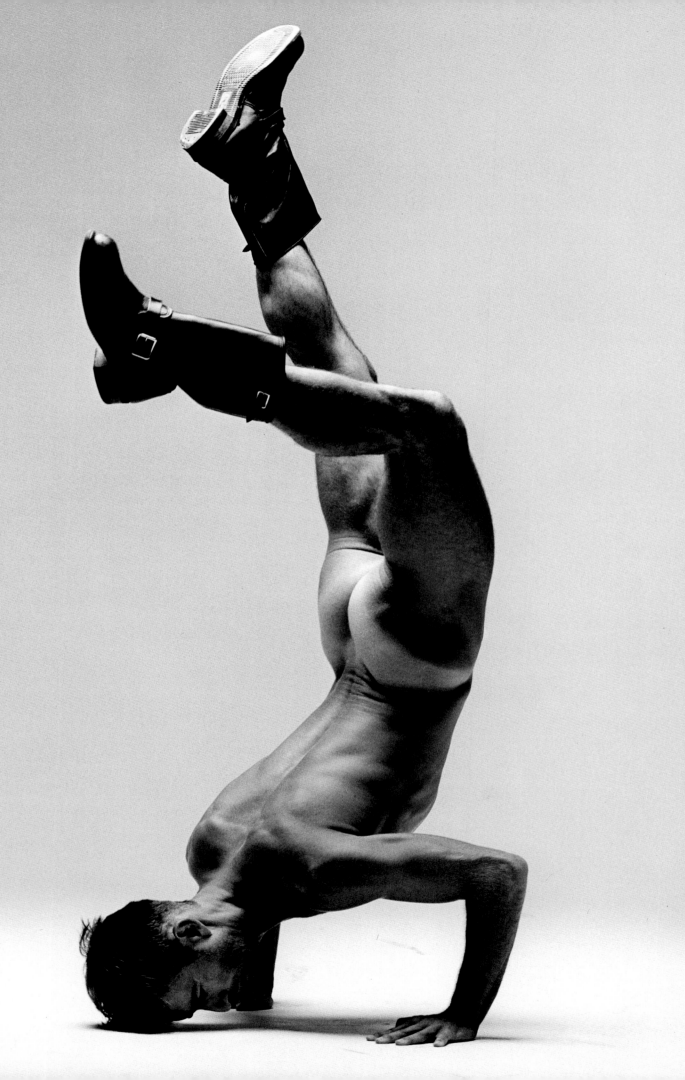

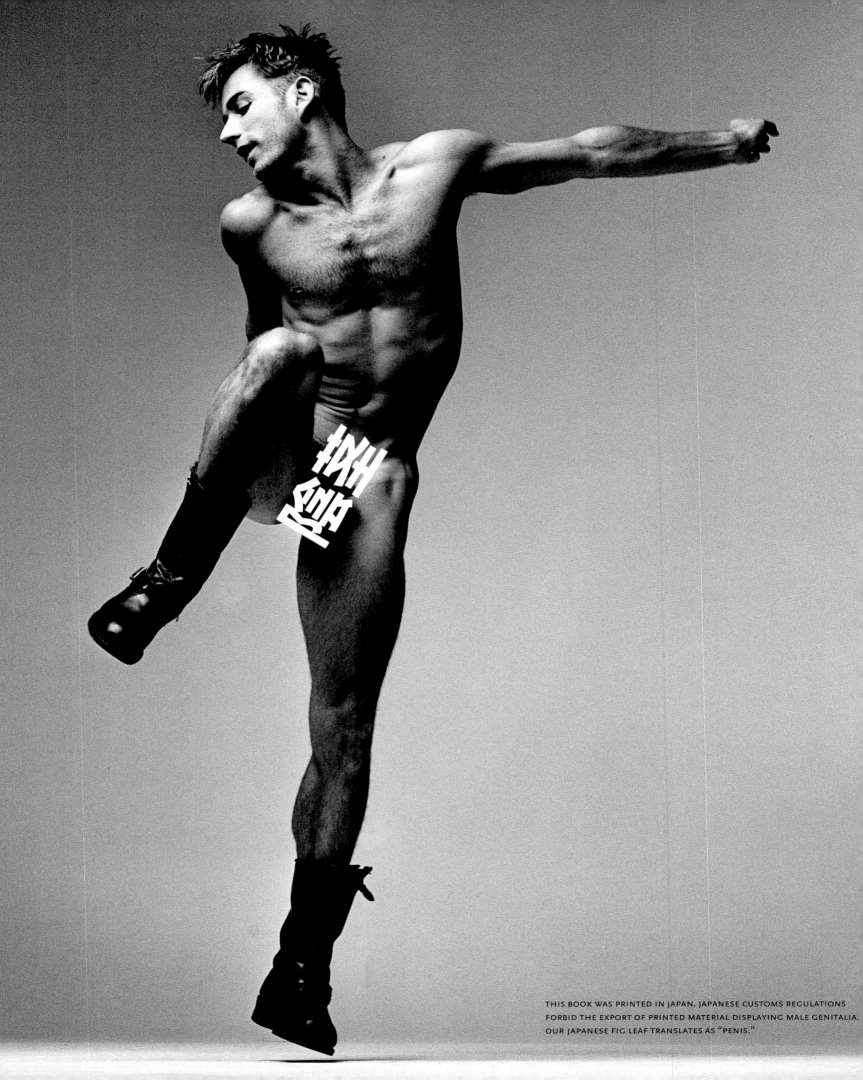

THIS BOOK WAS PRINTED IN JAPAN. JAPANESE CUSTOMS REGULATIONS
FORBID THE EXPORT OF PRINTED MATERIAL DISPLAYING MALE GENITALIA.
OUR JAPANESE FIG LEAF TRANSLATES AS "PENIS."

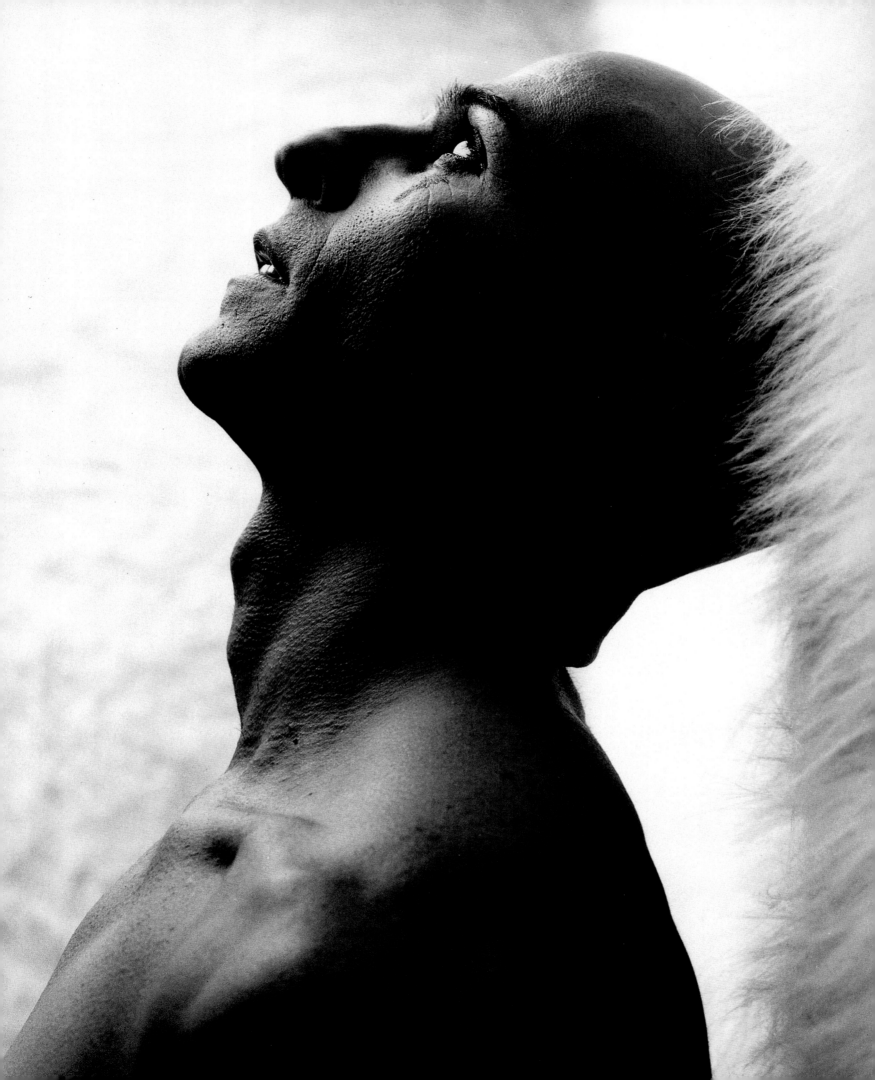

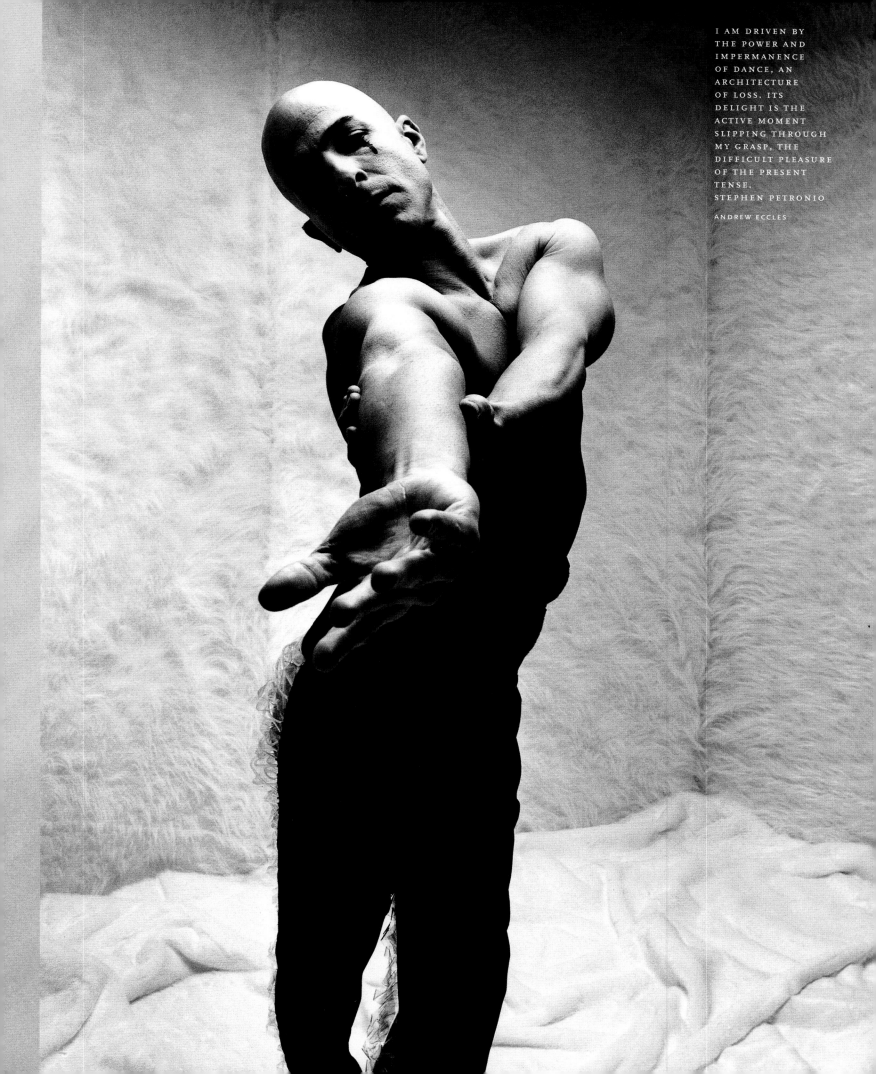

I AM DRIVEN BY
THE POWER AND
IMPERMANENCE
OF DANCE, AN
ARCHITECTURE
OF LOSS. ITS
DELIGHT IS THE
ACTIVE MOMENT
SLIPPING THROUGH
MY GRASP, THE
DIFFICULT PLEASURE
OF THE PRESENT
TENSE.
STEPHEN PETRONIO

ANDREW ECCLES

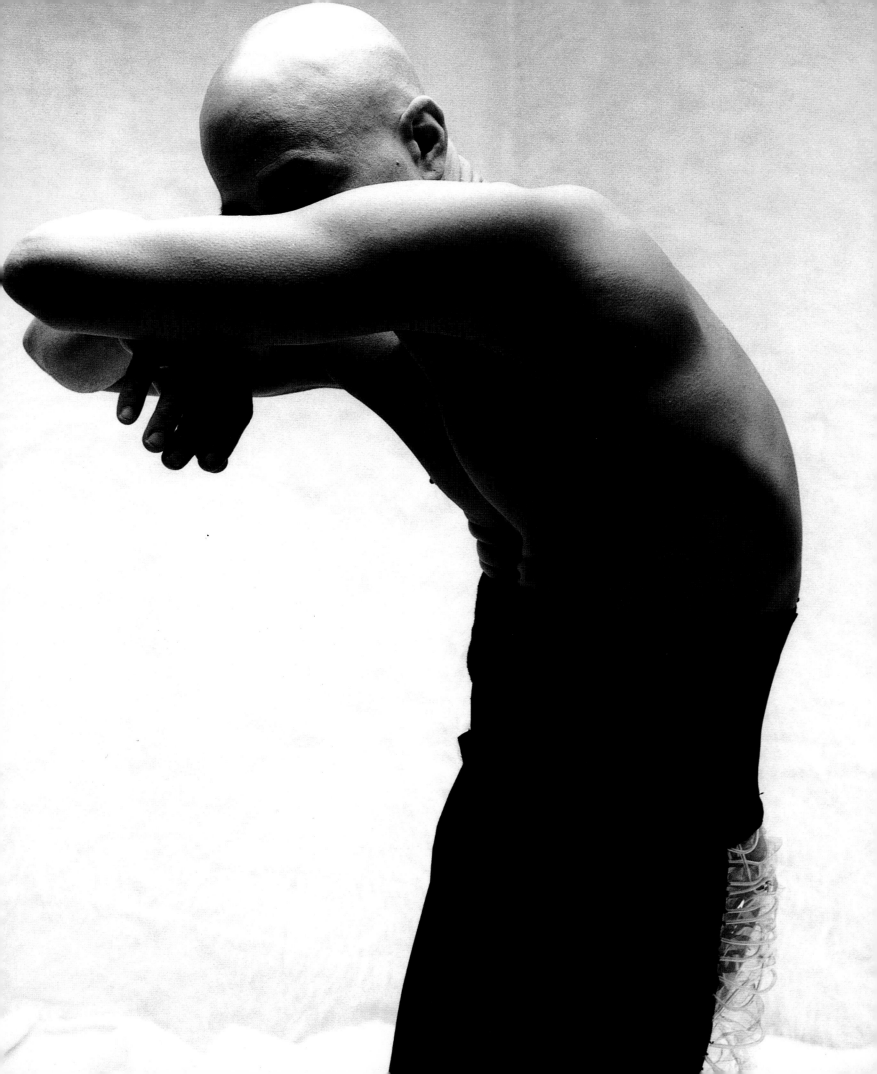

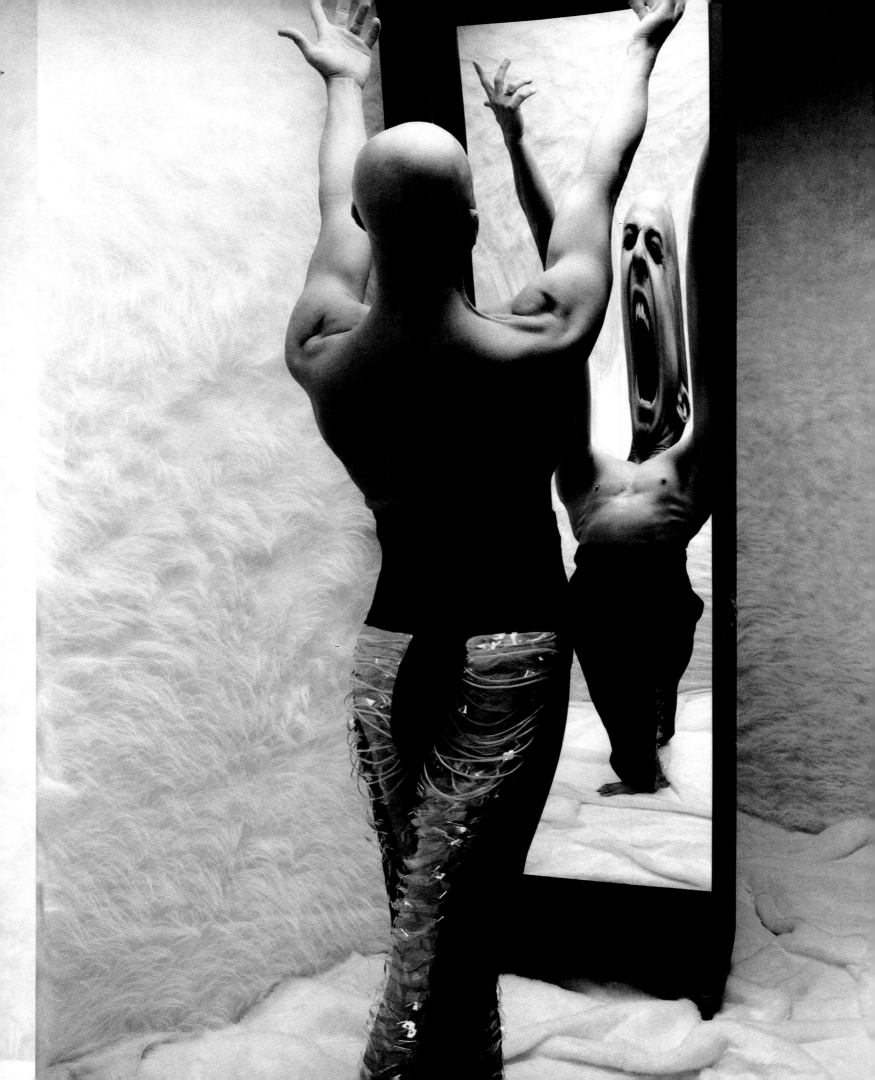

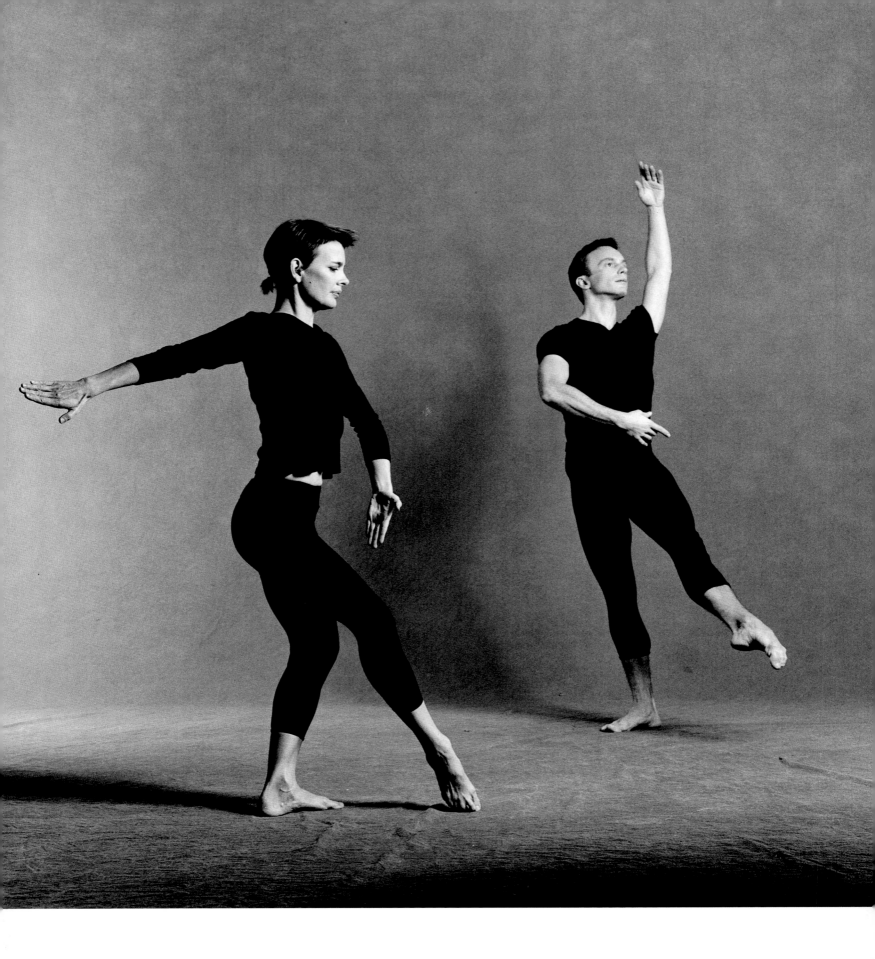

MOLISSA FENLEY
PETER BOAL
TIMOTHY GREENFIELD-SANDERS

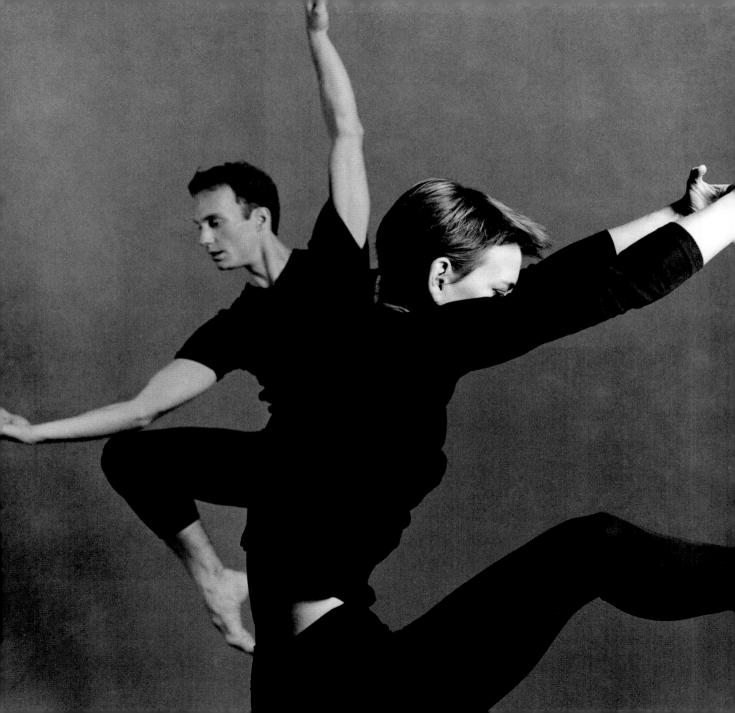

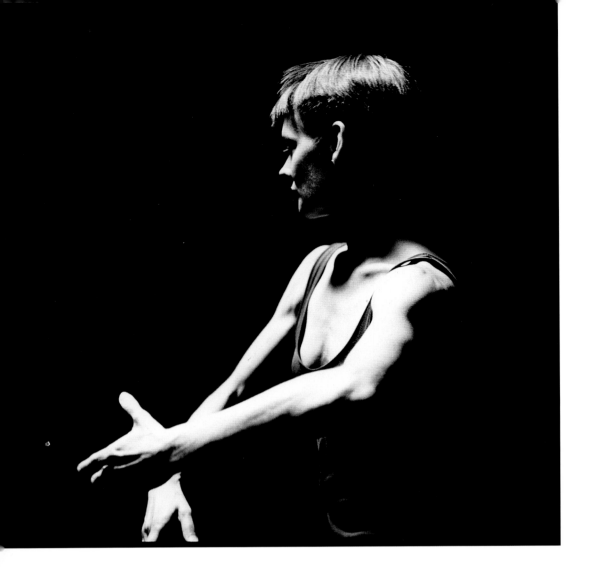
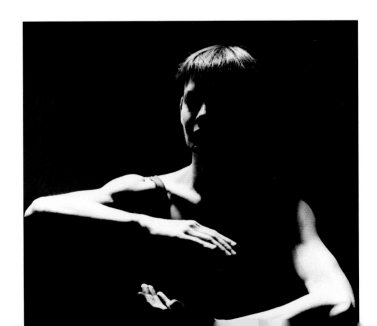

ALONE IS THE STATE IN
WHICH WE ALL FIND
OURSELVES.
MY WORK IS ABOUT
DISCOVERING SOMETHING
ABOUT THAT STATE OF
INDIVIDUALITY—
THE INDIVIDUAL STANDING
IN SPACE, THE JOY
AND EXHILARATION
OF THAT NATURAL STATE.
MOLISSA FENLEY

TIMOTHY GREENFIELD-SANDERS

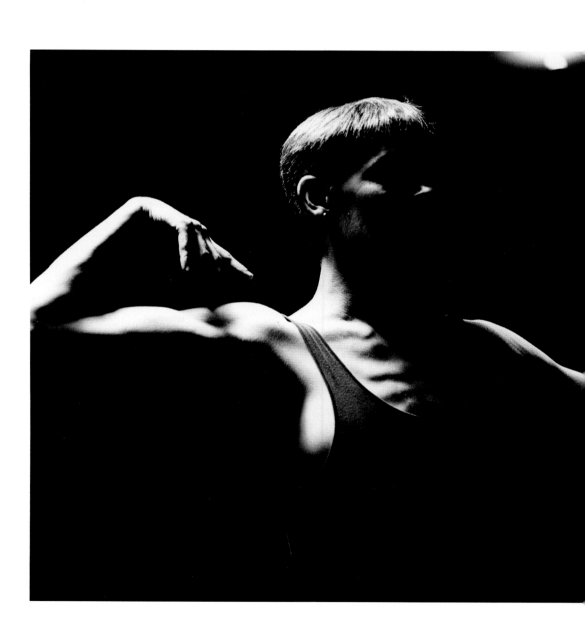

INTERMISSION

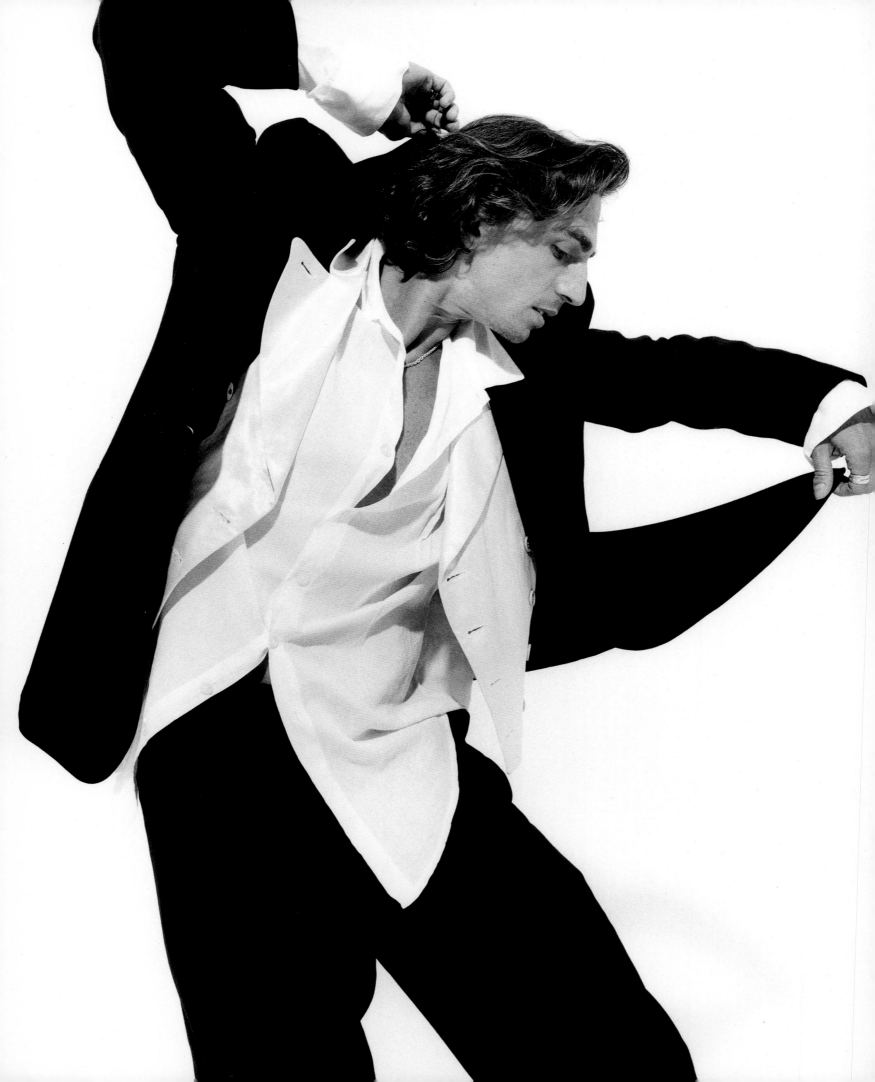

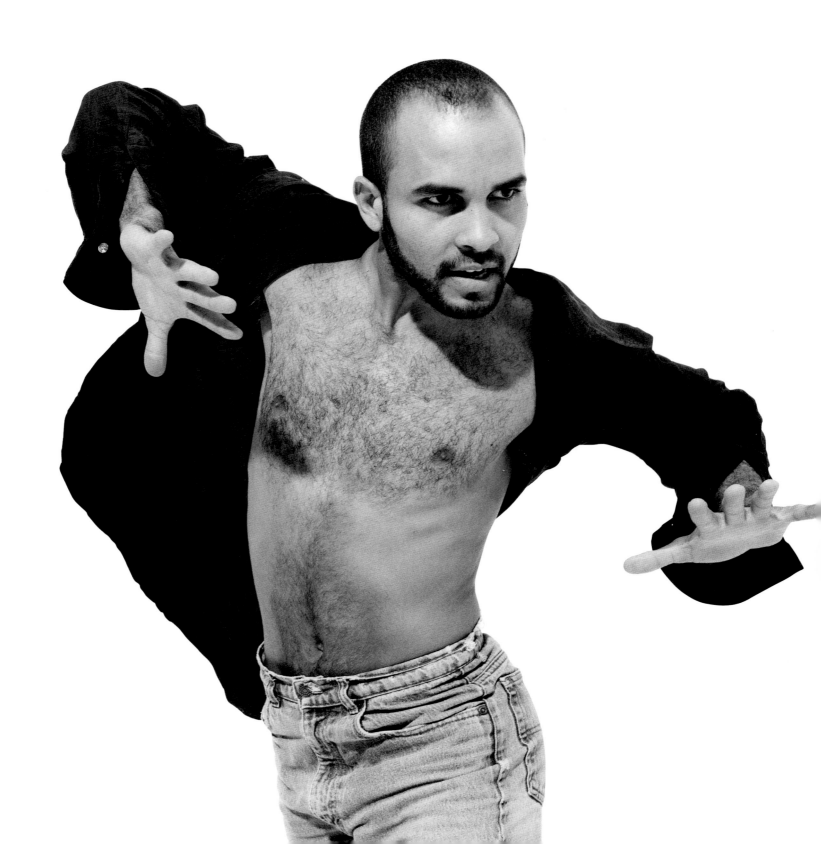

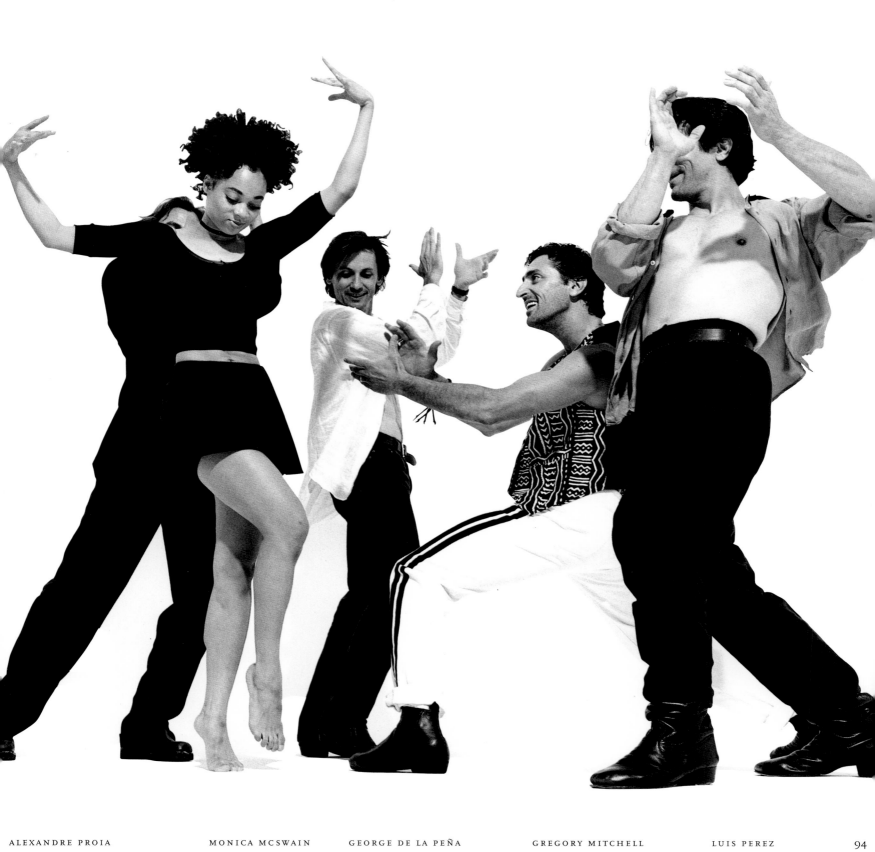

ALEXANDRE PROIA MONICA MCSWAIN GEORGE DE LA PEÑA GREGORY MITCHELL LUIS PEREZ 94

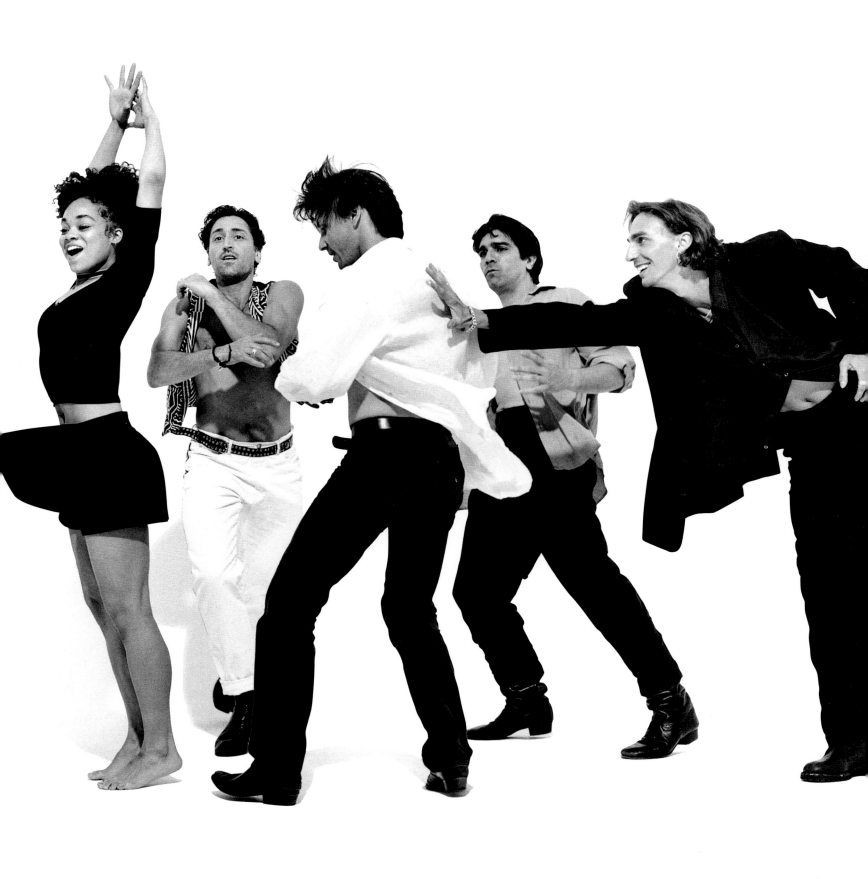

MC SWAIN MITCHELL DE LA PEÑA PEREZ PROIA

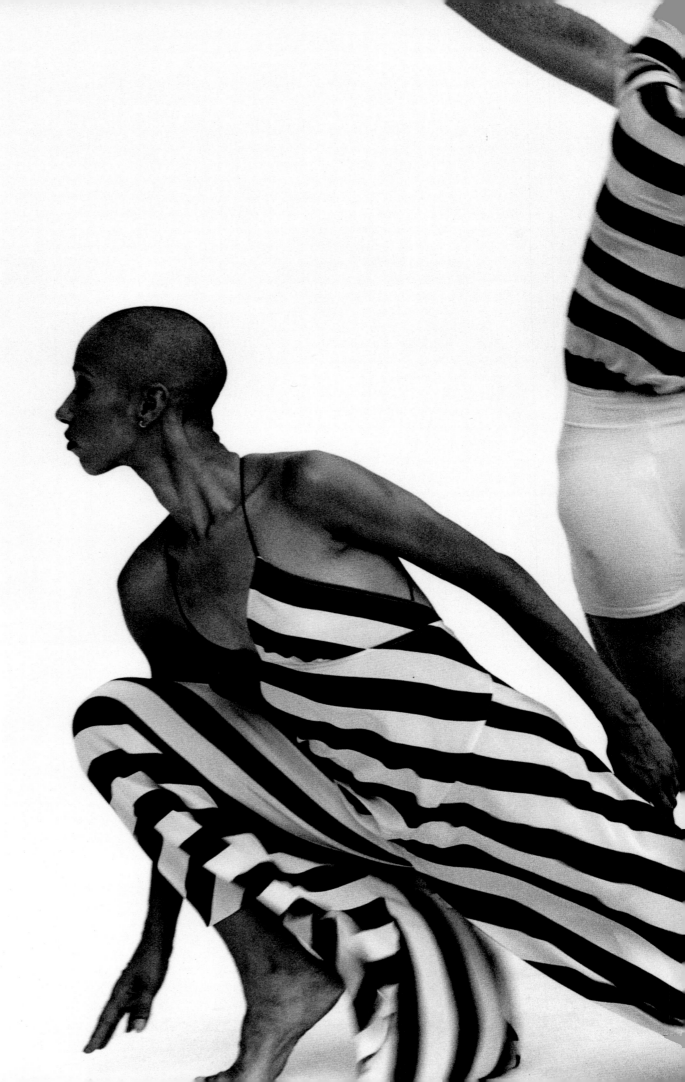

BILL T. JONES / ARNIE ZANE COMPANY
ODILE REINE-ADELAIDE, ARTHUR AVILES, LAWRENCE GOLDHUBER, BILL T. JONES
ANNIE LEIBOVITZ

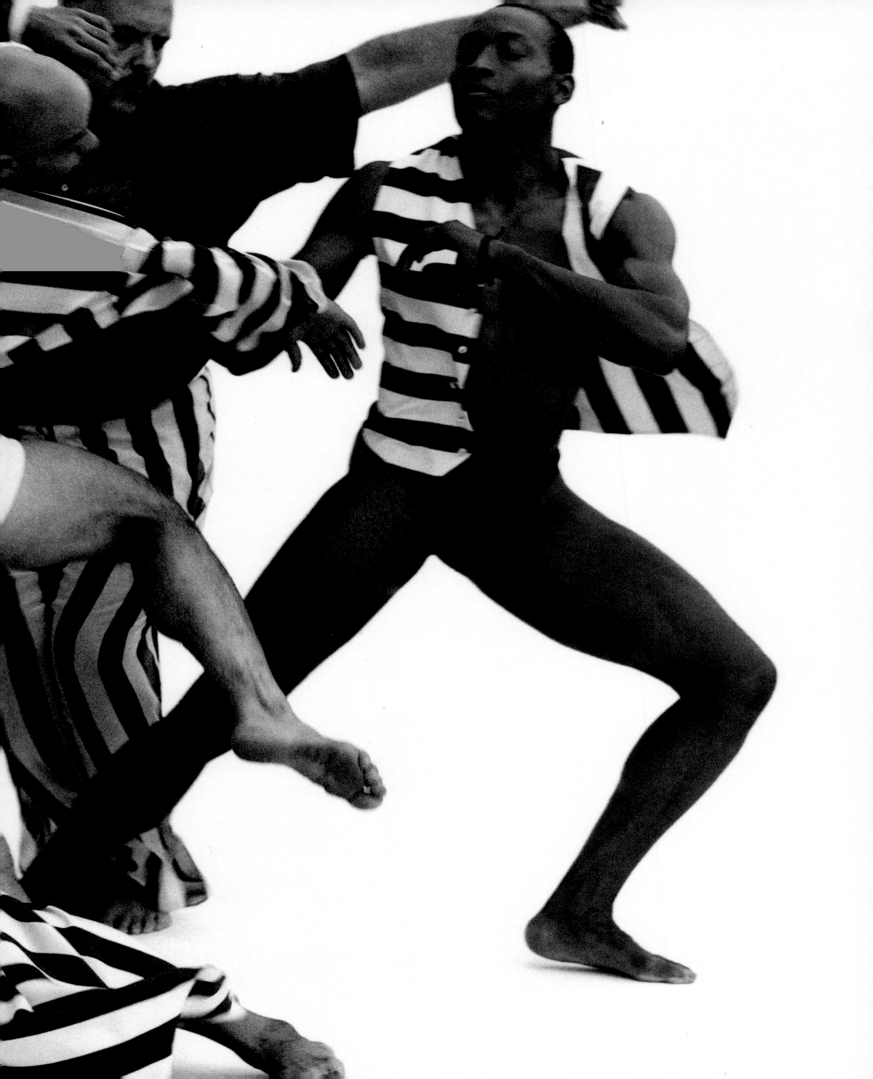

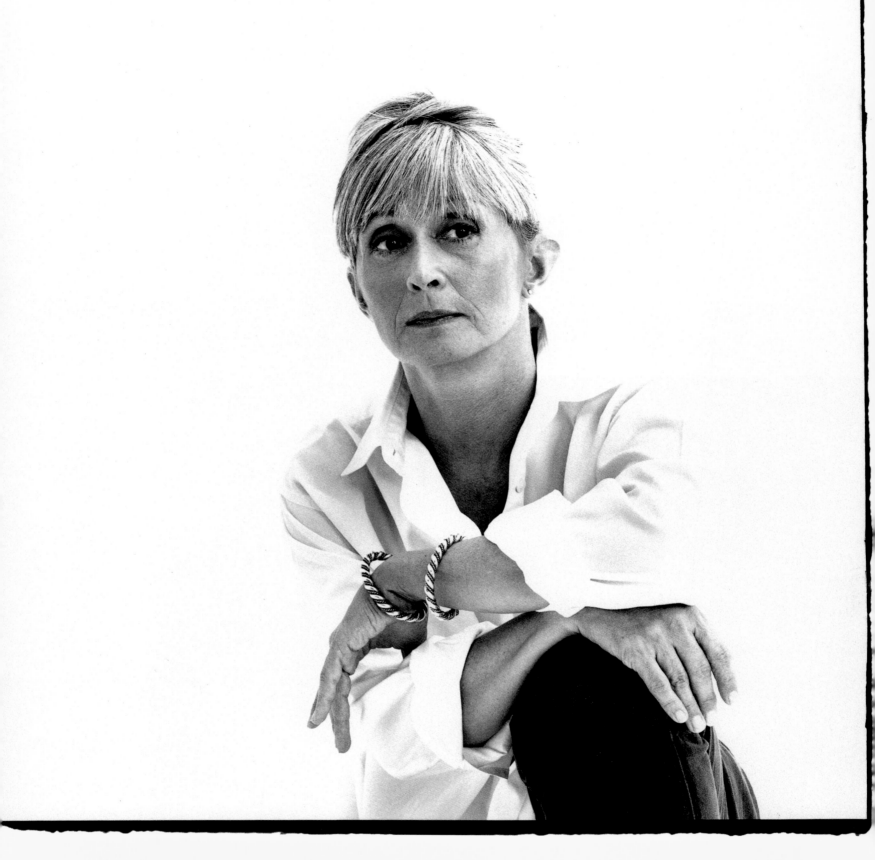

TWYLA THARP

[ACT 4]

TWYLA THARP

Twyla wraps itself around you like a boa, languorous, loopy, bendy, swoony. *Tharp* starts off soft and low with a purr, then pops up and punches you—pow!—smack in the solar plexus. You're seduced, smitten, doubled over, gasping for breath, and you haven't even shaken hands yet. *Twyla Tharp.* (It's the perfect name.) There are many artists who deal in contradictions, who revel in them, in fact. Contradictions of mood, for instance, are many a choreographer's stock-in-trade. Happy, sad. Funny, pathetic. Light, dark. Yin, yang. The yolk, the egg. As anyone who has seen her perform knows, Twyla Tharp simply *is* contradictory— scrappy and elegant, combative and malleable, ironic and (however much she likes to deny it) romantic.

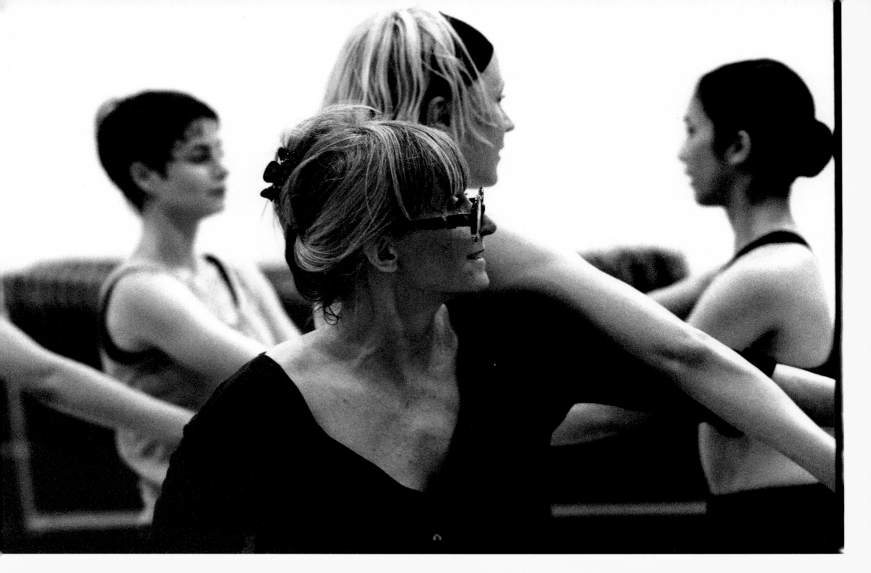

At first, one might have supposed her idiosyncratic choreography sprang from her compact, low-down body and its idiosyncratic wiggle-and-melt ways. Now—having seen her, with a variety of companies, work her way through a staggeringly broad inventory of music, formats, techniques, and idioms— we can see that her choreography also springs (as all choreography springs), from a particular temperament and cast of mind. Yes, Tharp is the mistress of torque and slither, of abandon and control, of balance and wobble—all at once, all on the same body. But that is just the body. In the contrapuntal structure of her work—the blueprint component of the choreography— you find similar contrasts and oppositions, all served up with the flourishes and syncopations that are signature Tharpian grace notes.

You will note, for instance, the continuing battles between classicism and romanticism, between high art and the vernacular, between ballet technique and modern—this last played out in a series of skirmishes pitting the uplifted and aerial against the grounded and pelvic. You cannot miss, either, the perpetual Tharpian war between the intellect and the senses. Sometimes the choreographer casts this battle as instruction versus entertainment, sometimes as the refined versus the down-and-dirty. But always, hers is the story of Cyrano de Bergerac and Roxanne, over and over: on the left, the mind wanting to be embraced; on the right, the body wanting to talk.

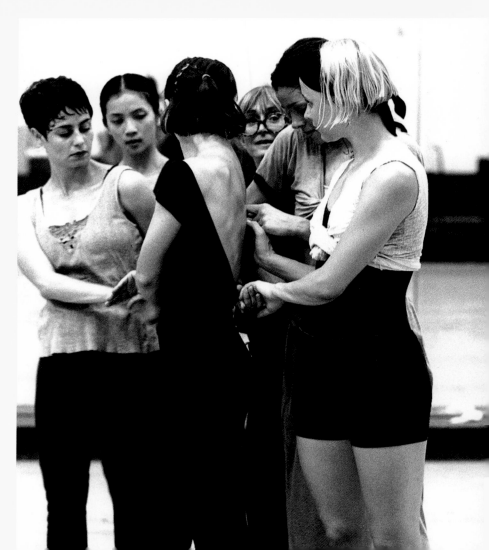

GABRIELLE MALONE
YI CHO
JULIE STAHL
TWYLA THARP
SANDRA STANTON
JENNIFER HOWARD
JESSE HUOT

No wonder, then, that dance is Tharp's chosen medium. Here, where the arc of the choreographer's thought is cloaked in the dancers' beauty, she finds herself, invents herself— and all that she brings with her—whole. To call Tharp eclectic, given the current degenerate artistry that this word now conjures, does her an injustice. Shall we call her a collector, a mixer, a sublime combiner? Boxing, yoga, ballroom dance, Broadway musicals, movies, you name it—the list is thirty years long. Yet with each item appropriated, there is initially a wholesale abandonment to the exigencies of its form, its energies. Whatever Tharp brings into her fold thus remains itself, recognized and honored.

This is the best Tharp irony, the most delicious contradiction: if there is something inherently antagonistic in Tharp, or in Tharpian structure, there is also something abundantly optimistic. (Even "off-balance," aggressively sustained, is another kind of balance.) In her work we have the wish, and the proof, that dissimilar and divergent elements can be marvelously and distinctively united. Hers is, willy-nilly, a utopian vision, hopeful and humane. *E pluribus Twyla.*

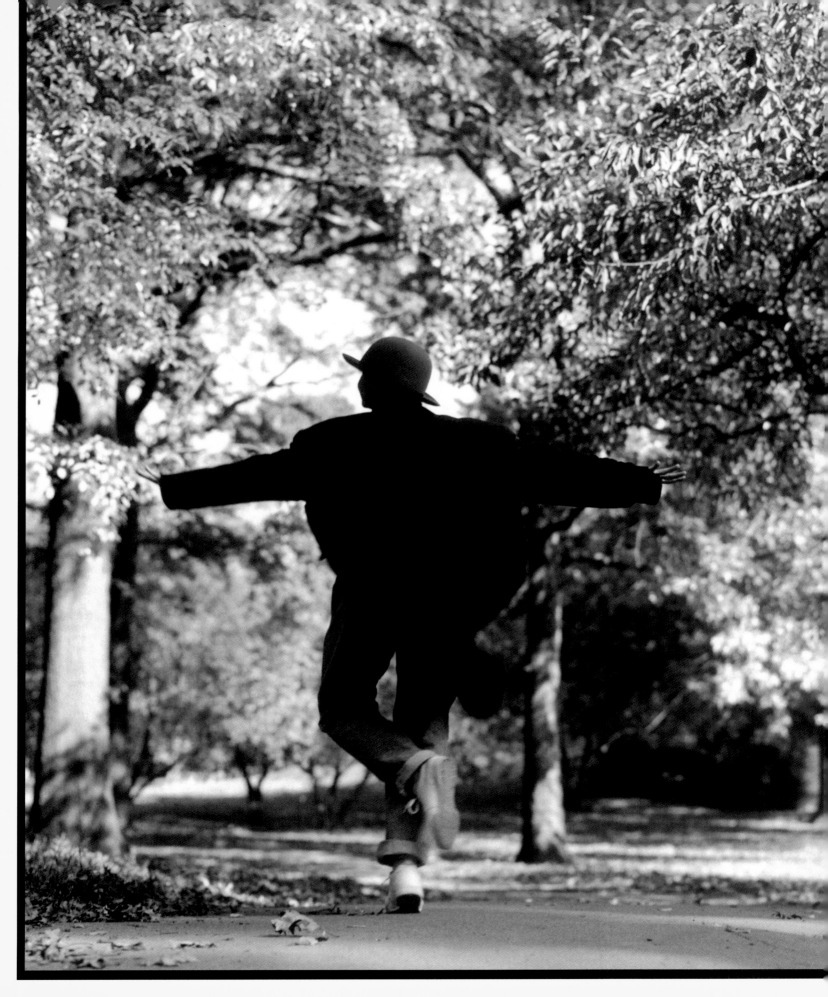

TWYLA THARP

ANNIE LEIBOVITZ

MIKHAIL BARYSHNIKOV

KATE JOHNSON

ANNIE LEIBOVITZ

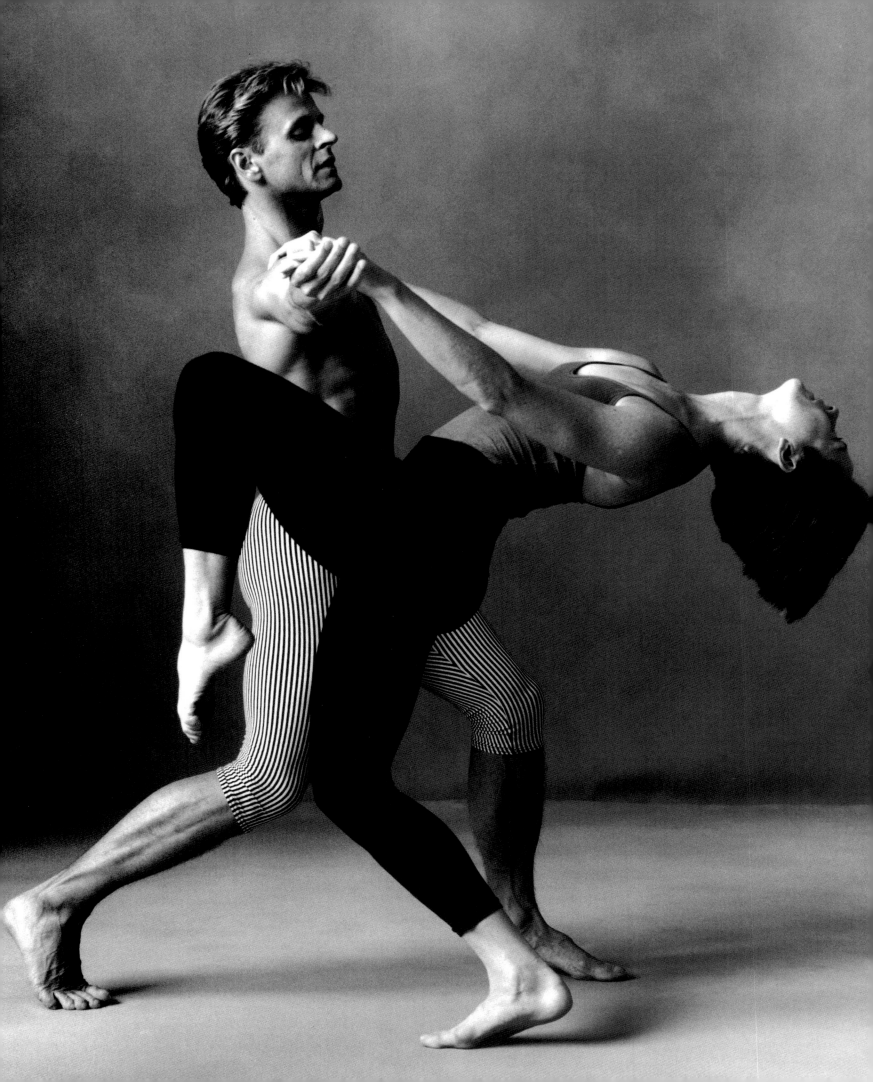

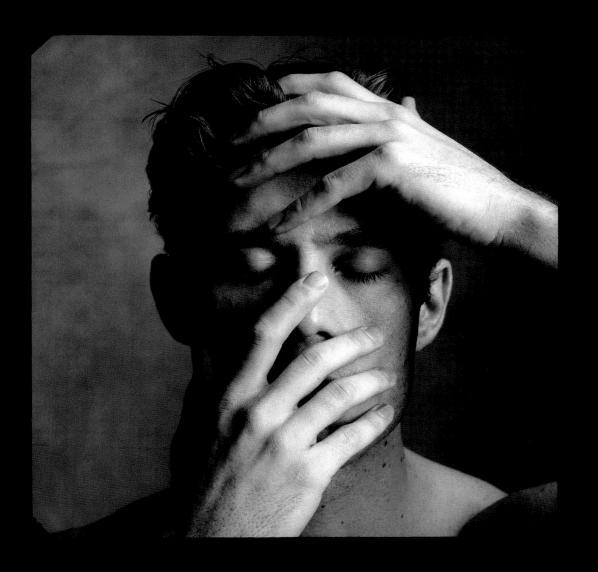

JAMIE BISHTON
ANDREW ECCLES

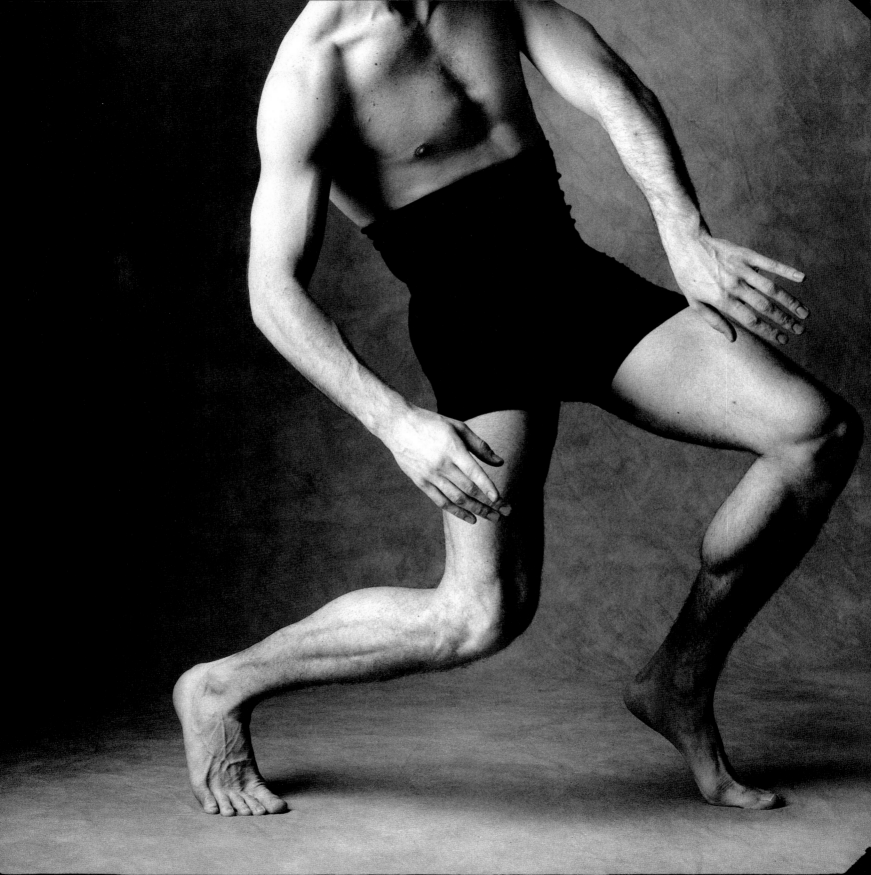

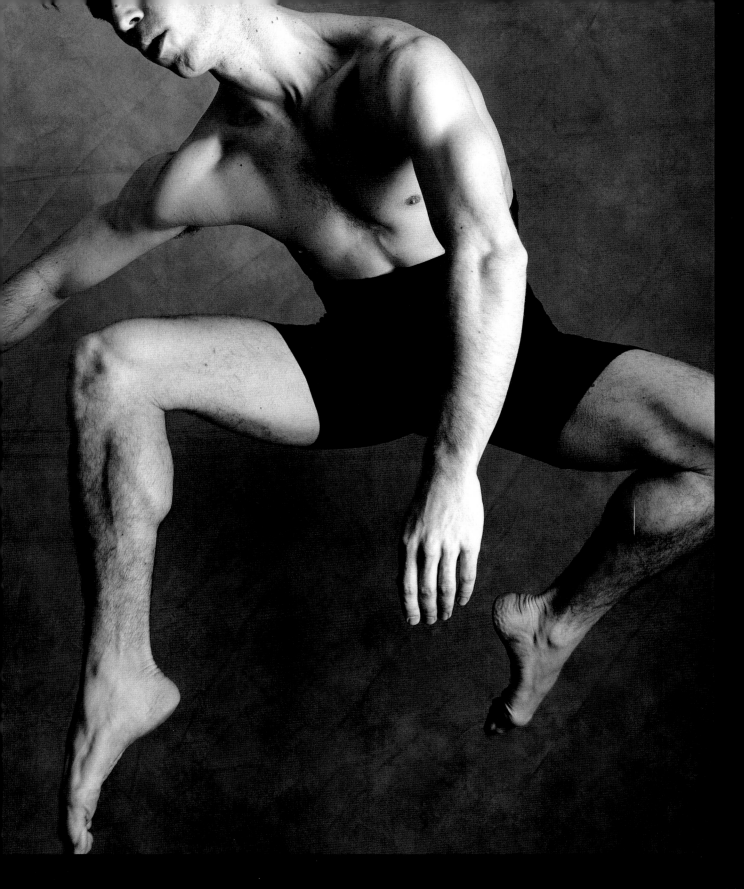

DANCE ALLOWS
MY SOUL TO SPEAK
AND MY HEART
TO FLY.
JAMIE BISHTON

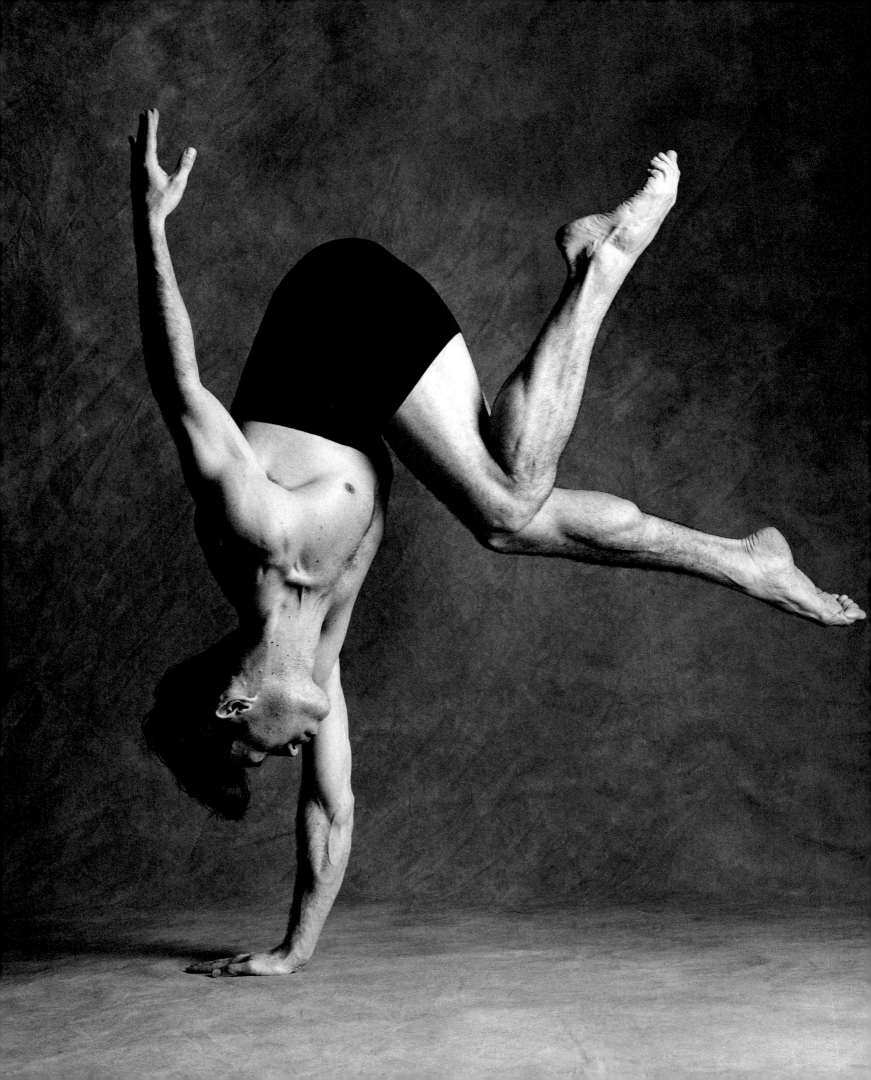

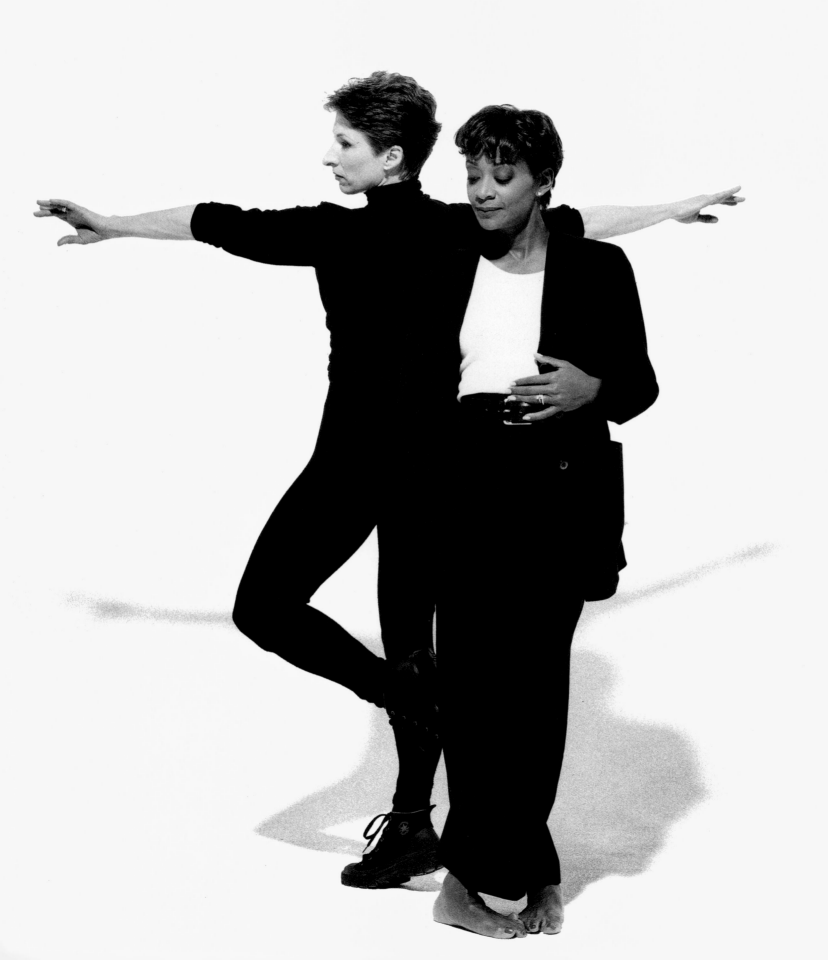

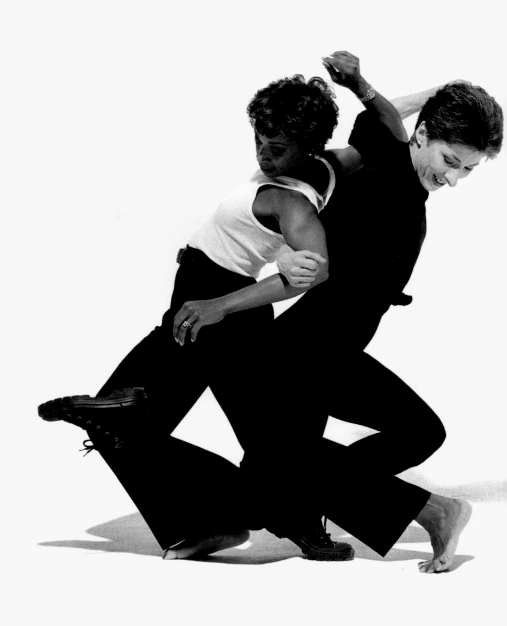

JENNIFER WAY
SHELLEY WASHINGTON
ANDREW ECCLES

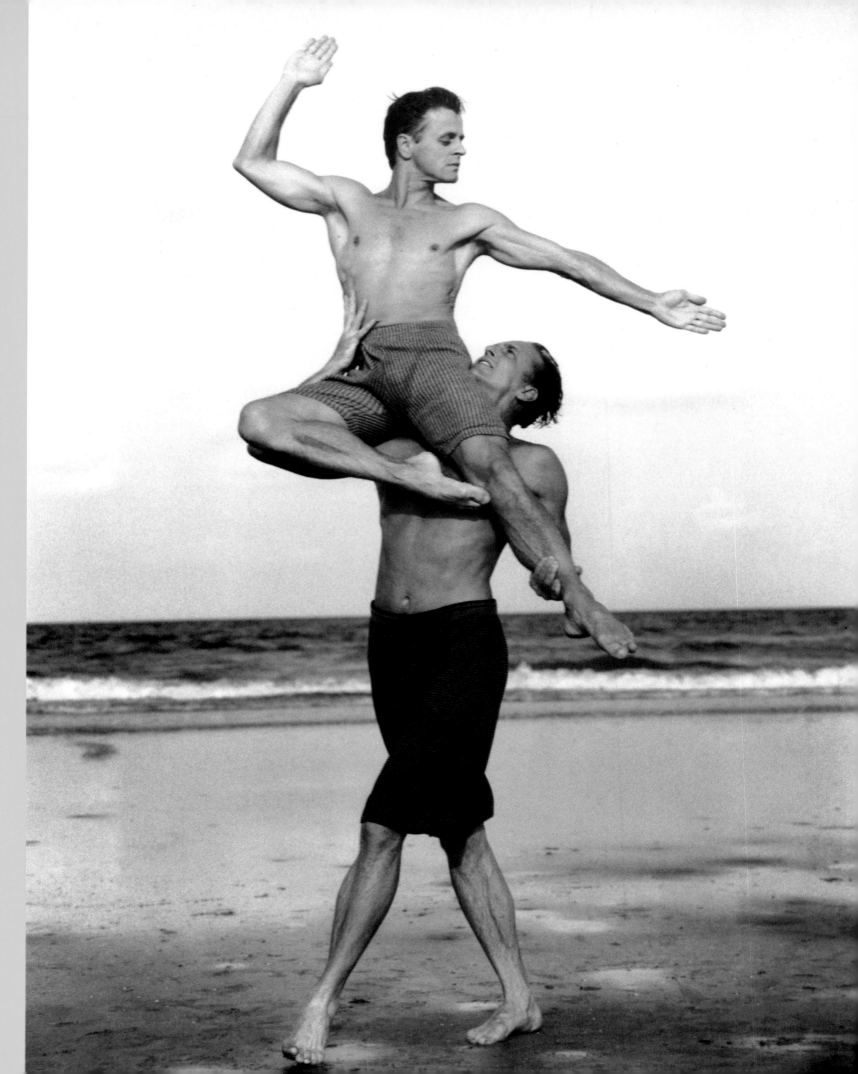

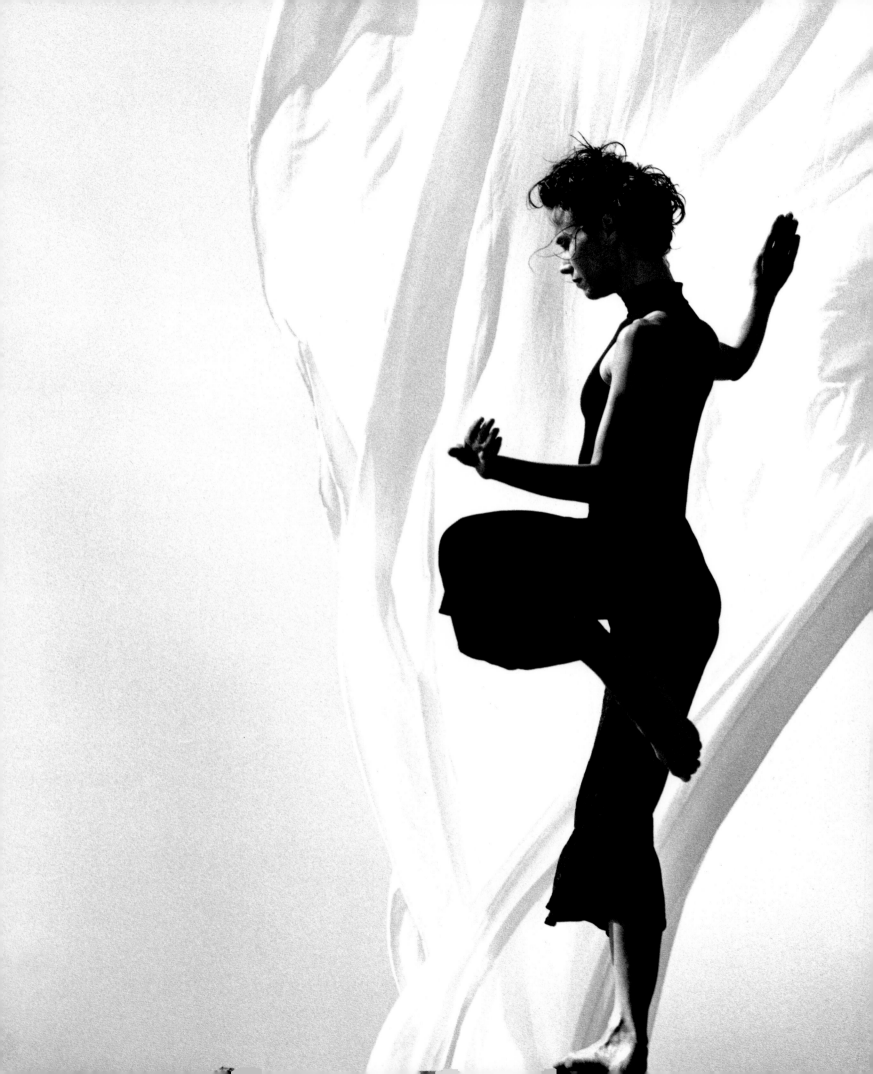

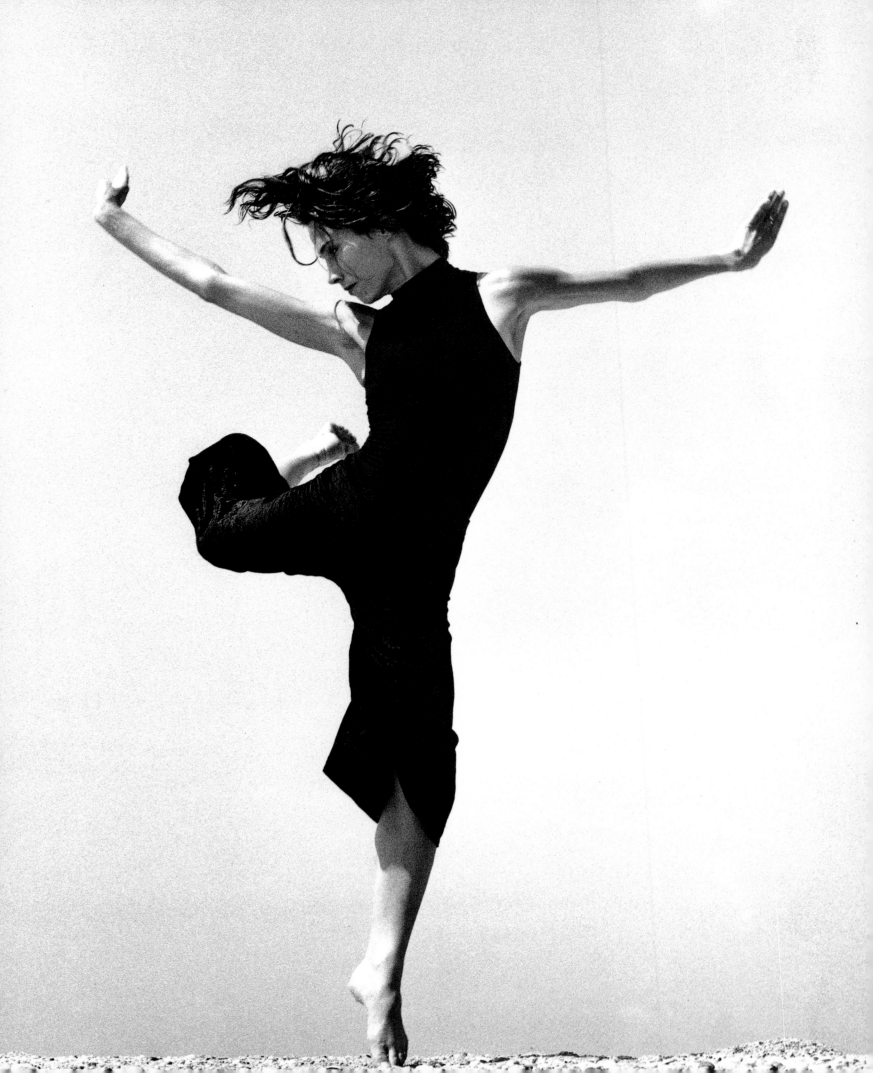

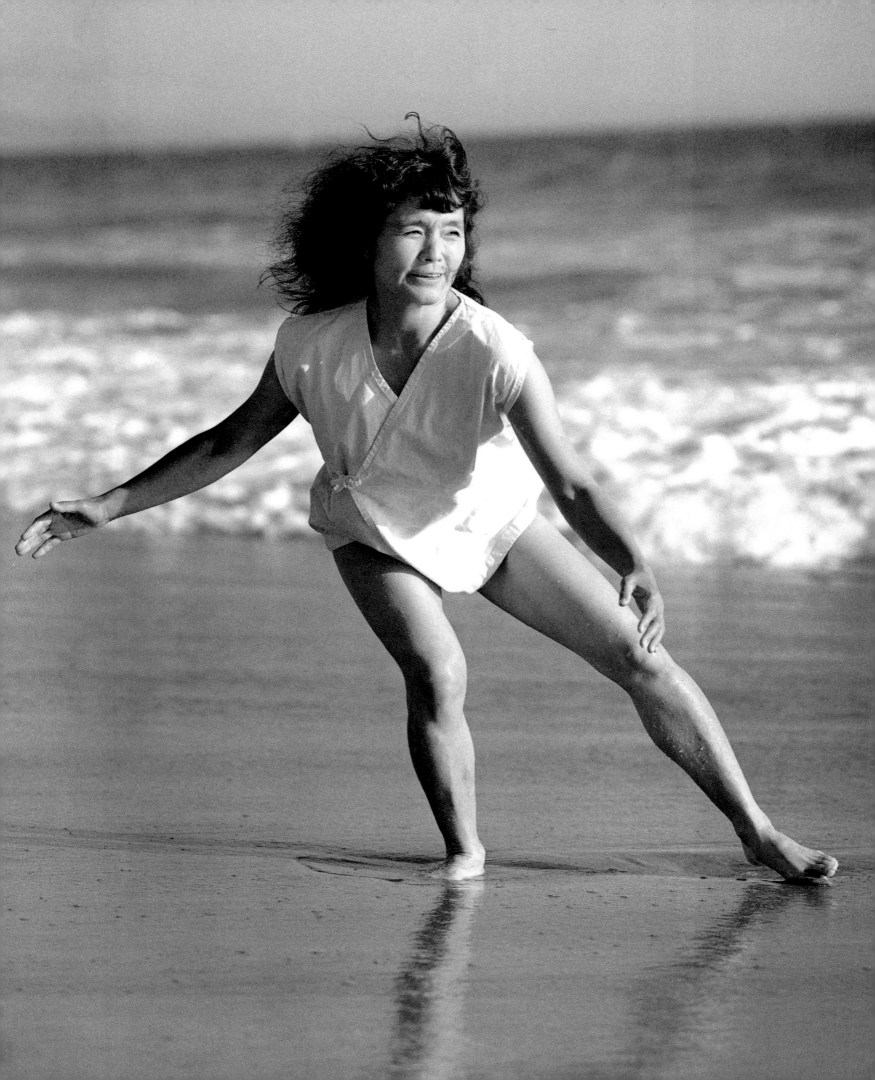

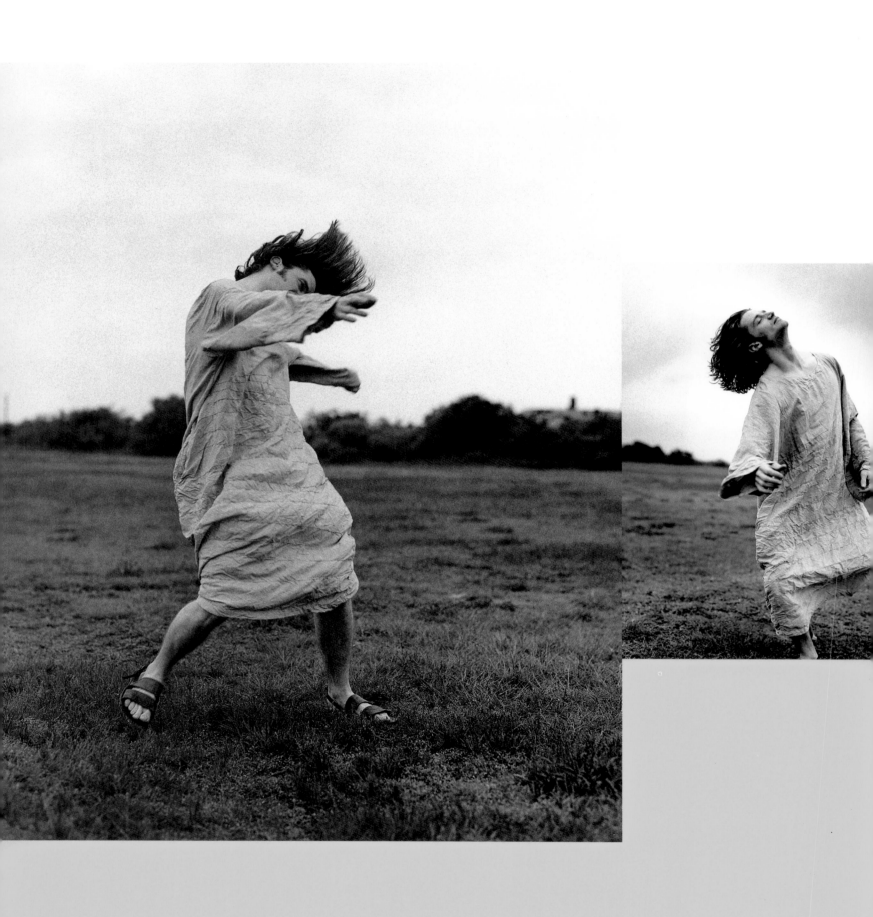

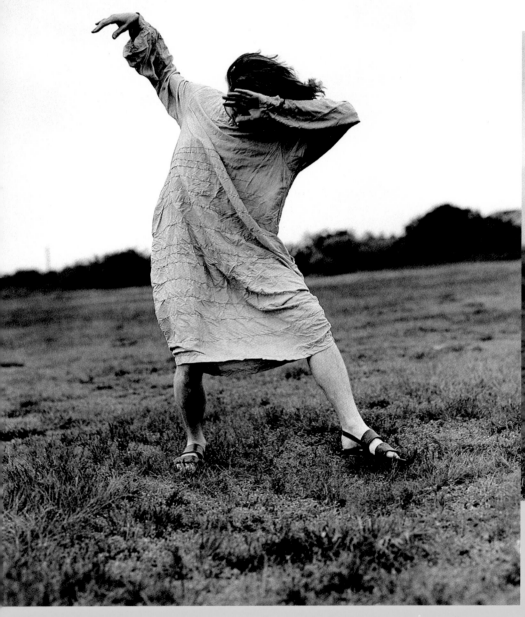
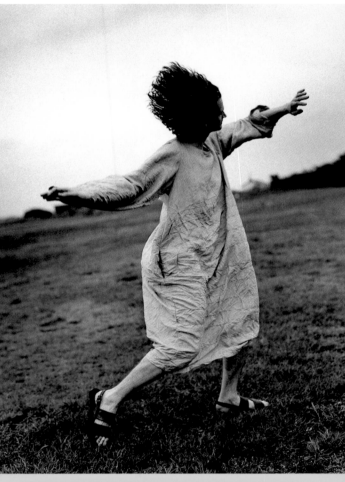

DENNIS O'CONNOR
STEWART SHINING

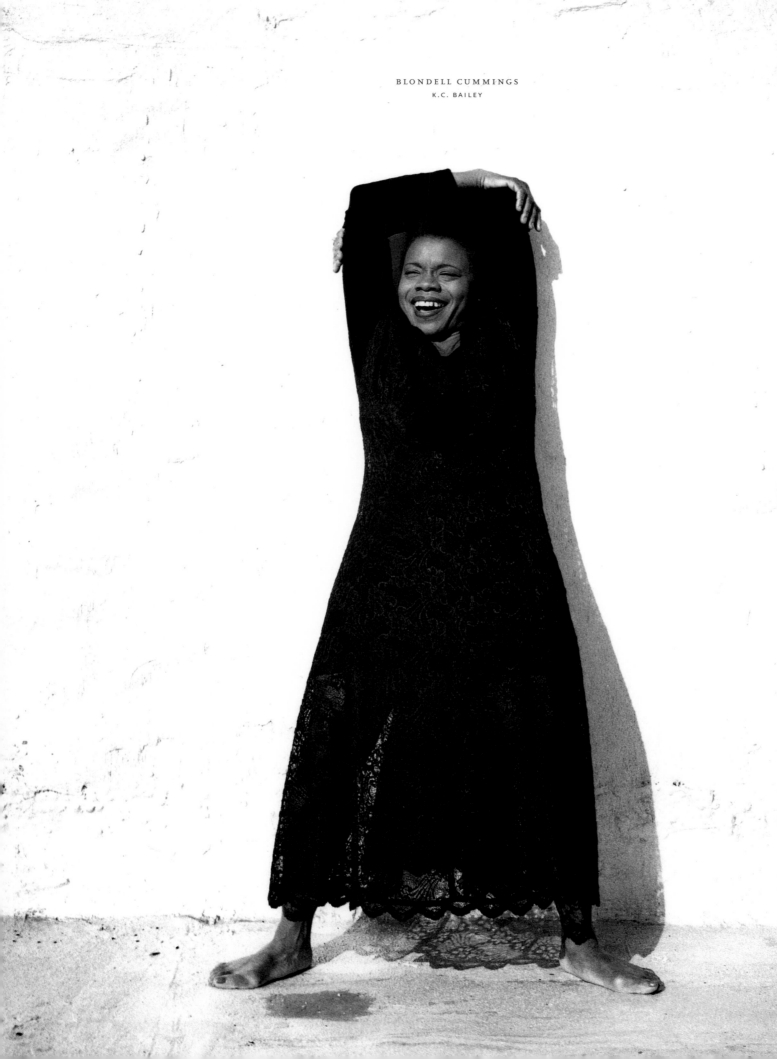

BLONDELL CUMMINGS
K.C. BAILEY

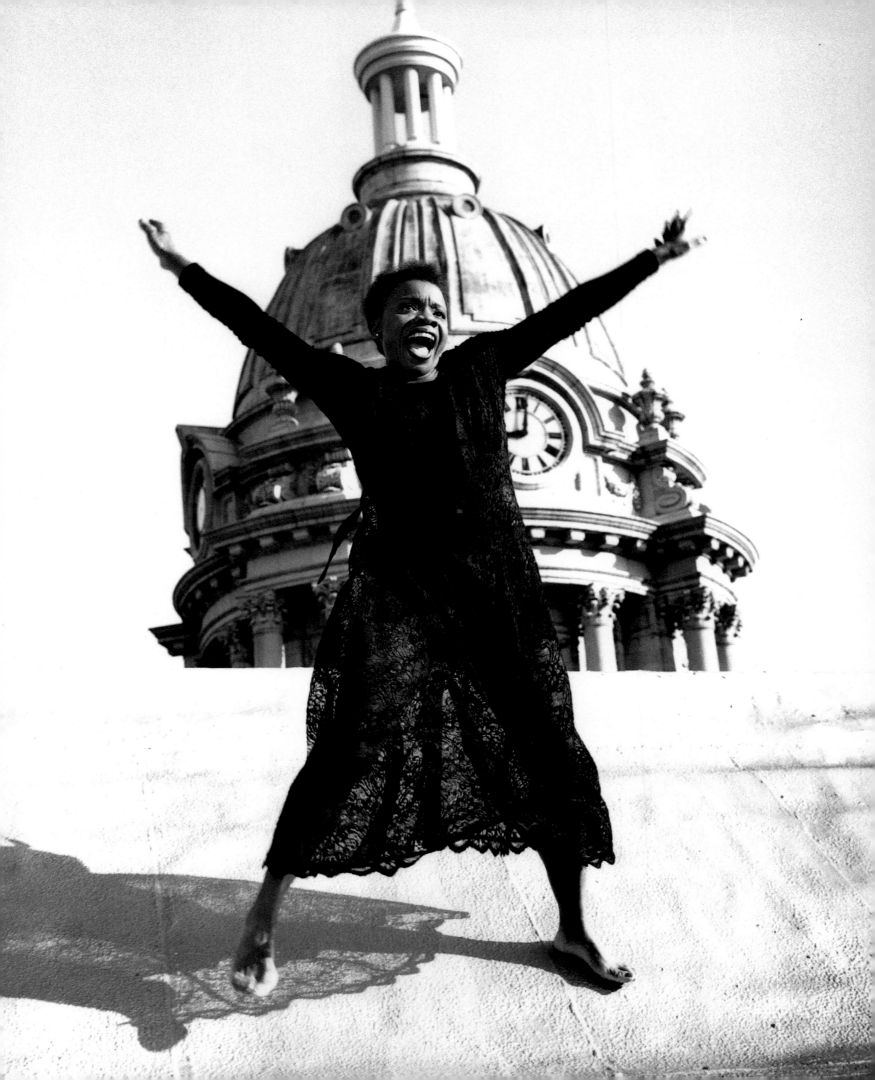

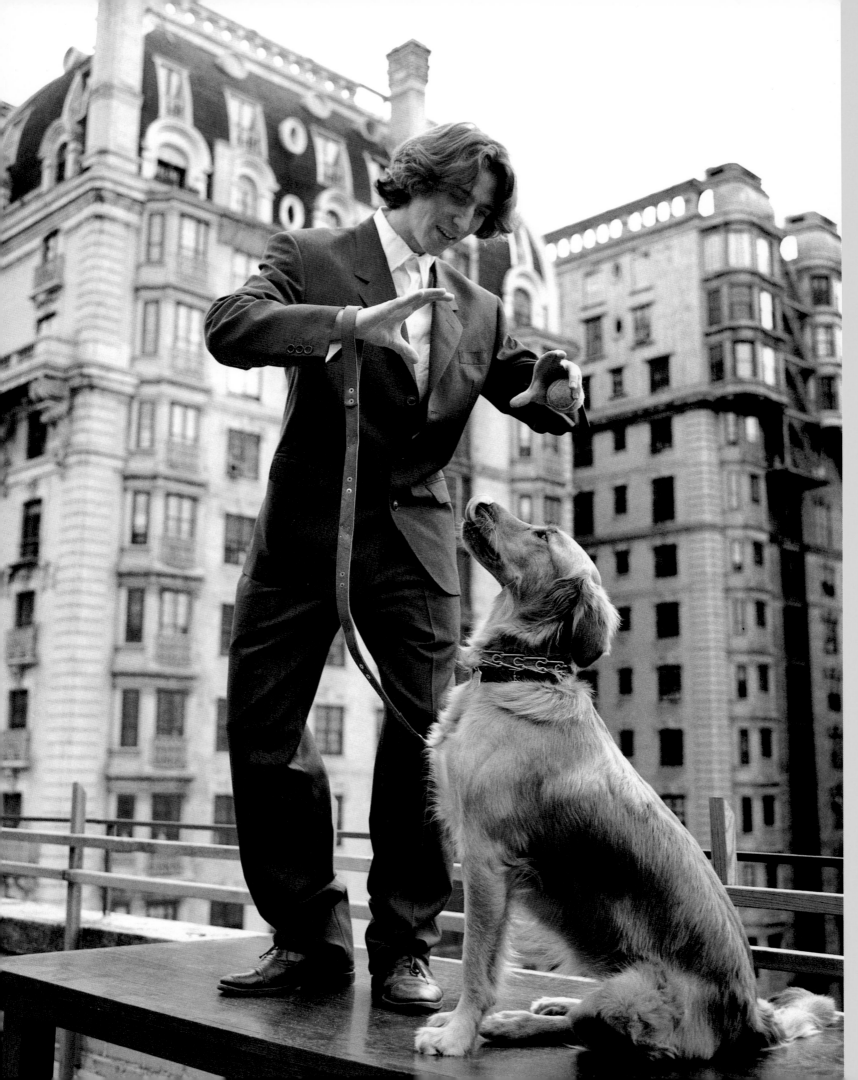

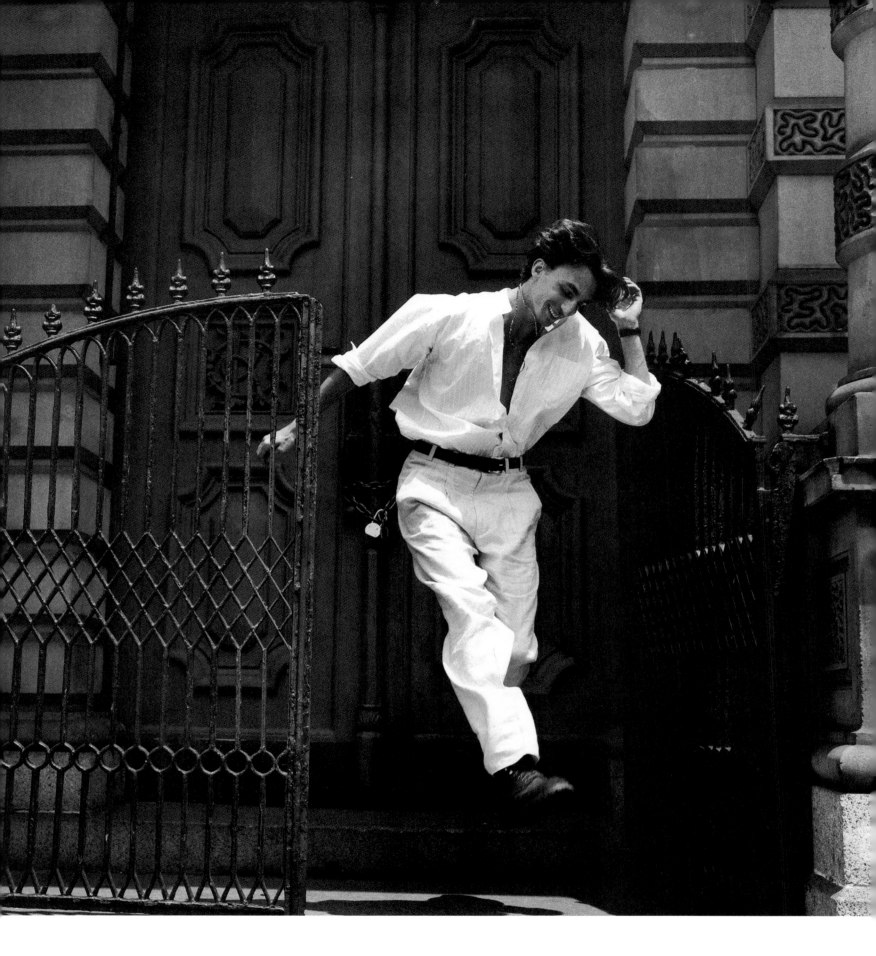

ALEXANDRE PROIA
K.C. BAILEY

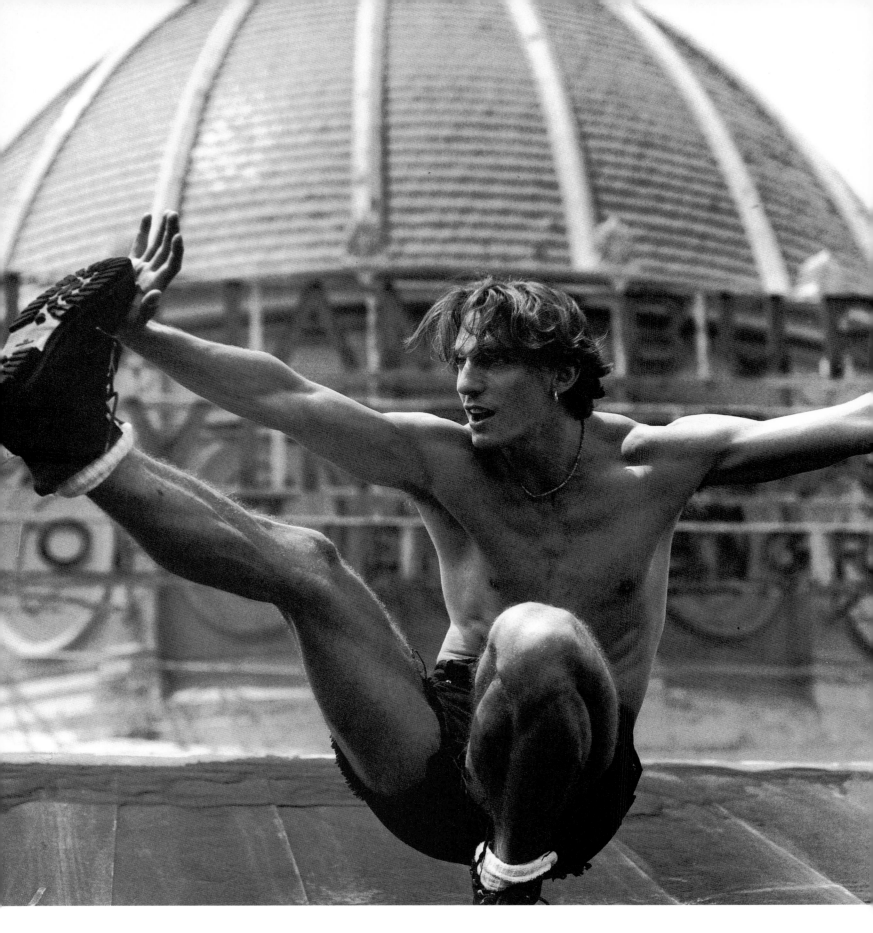

ALEXANDRE PROIA
K.C. BAILEY

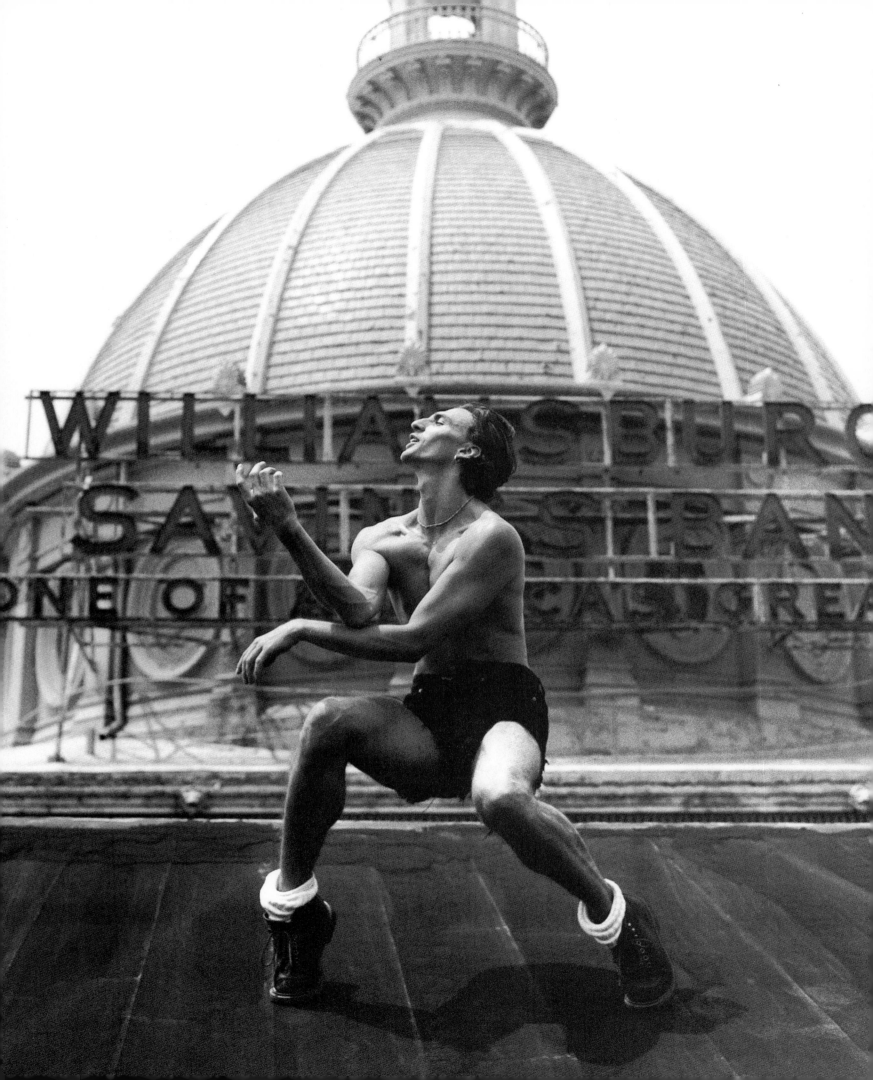

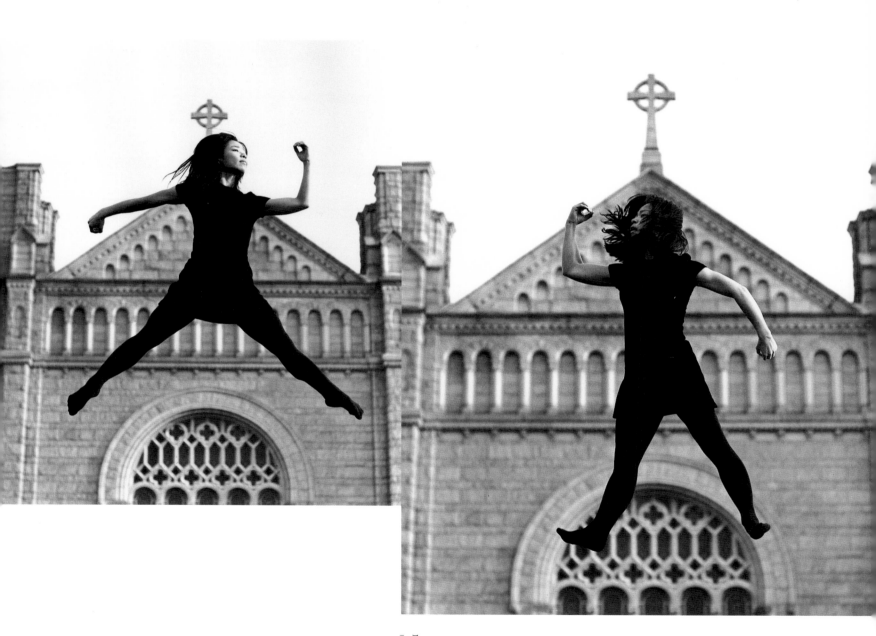

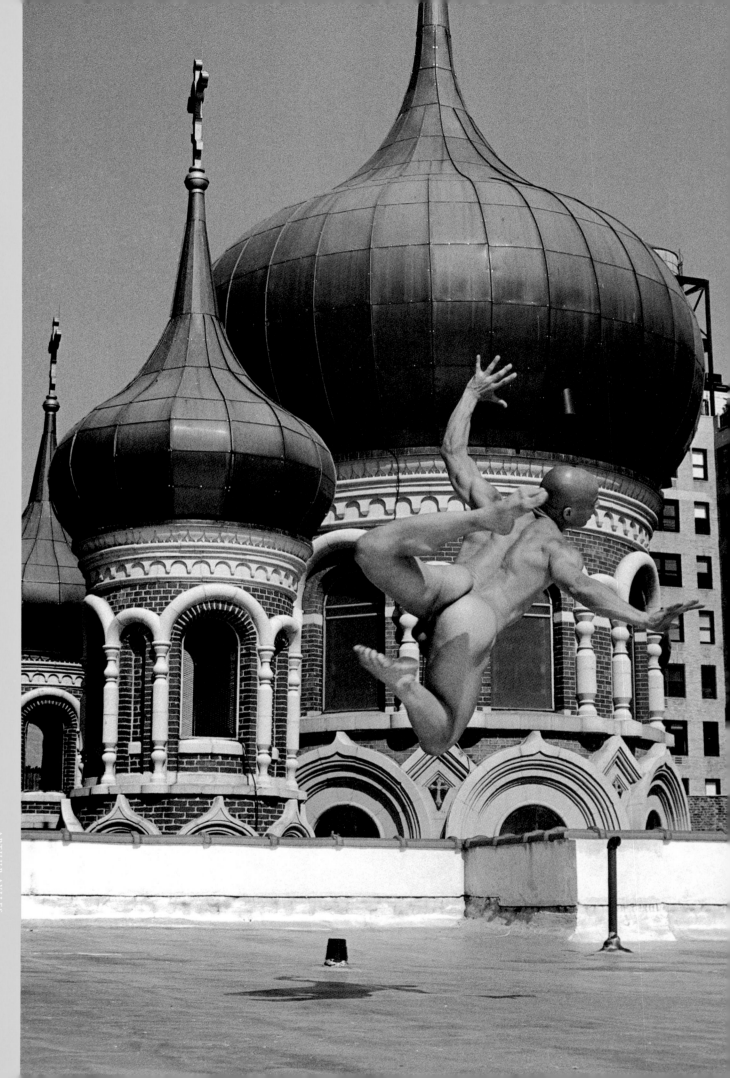

ARTHUR AVILES
K.C. BAILEY

TO BE DANCING IS TO BE RHYTHMICALLY
ENGAGING MY BODY, MOVING AND
TOUCHING PEOPLE IN WAYS THAT GO
BEYOND WHERE OTHER FORMS
OF COMMUNICATION CAN REACH.
AMY PIVAR

K.C. BAILEY

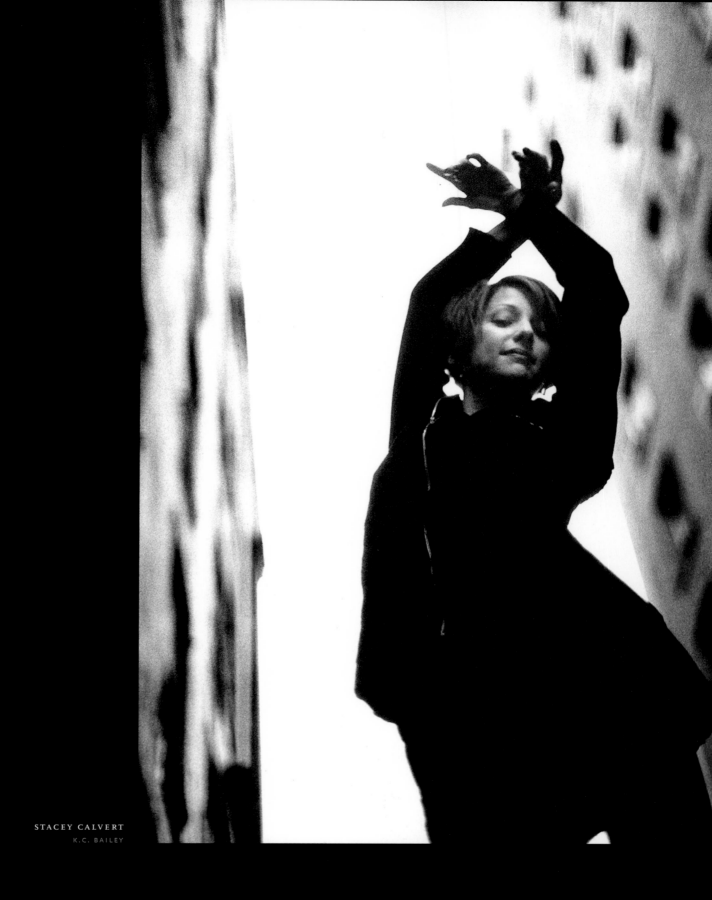

STACEY CALVERT
K.C. BAILEY

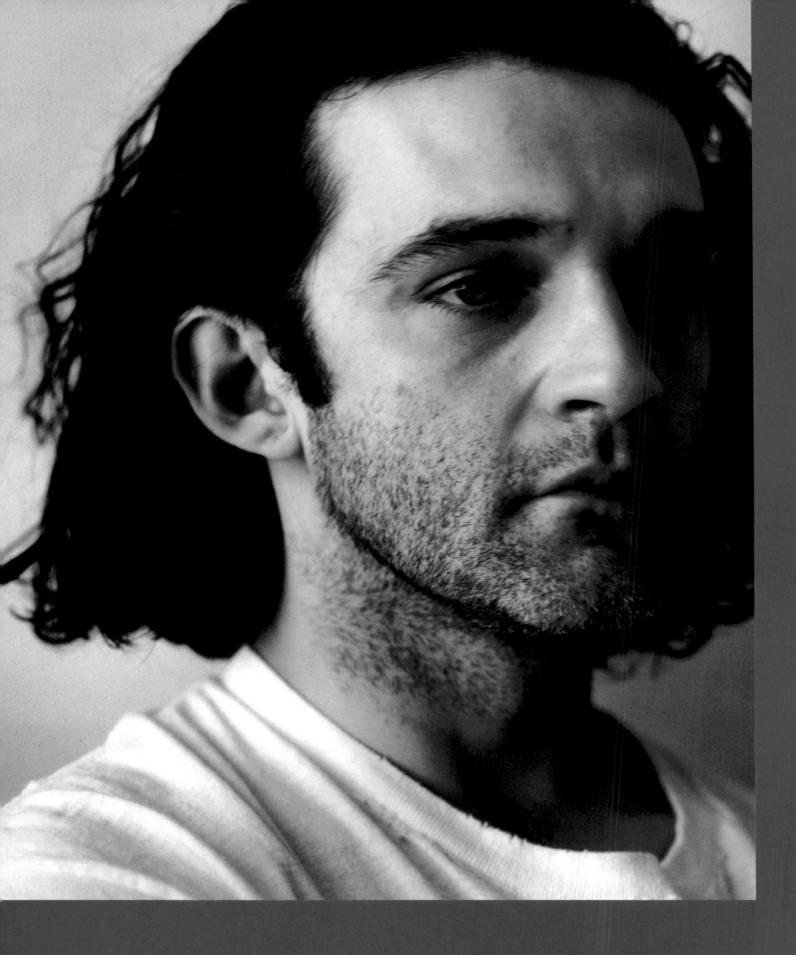

MARK MORRIS
ANNIE LEIBOVITZ

MARK MORRIS

One fine spring afternoon some years ago, Mark Morris was honored with an award. Given the opportunity to choose their presenters, the recipients who preceded him chose Arthur Mitchell and Paul Taylor. Mark Morris chose his mother.

Maxine Morris spoke in a beautiful, mellow contralto tinged with a fine irony: "You'll notice when Mark comes out," she said, "how nice he looks in his suit." (And he did look nice, in an fine ironic way.) Right before that, Mrs. Morris told us something just as true, and not at all ironic: "Mark is always honest, and that is difficult." Indeed it is—sometimes for him; sometimes, one supposes, for his mother and his dance group; sometimes for his audience. Even when attired in their under-pants, or no pants at all—as Morris frequently is photographed—

moralists are unsettling. They are not politicians. Their paths are unswerving.

Whether in his suit or his birthday suit, Mark Morris stands now, as the decade winds down, as our century's youngest great choreographer. He is our Janus. He looks forward, and he looks back. In his very person he erases the boundaries we like to impose on time, on identity, on the nature of people and the nature of things. On stage, Morris possesses an eerie power of evocation: when he dances, you find yourself thinking about Isadora and Ruth St. Denis. His visage is confounding. Wing-browed, craggy-chinned, snaggle-toothed, bee-stung, moon pale—this is the face Oscar Wilde imagined as he wrote *Salome*, the face he saw as he was writing the part of Saint John the Baptist. This is the head Herod delivered to Salome on a platter.

In Virgil's *Aeneid*, Dido, the queen of Carthage, promises her lover, Aeneas, that she will make no distinction between his people and hers. No wonder Morris cast himself as Dido in his own *Dido and Aeneas*. He is Dido! In his movement world, he makes no distinctions—story ballet, Graham, Balanchine; sign language, clogging, flamenco; tableaux vivants, country western, *barat natyam*; church processionals, the laying on of hands, the simple sight of people turning in their sleep—all this, and more, Morris embraces.

This grand choreographic statement of inclusion—the Morris philosophy expressed in dance terms—is also expressed though his taste in music. It runs the gamut from Vivaldi to the Violent Femmes, with the musical meter functioning for

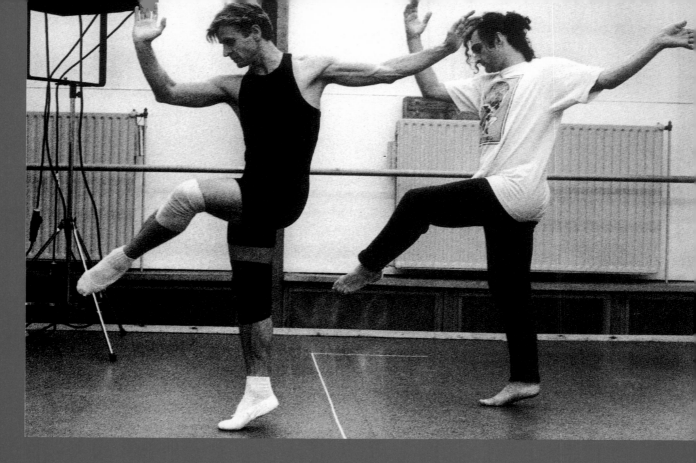

the choreographer the way metrical forms do for poets—in every case the ground and the given. Utopian, too, is his choice of dancers, both in their physique and affect, and in their interaction. Within the Mark Morris Dance Group there is a continuum of color and of sexuality, with both genders ranging from sinuous to sturdy, and all considered beautiful. With the troupe in its seventeenth year, there are dancers old—some there since the beginning, and before—and dancers new. Always, they perform communally, with soloists stepping out of the group only to return to it.

In Morris, the folk and fine, the premodern, the modern, and the postmodern, commingle in a peaceable kingdom. Morris shows us the world the way it is and the way he thinks it ought to be.

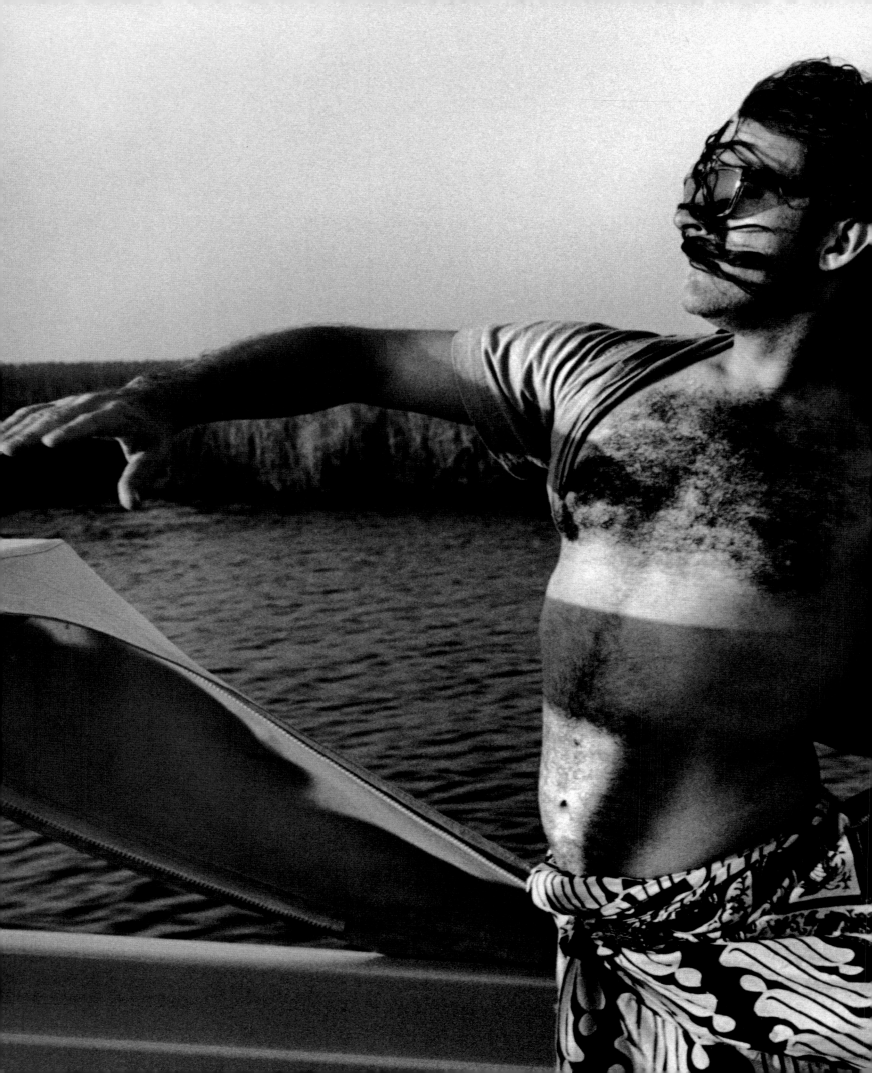

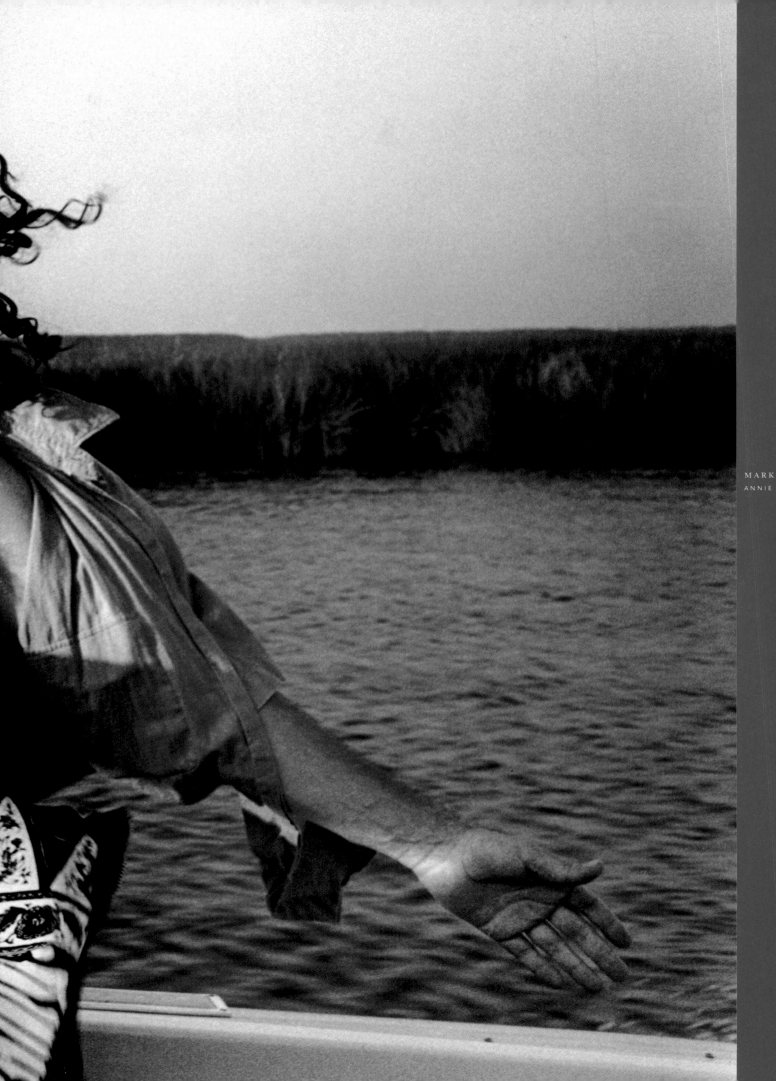

MARK MORRIS
ANNIE LEIBOVITZ

LANCE GRIES
JODI MELNICK
JAMIE BISHTON
ROBERT LA FOSSE
KEVIN O'DAY
STACEY CADDELL

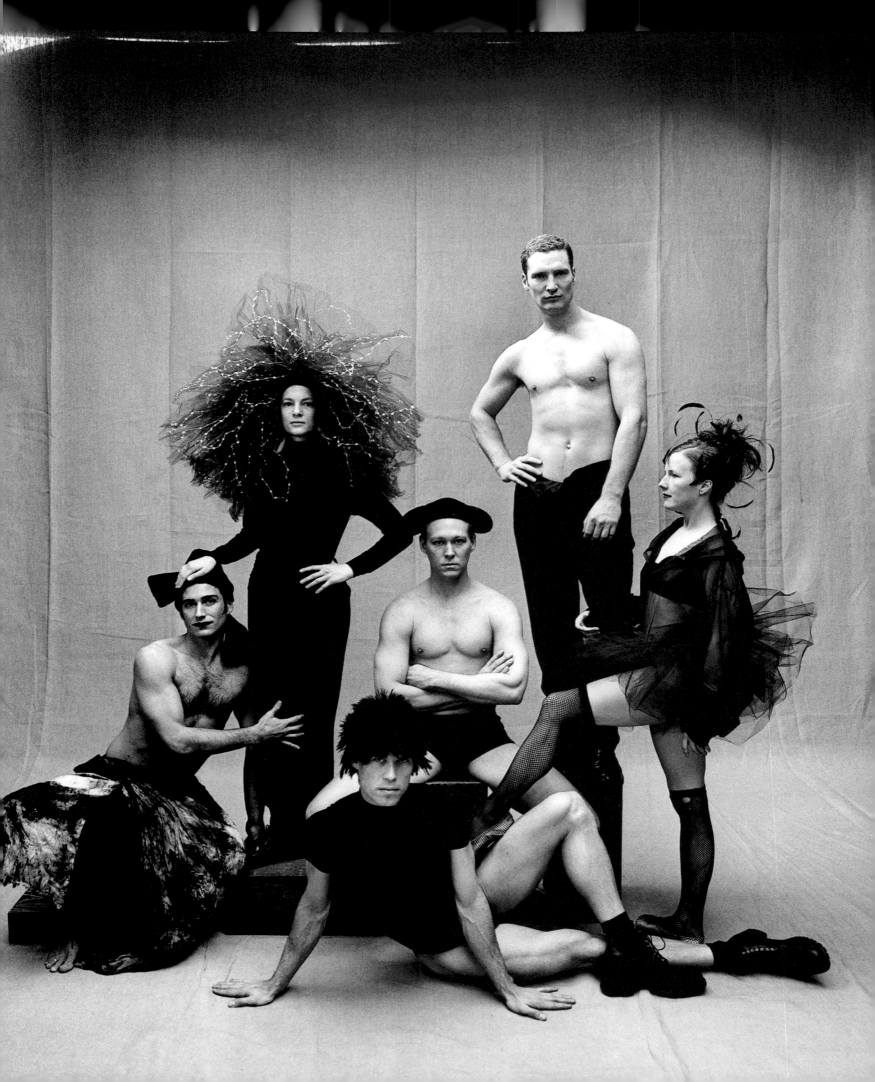

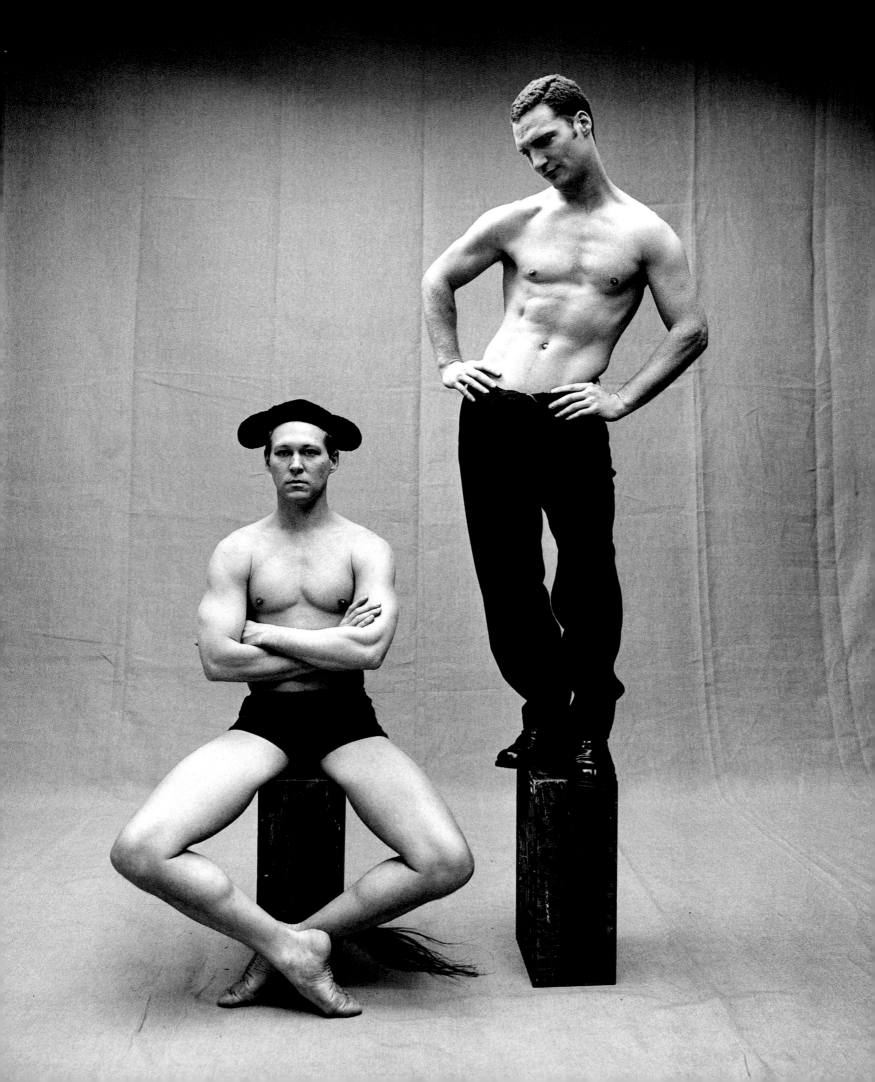

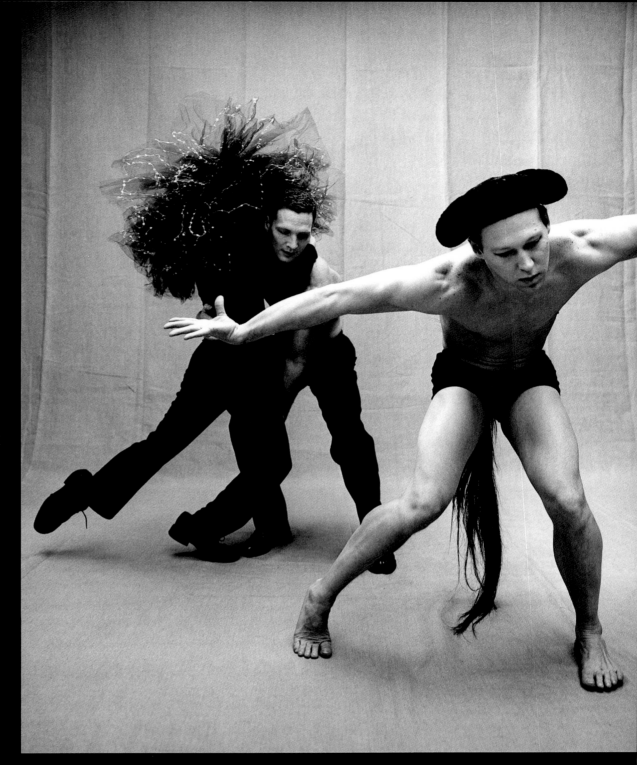

JODI MELNICK
KEVIN O'DAY
ROBERT LA FOSSE

ROBERT LA FOSSE
KEVIN O'DAY

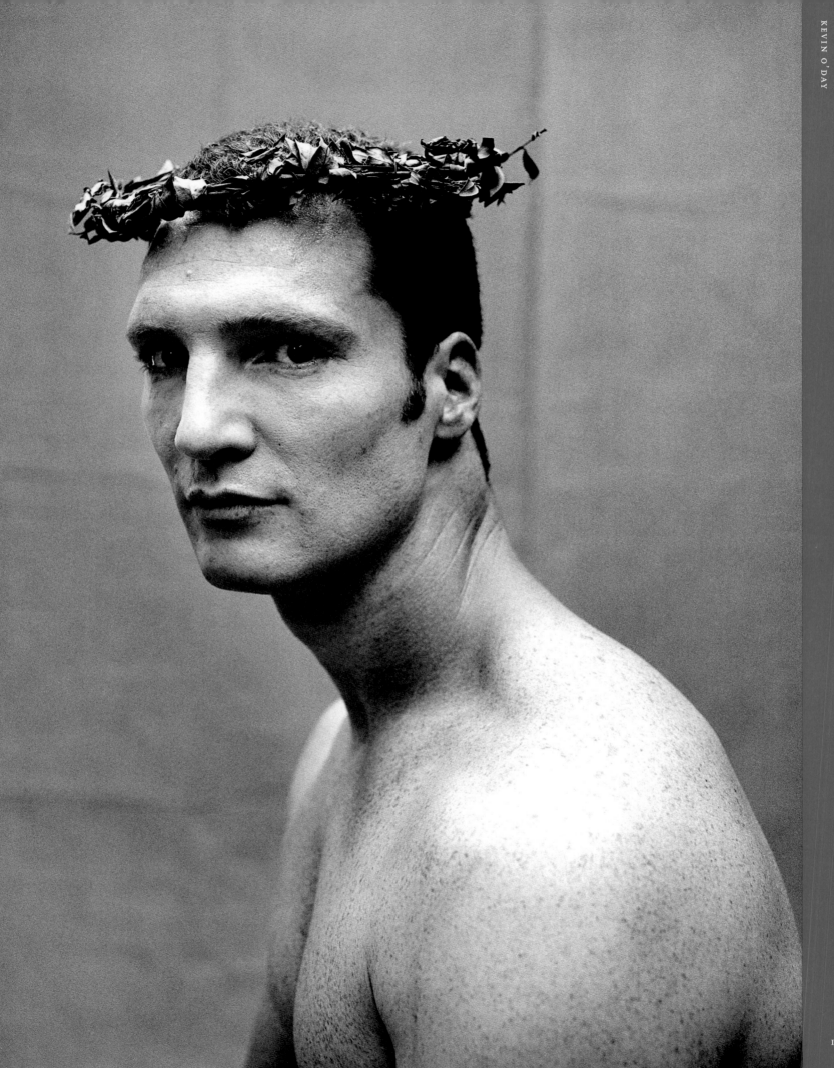

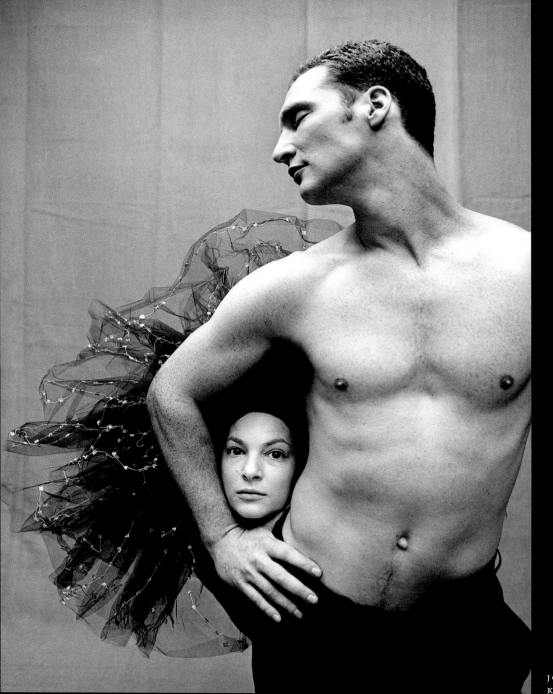

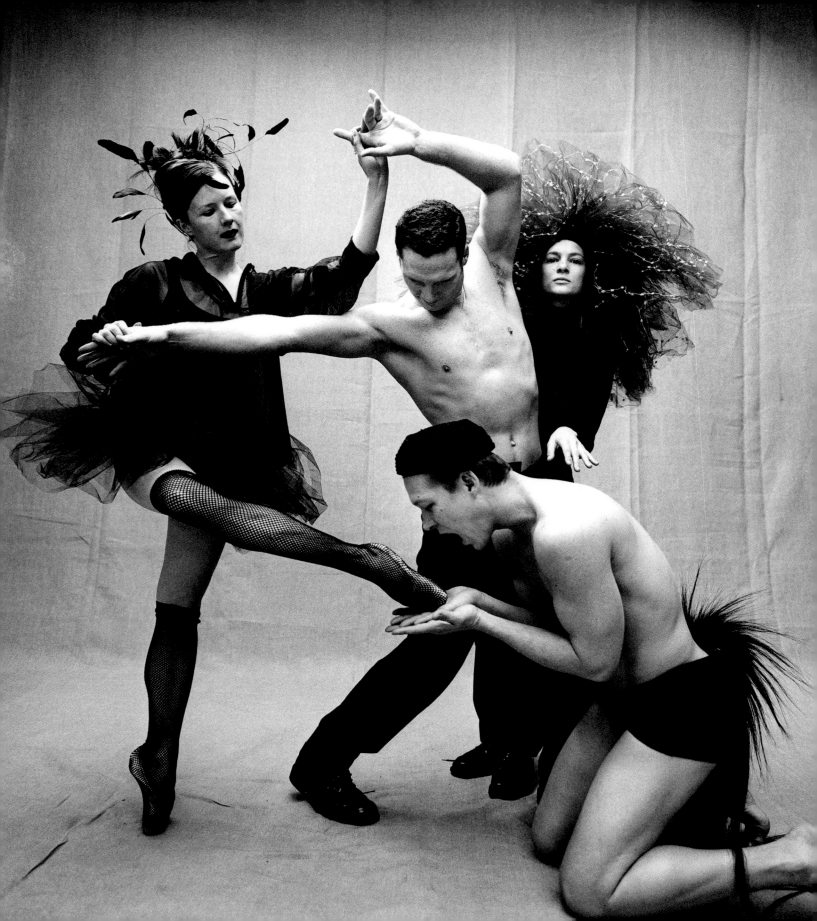

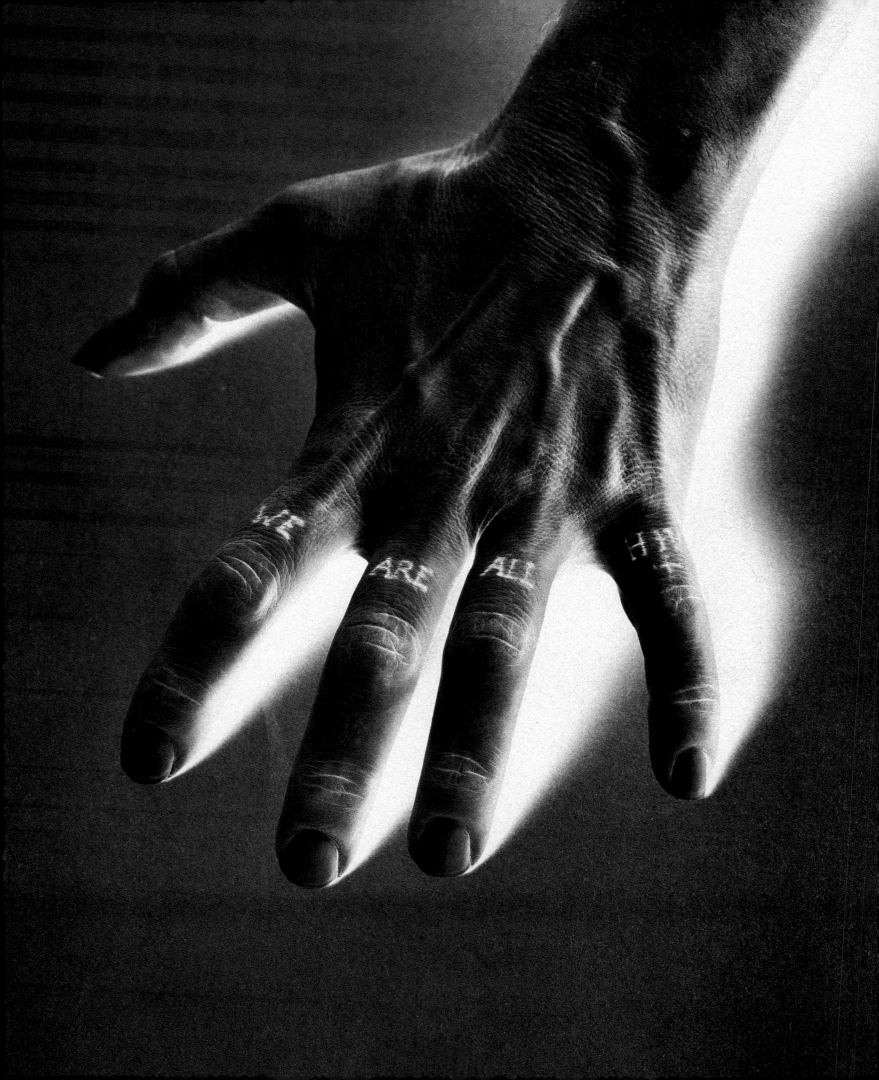

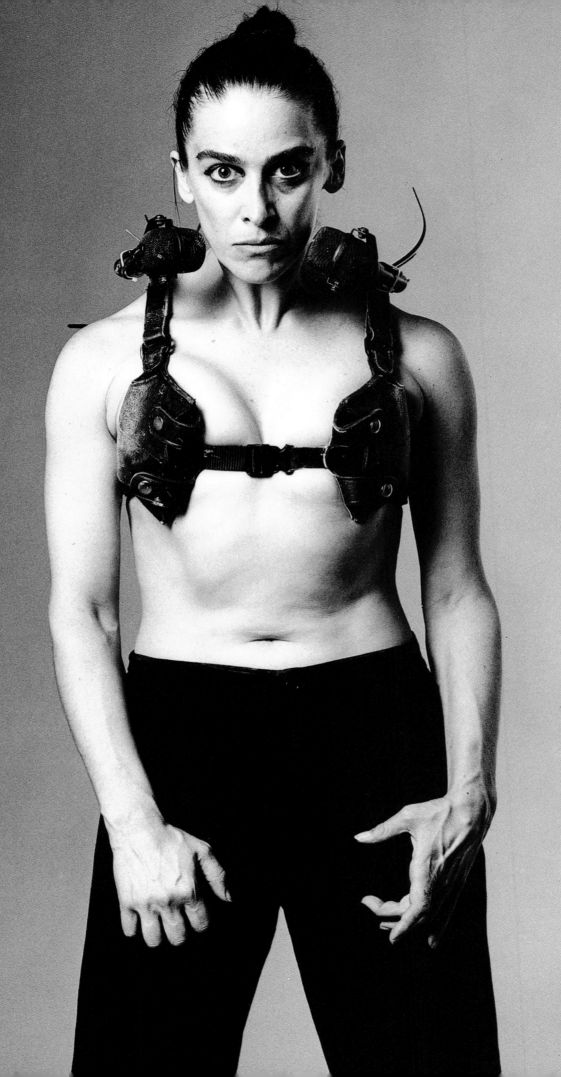

DIAMANDA GALAS
JOANNE SAVIO

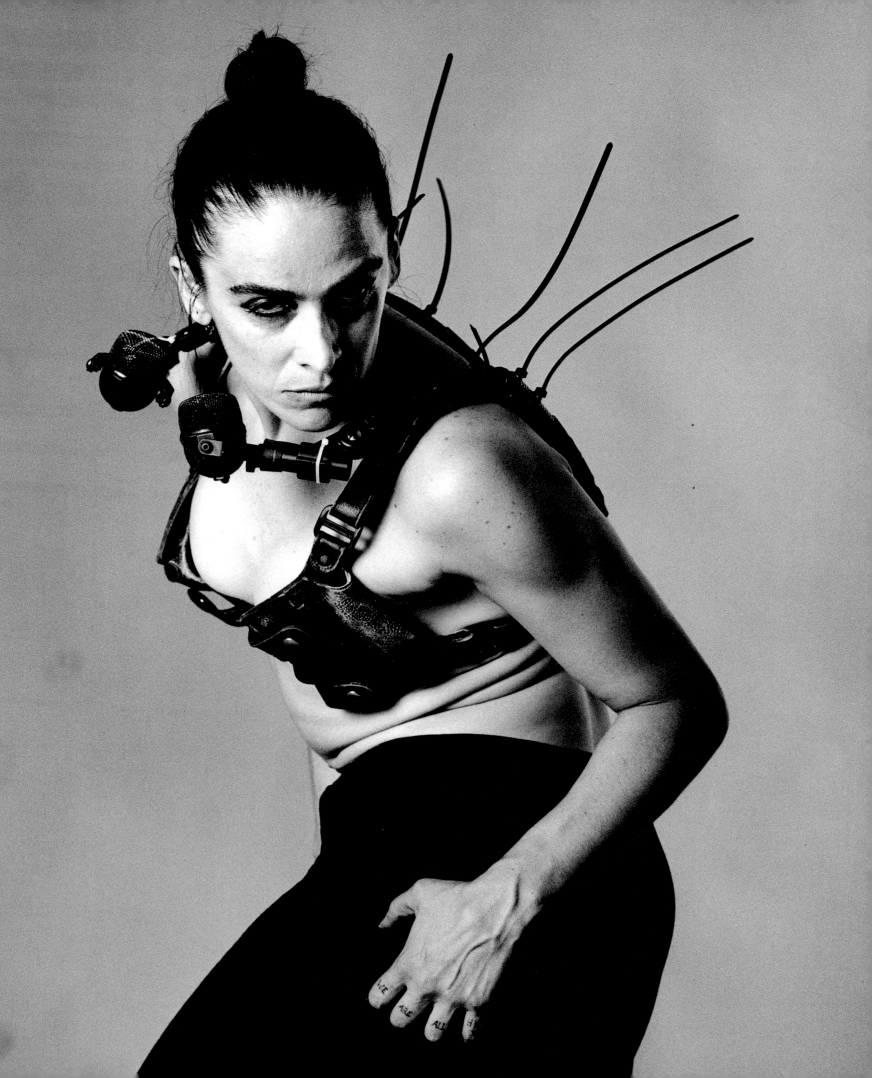

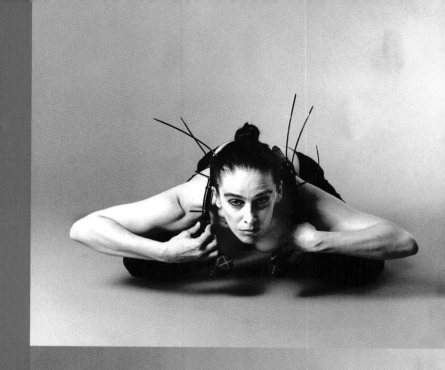

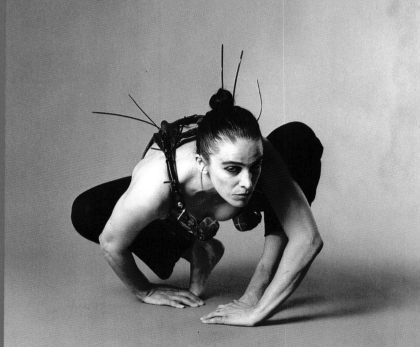

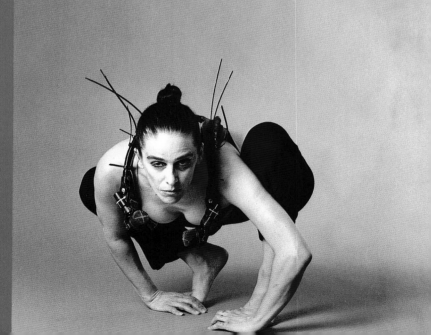

DIAMANDA GALAS
JOANNE SAVIO

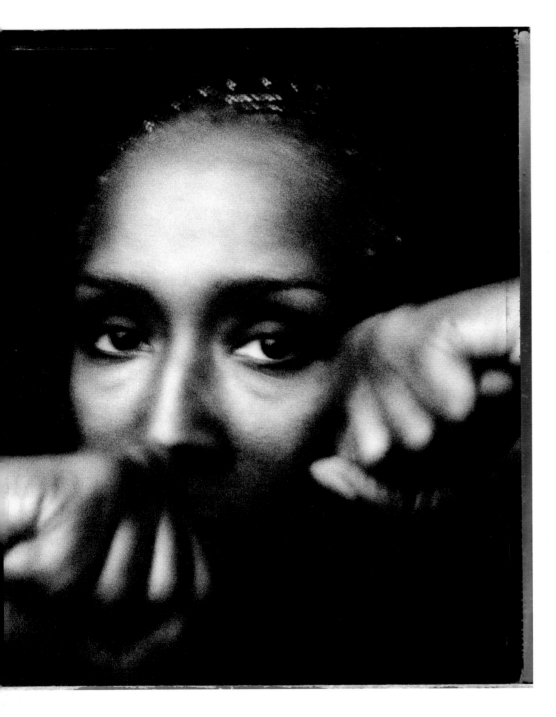

JUDITH JAMISON
ANDREW ECCLES

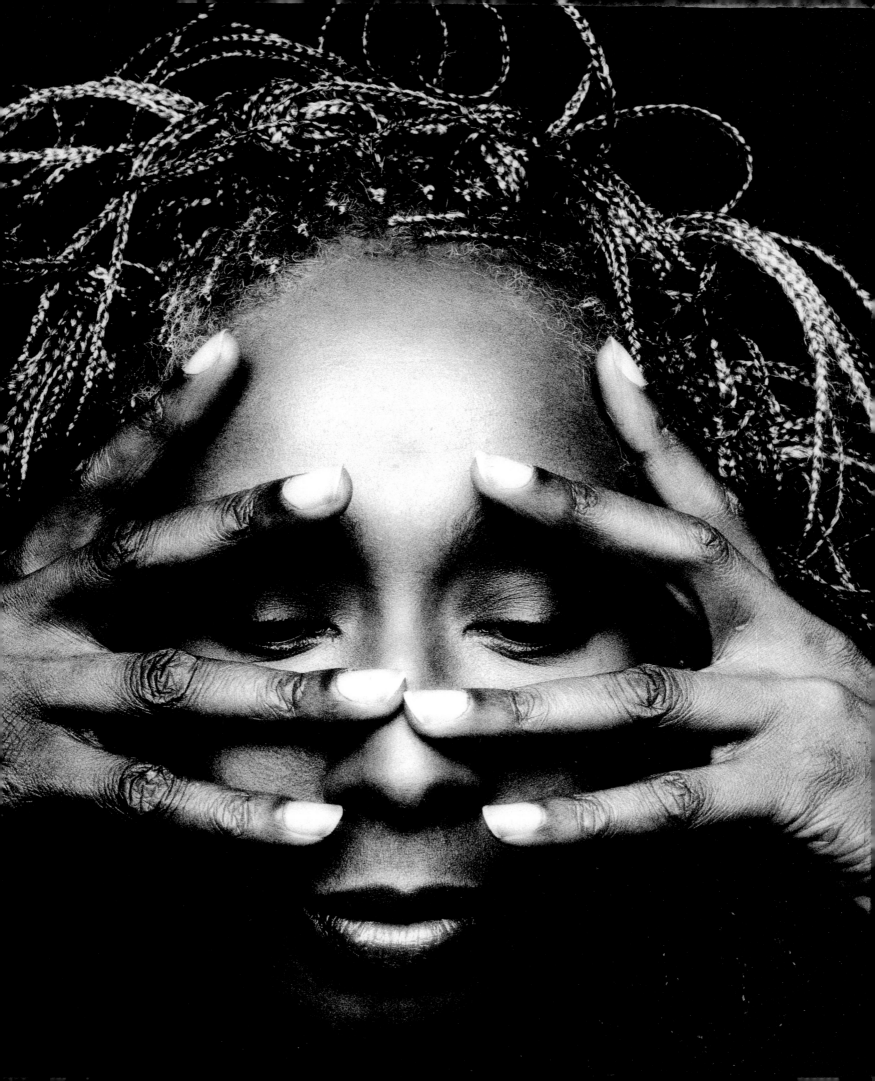

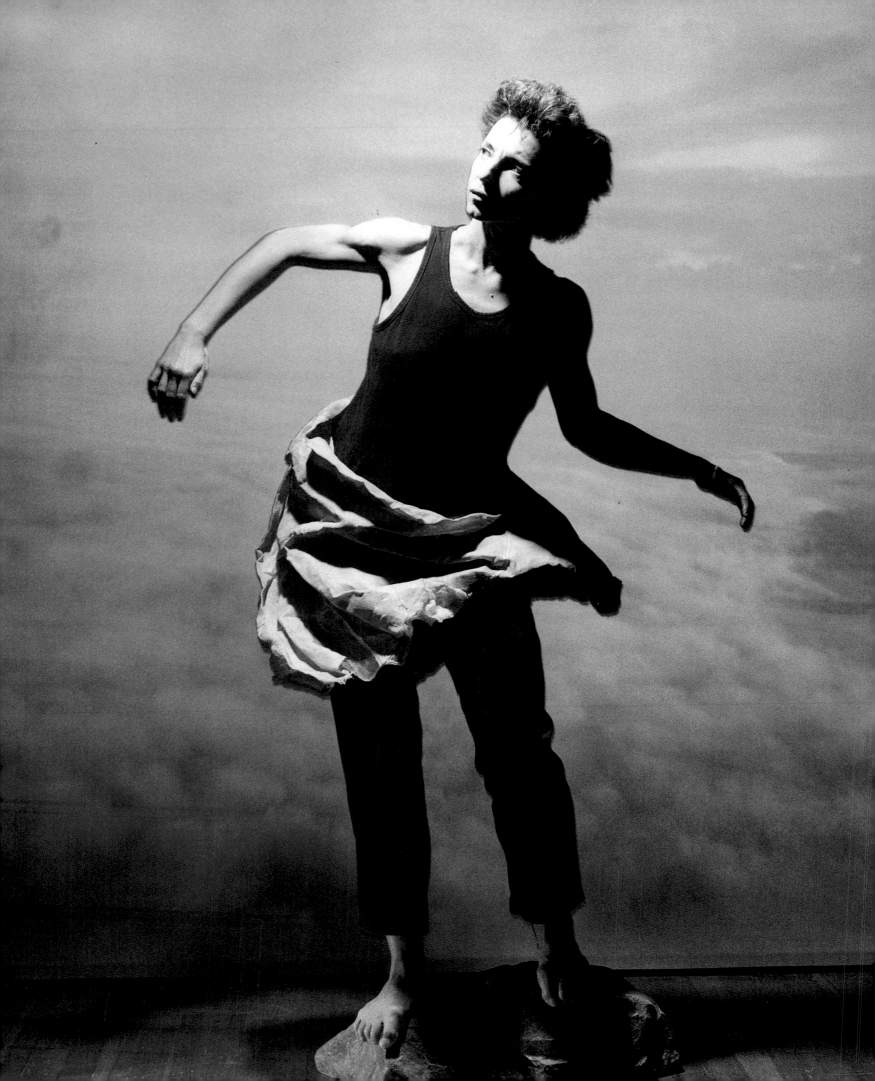

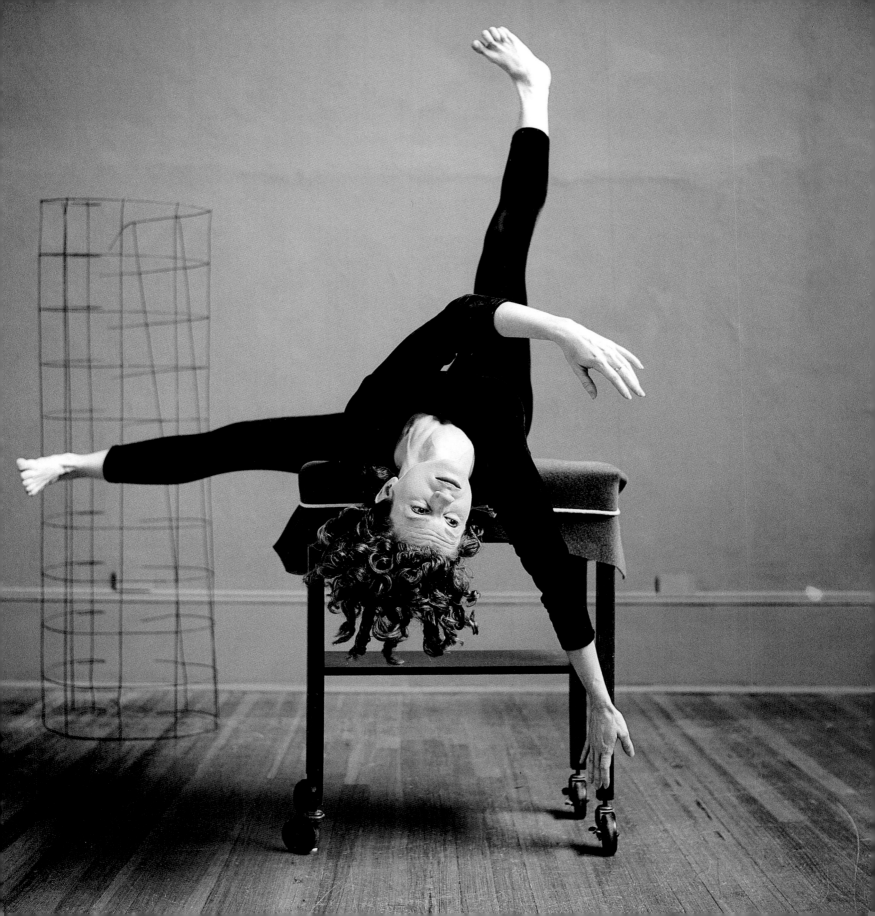

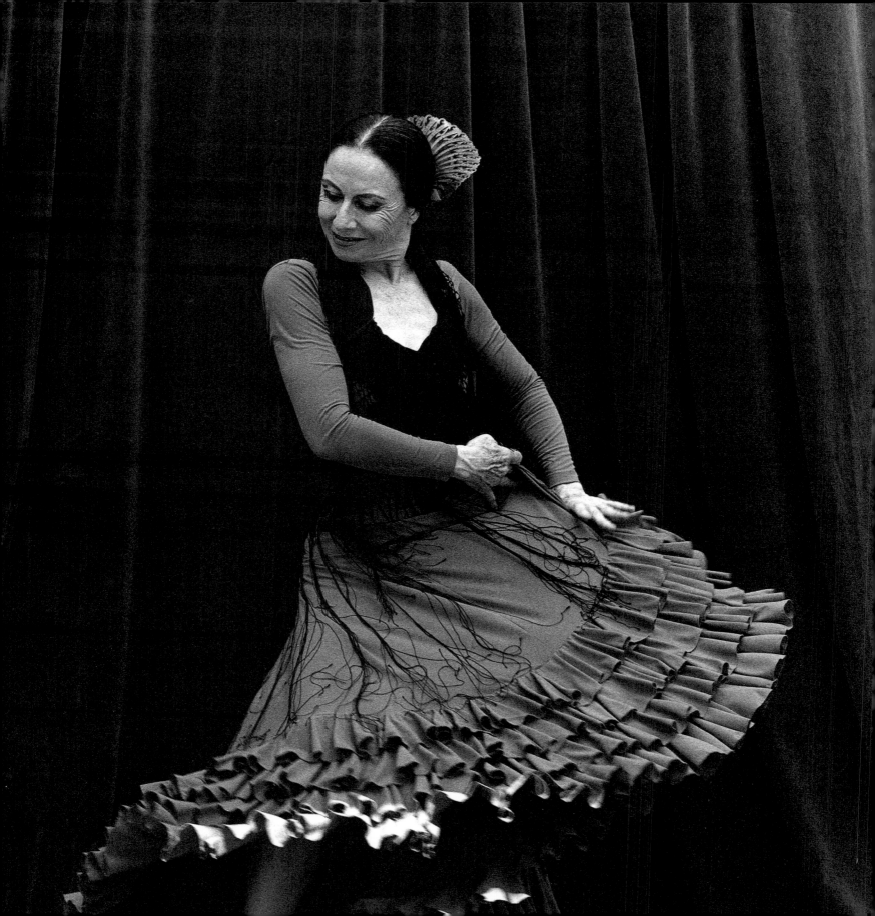

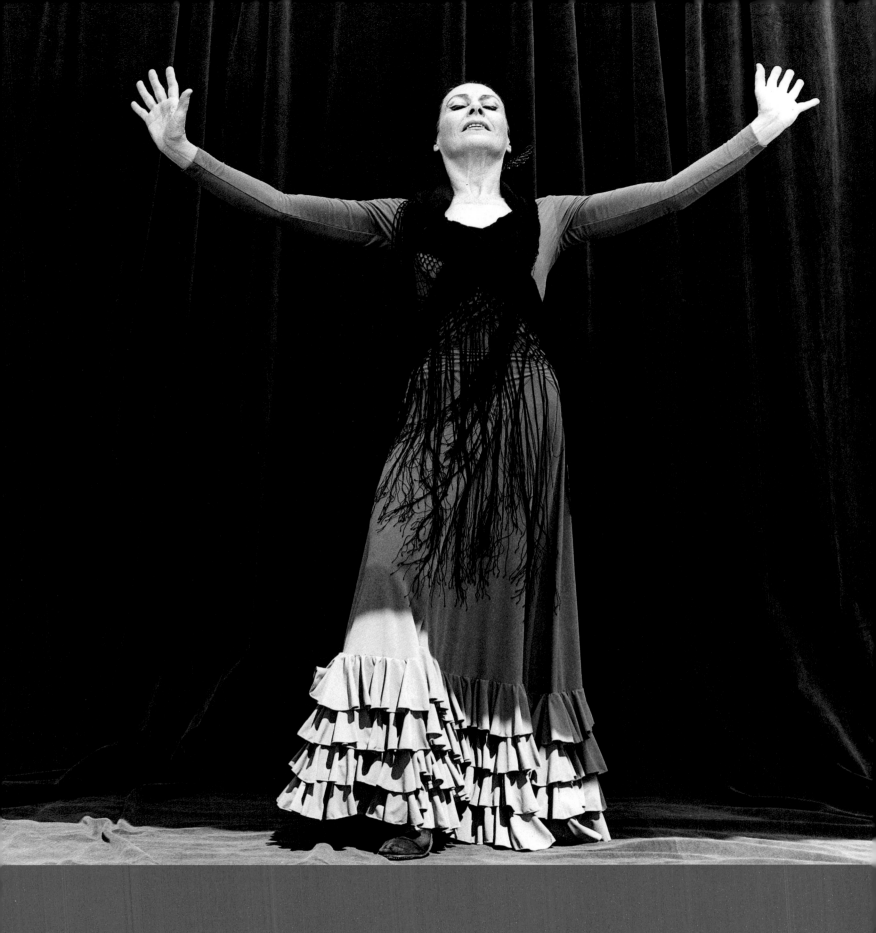

PILAR RIOJA
K.C. BAILEY

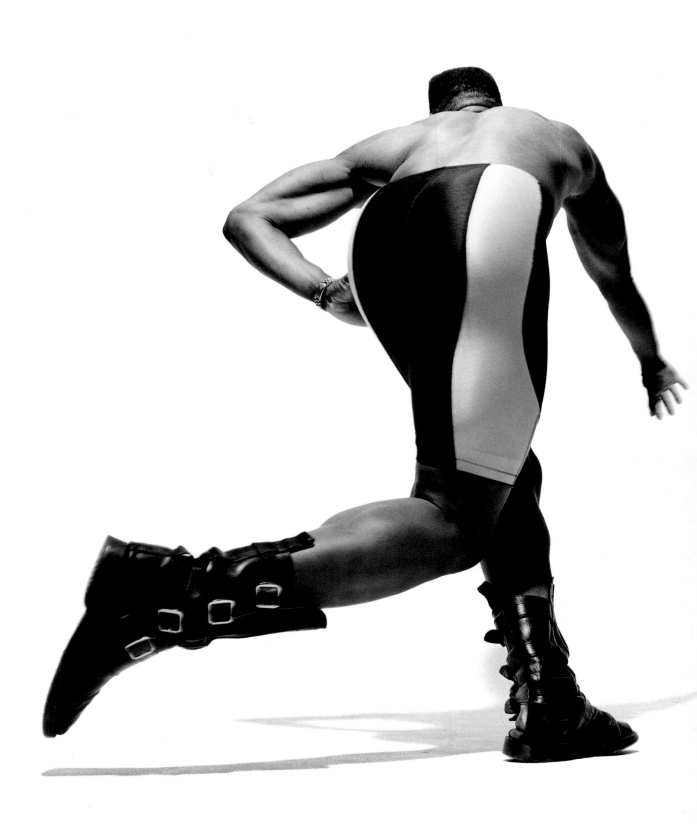

ARCHIE BURNETT
ANDREW ECCLES

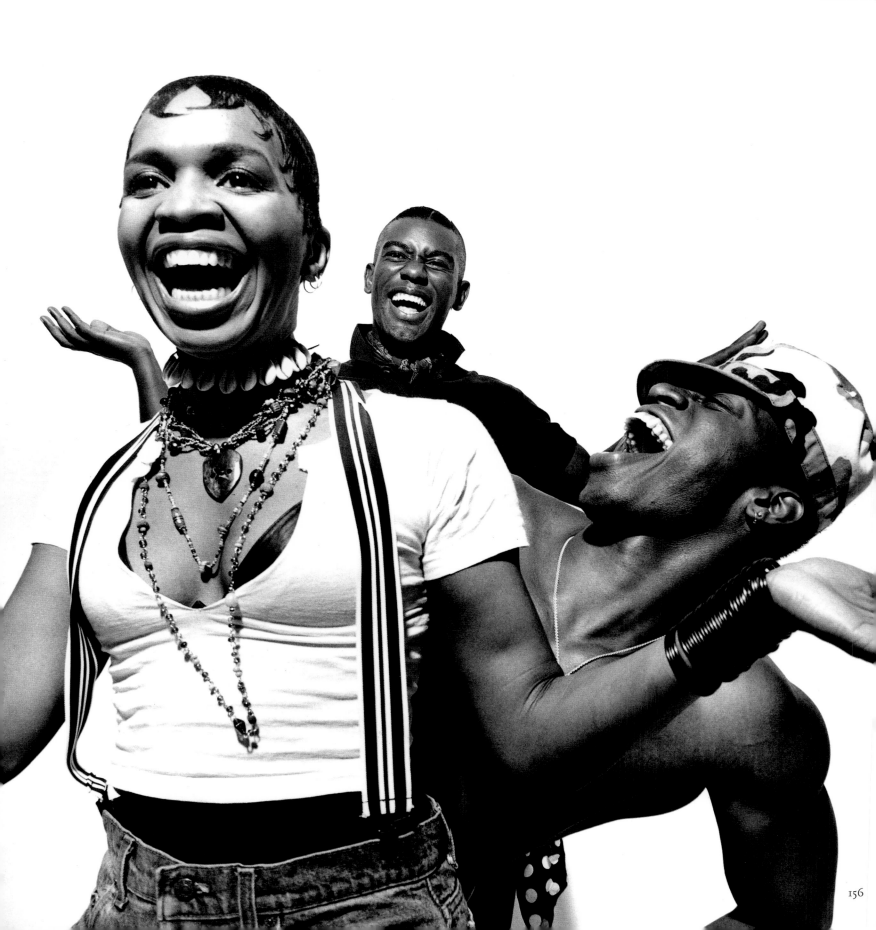

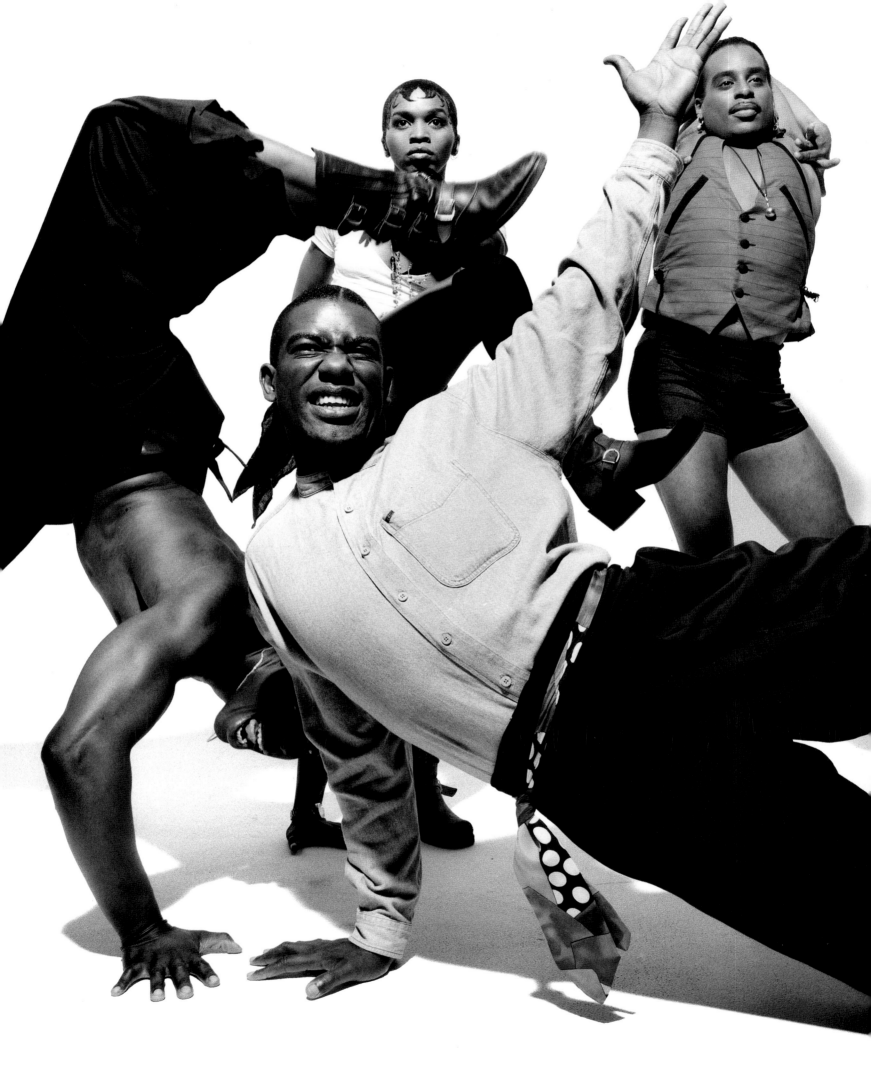

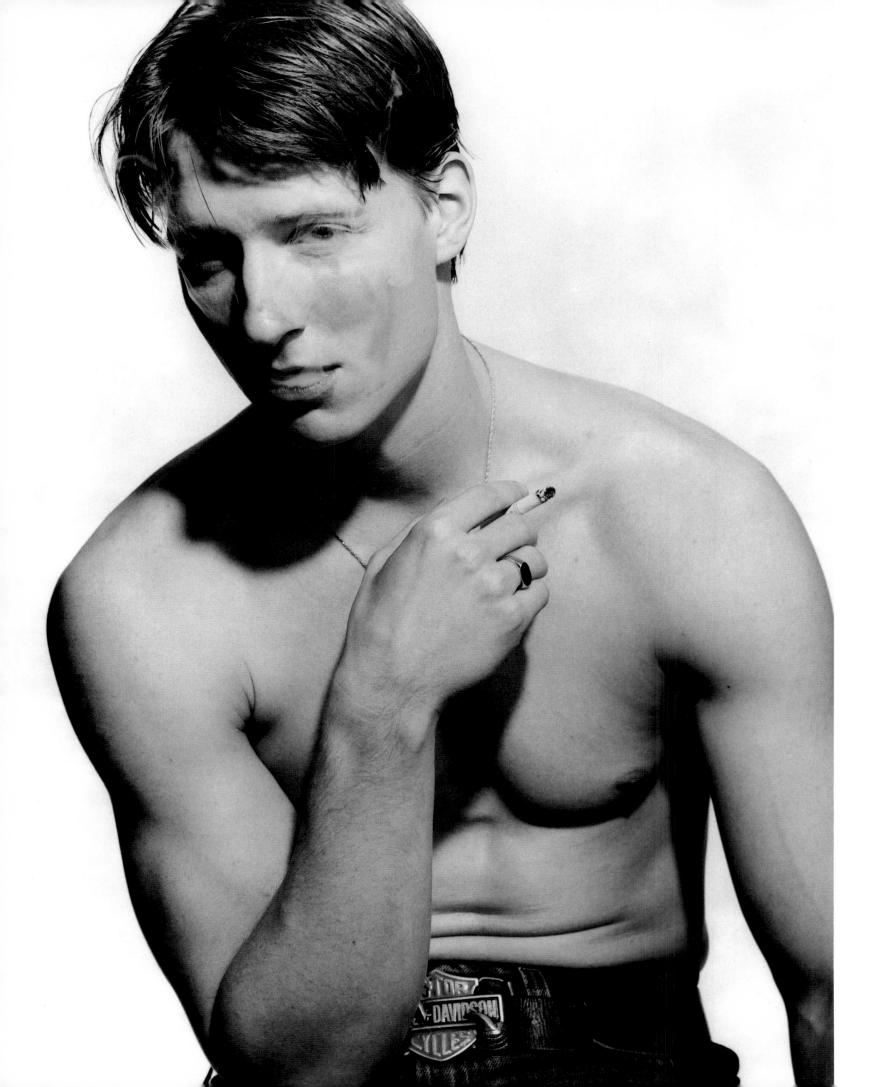

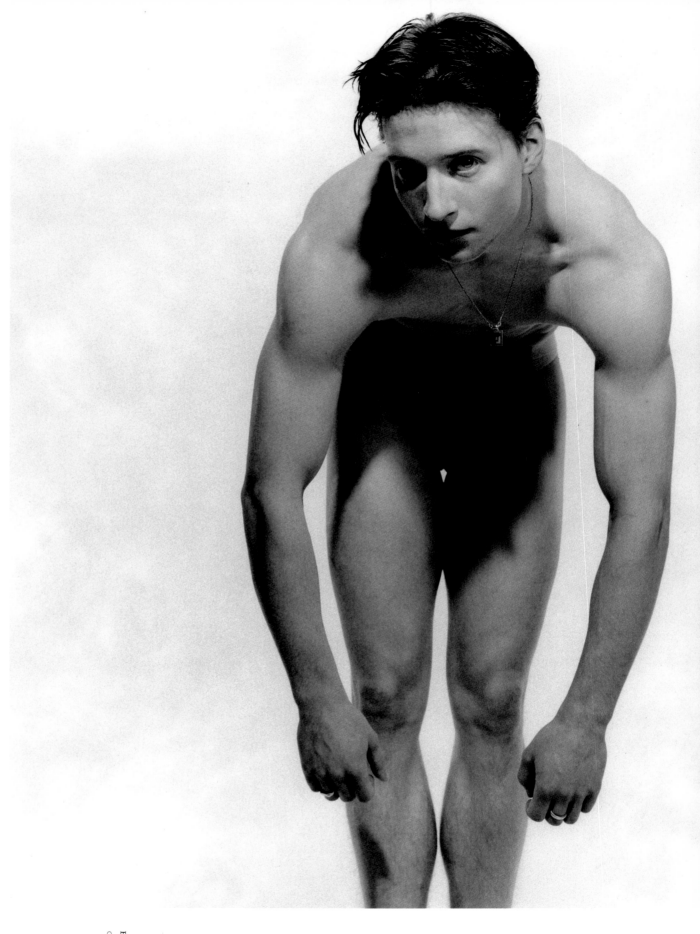

ETHAN STEIFEL
GUZMAN

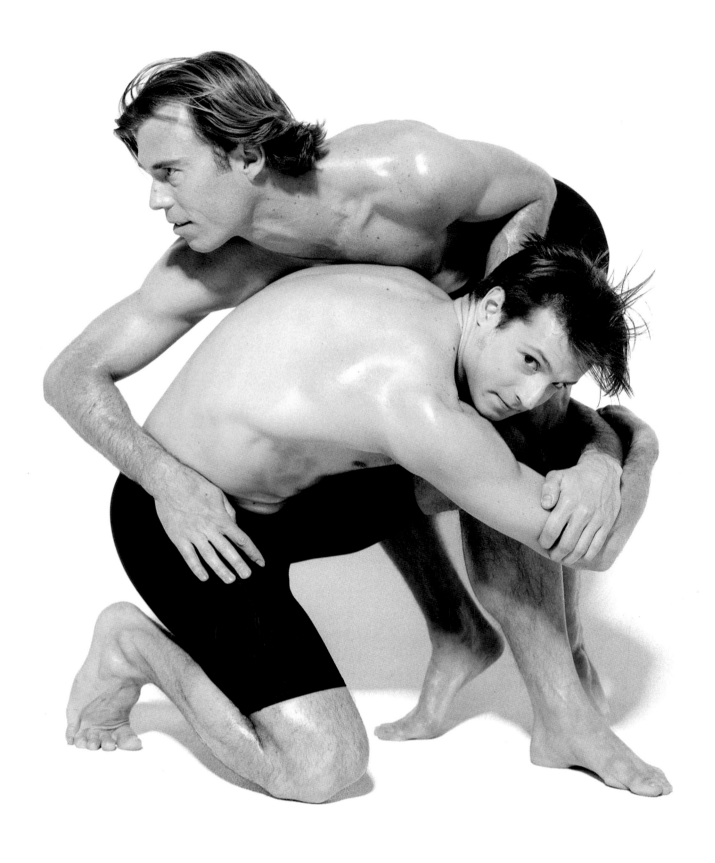

JAMIE BISHTON
JOHN SELYA
ANDREW ECCLES

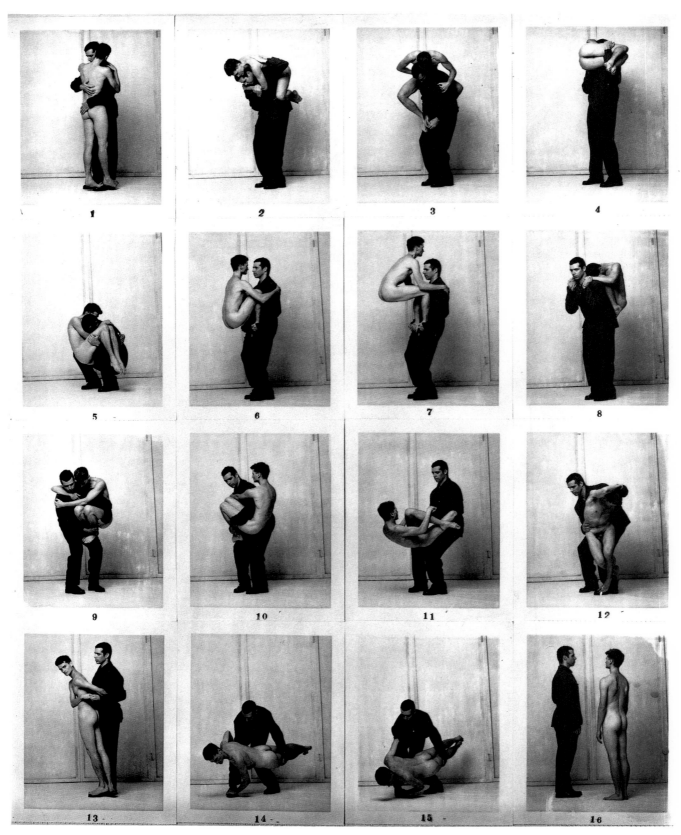

DENNIS O'CONNOR

GUZMAN

JOSEPH LENNON

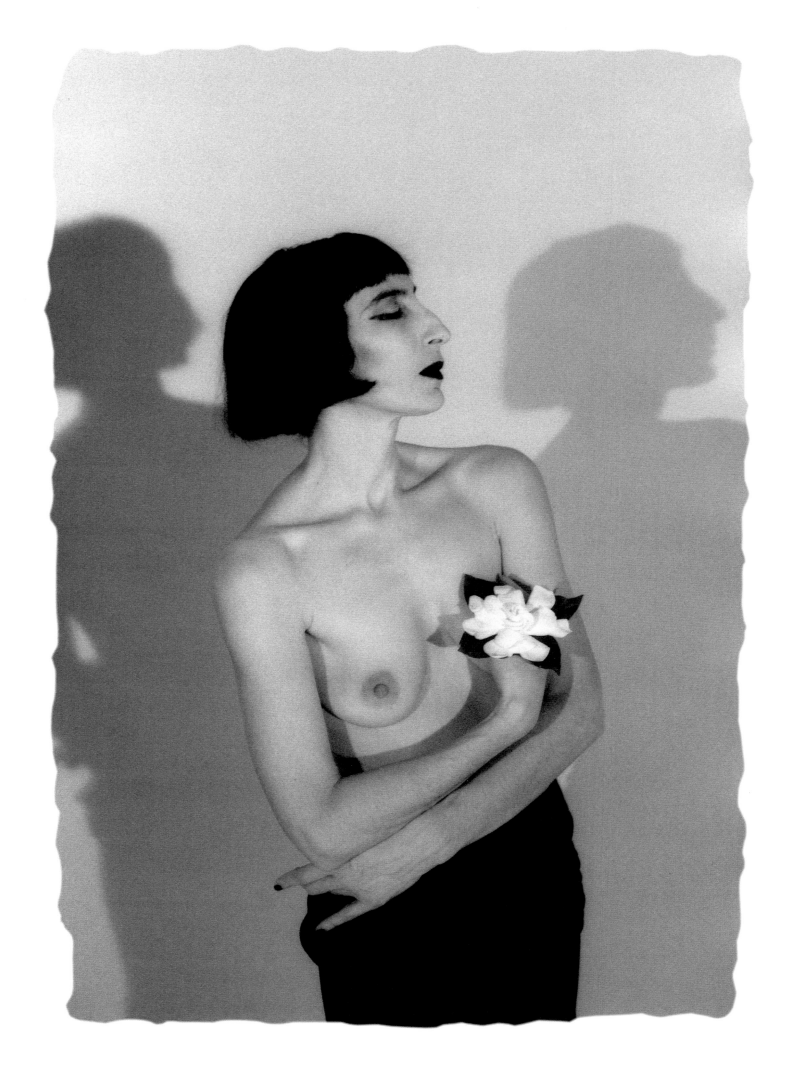

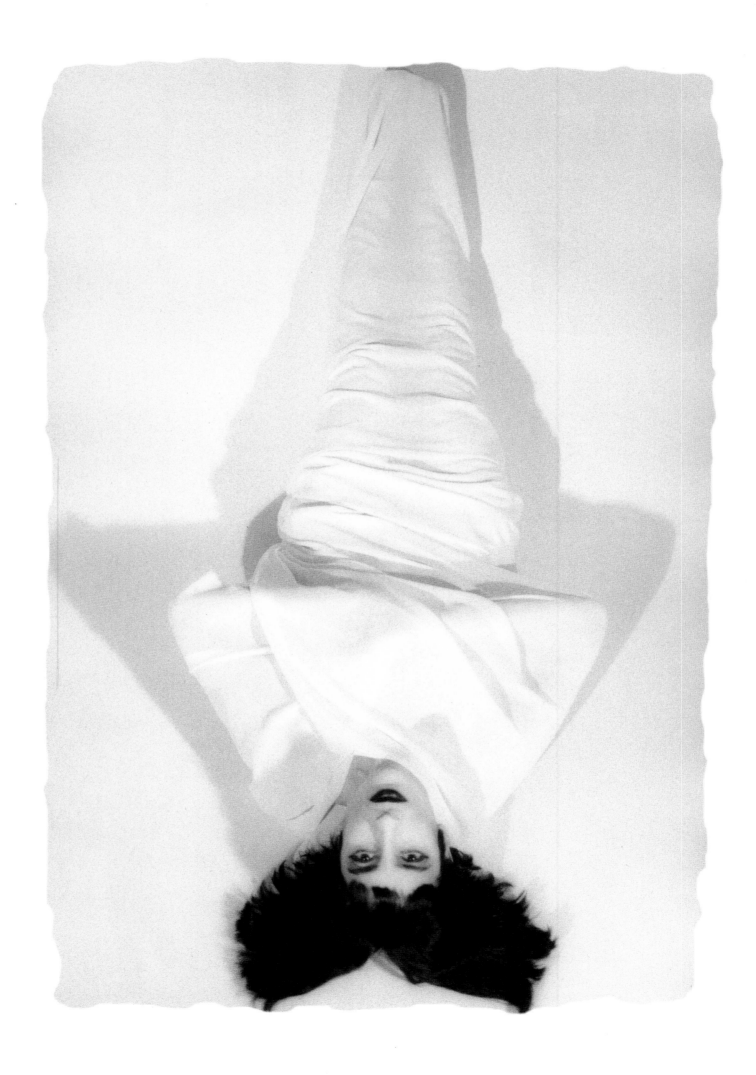

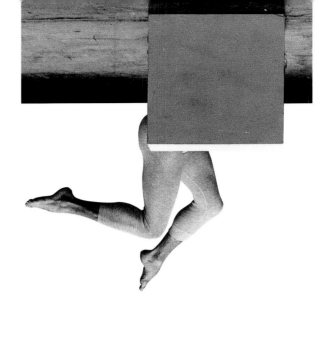
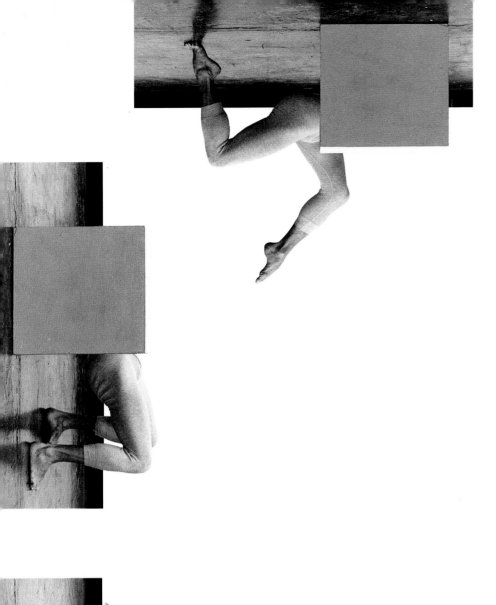
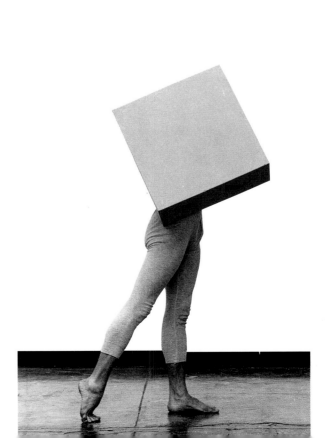
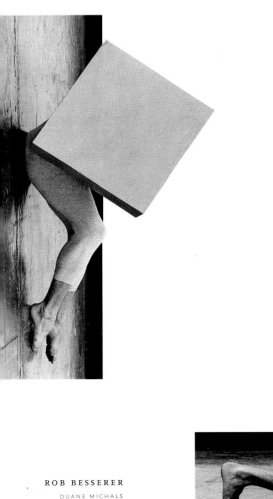
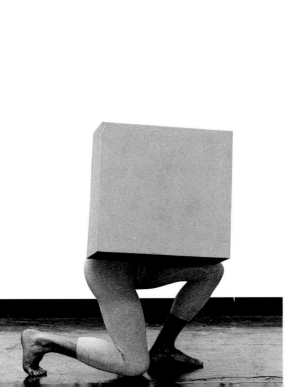

ROB BESSERER
DUANE MICHALS

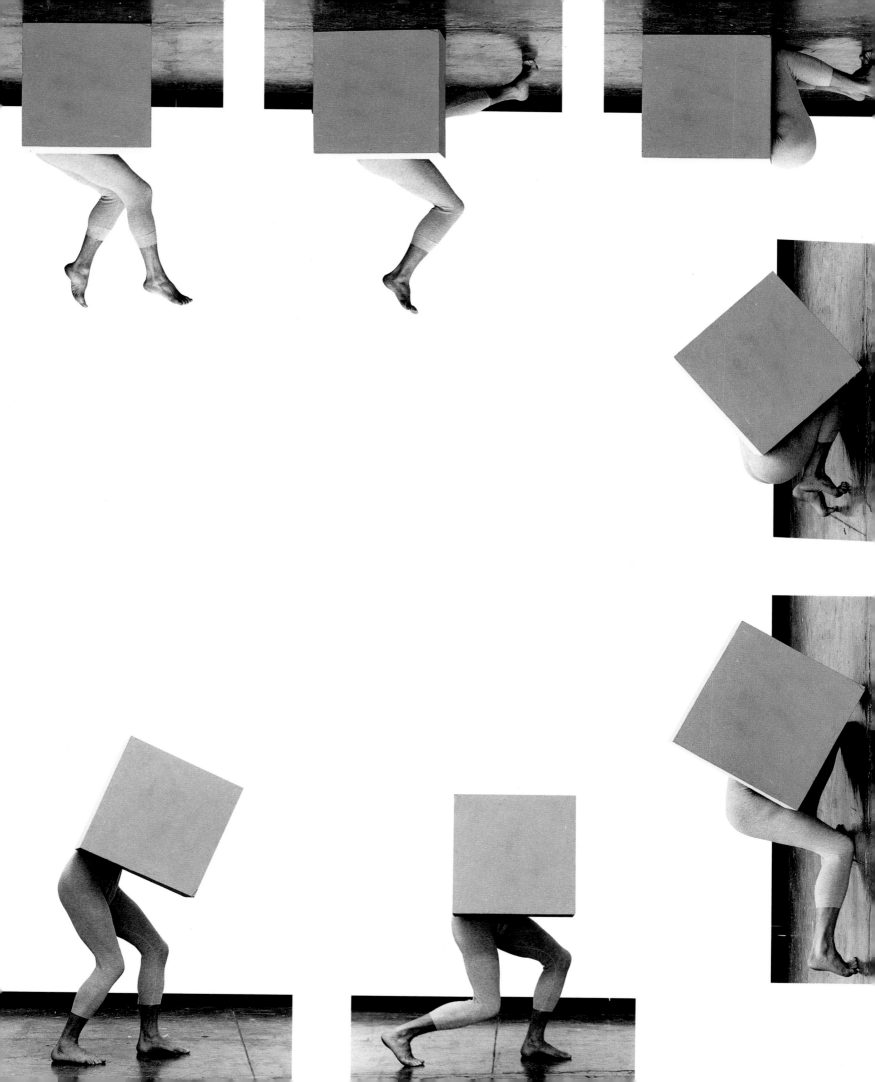

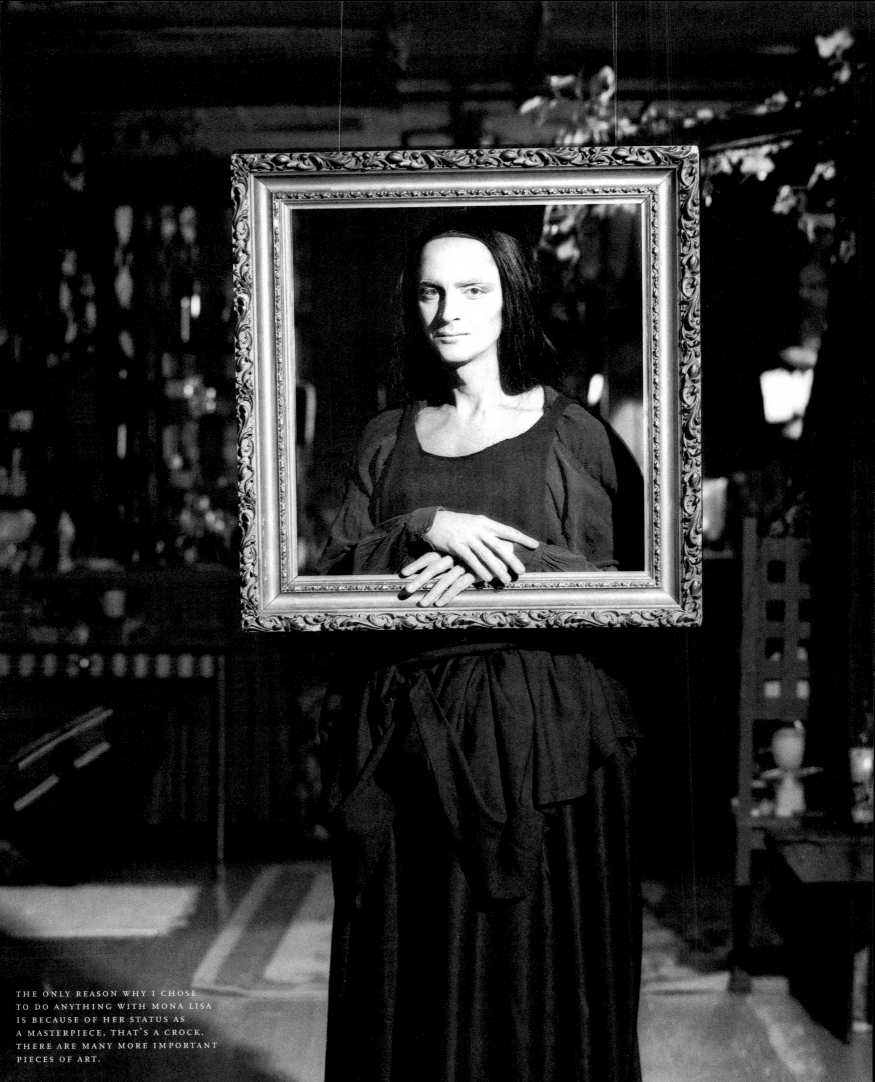

THE ONLY REASON WHY I CHOSE
TO DO ANYTHING WITH MONA LISA
IS BECAUSE OF HER STATUS AS
A MASTERPIECE. THAT'S A CROCK.
THERE ARE MANY MORE IMPORTANT
PIECES OF ART.

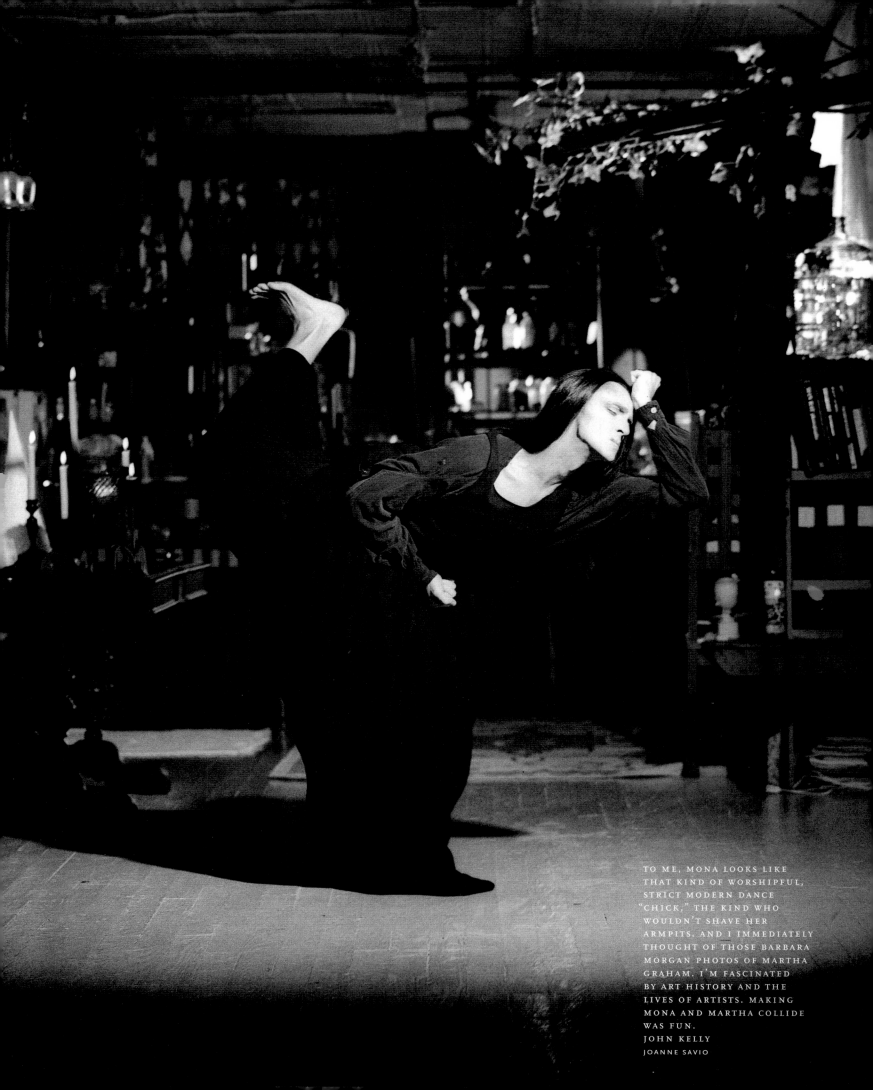

TO ME, MONA LOOKS LIKE
THAT KIND OF WORSHIPFUL,
STRICT MODERN DANCE
"CHICK," THE KIND WHO
WOULDN'T SHAVE HER
ARMPITS. AND I IMMEDIATELY
THOUGHT OF THOSE BARBARA
MORGAN PHOTOS OF MARTHA
GRAHAM. I'M FASCINATED
BY ART HISTORY AND THE
LIVES OF ARTISTS. MAKING
MONA AND MARTHA COLLIDE
WAS FUN.
JOHN KELLY
JOANNE SAVIO

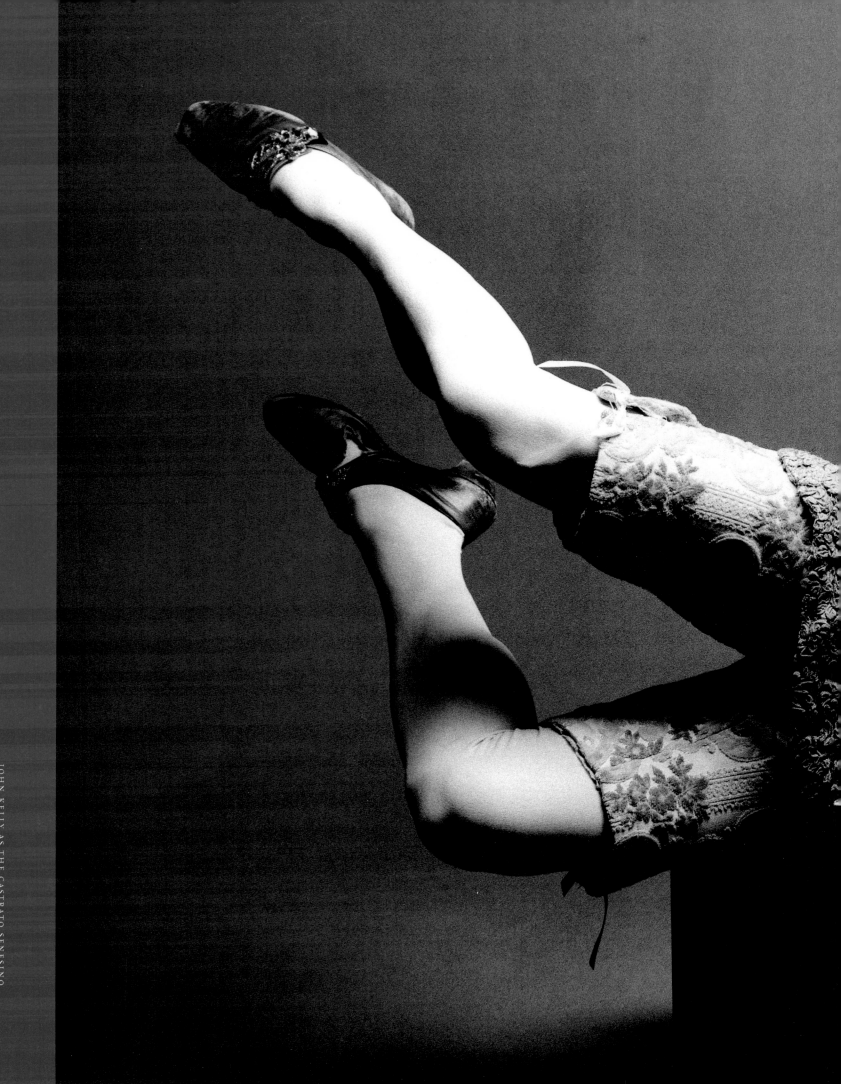

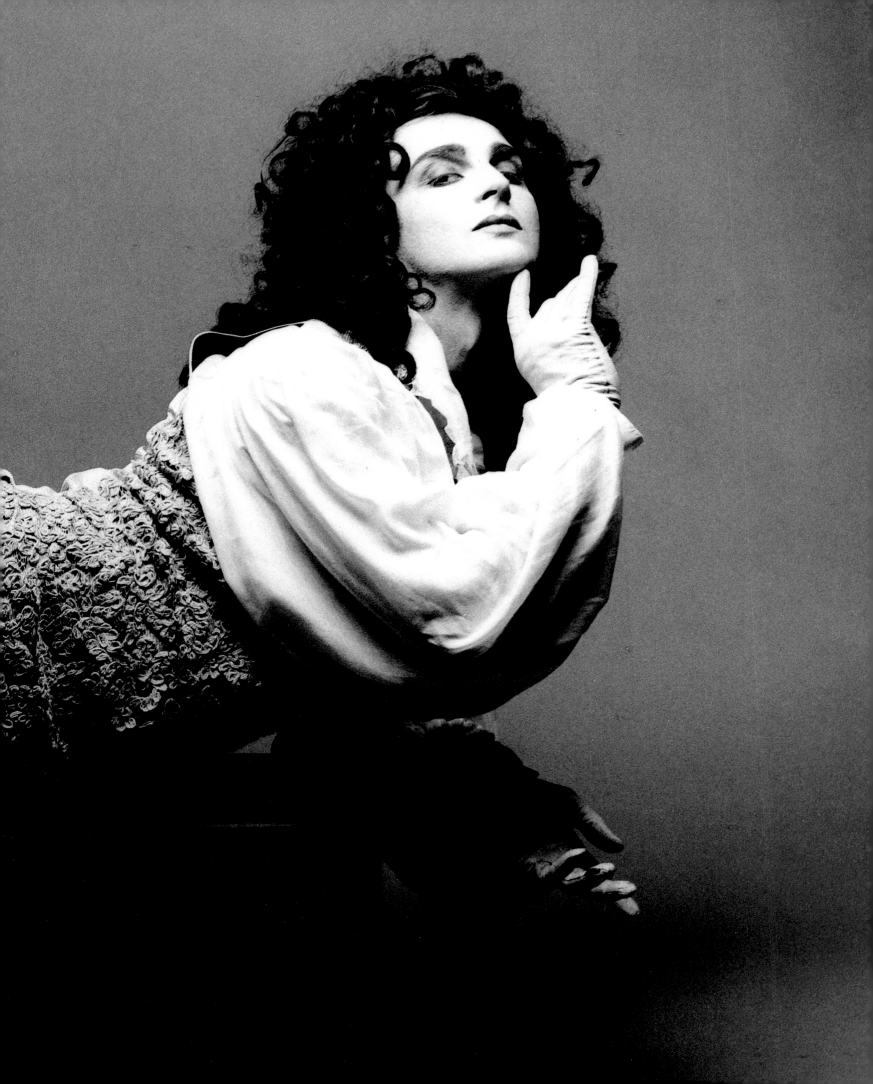

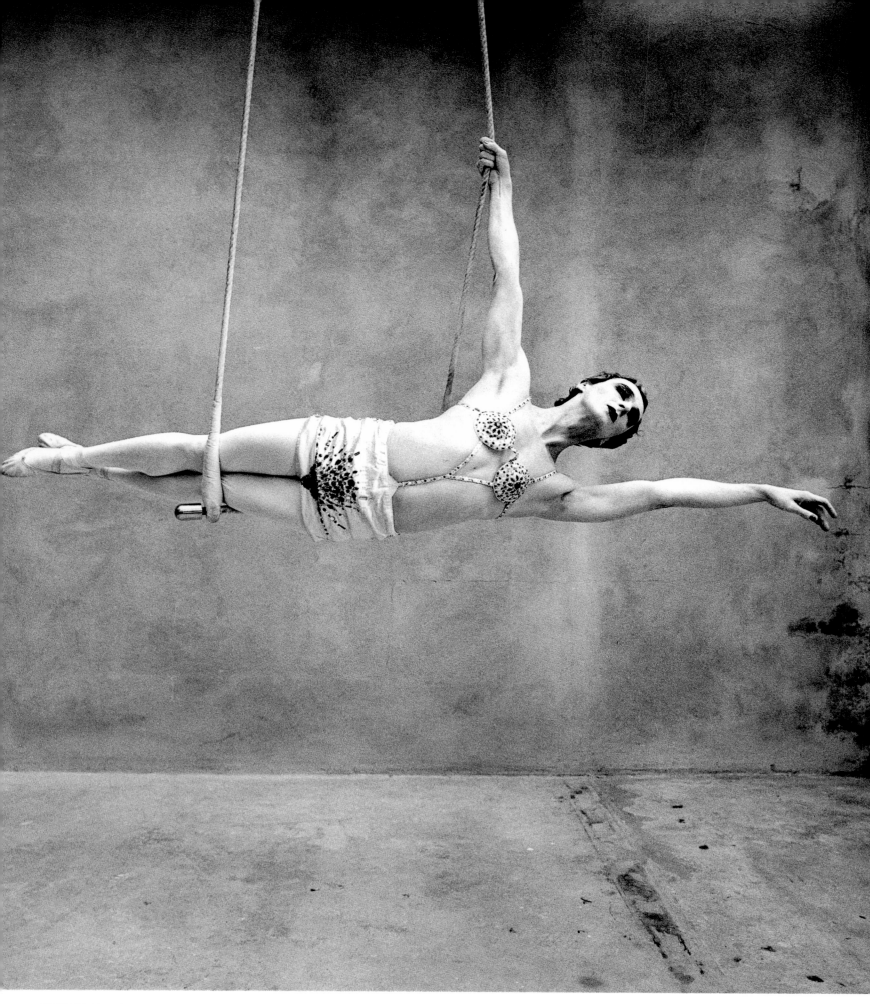

JOHN KELLY AS PARISIAN AERIALIST BARBETTE
TIMOTHY GREENFIELD-SANDERS

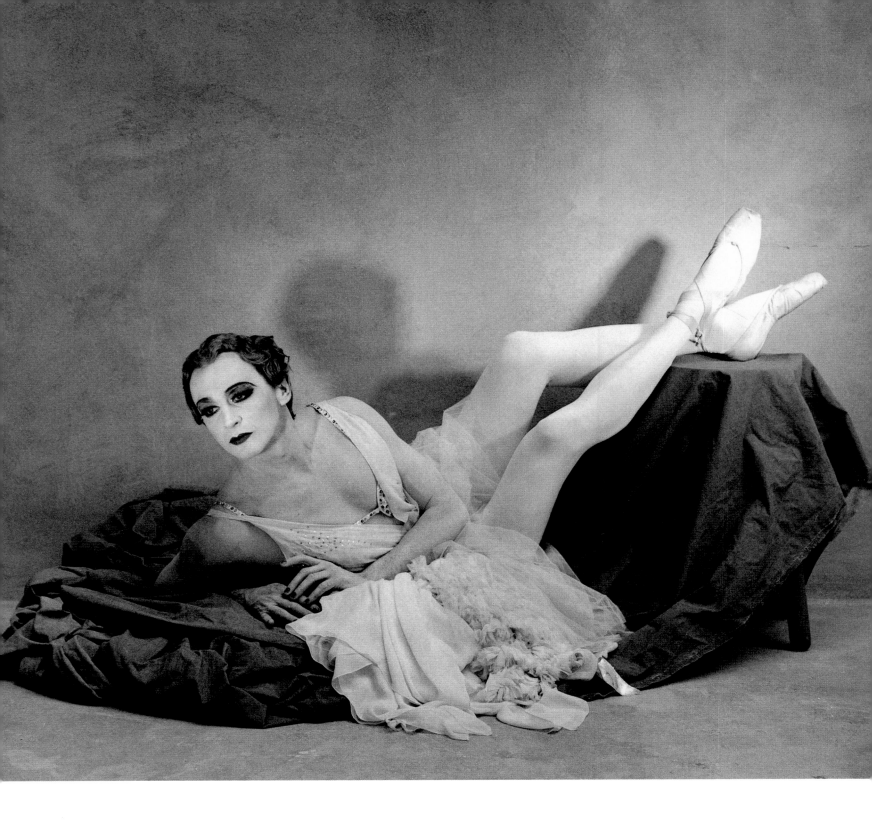

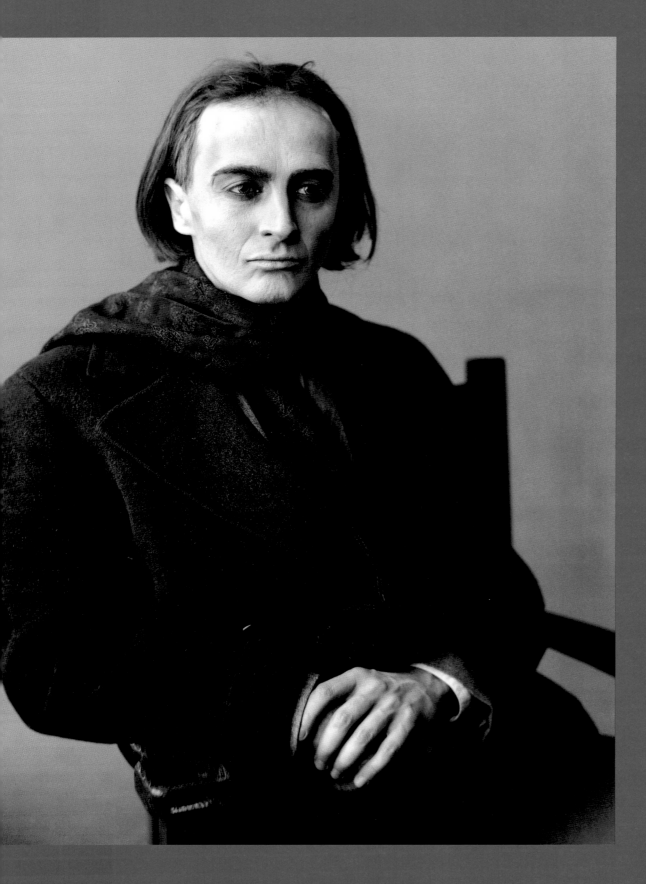

JOHN KELLY AS ANTONIN ARTAUD
TIMOTHY GREENFIELD-SANDERS

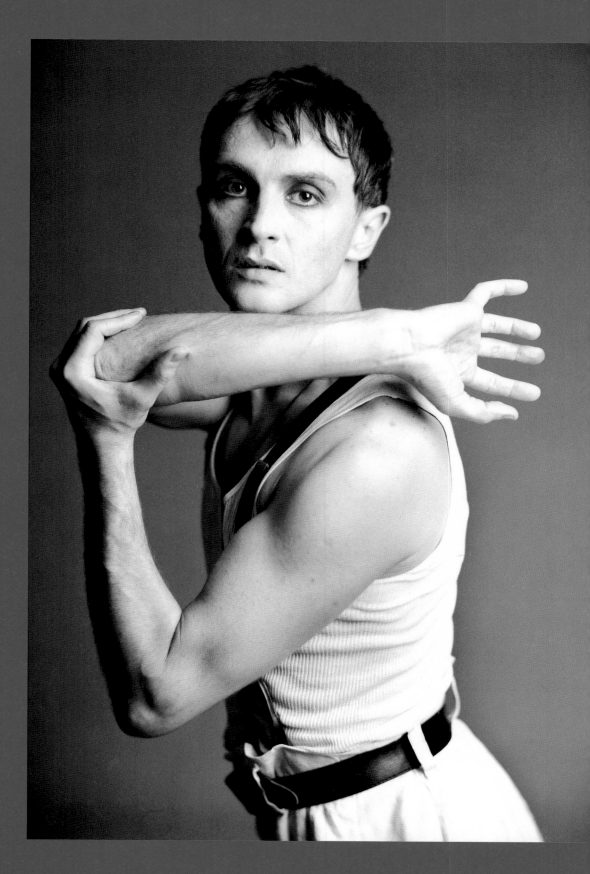

JOHN KELLY IN DIVINE PROMISCUE
TIMOTHY GREENFIELD-SANDERS

HELENA WHITE

STEVE BUSCEMI

CHING VALDES-ARAN

RUTH GRAY

DONNA HERMAN

JOHN JESURUN

VALERIE CHARLES

REBECCA MOORE

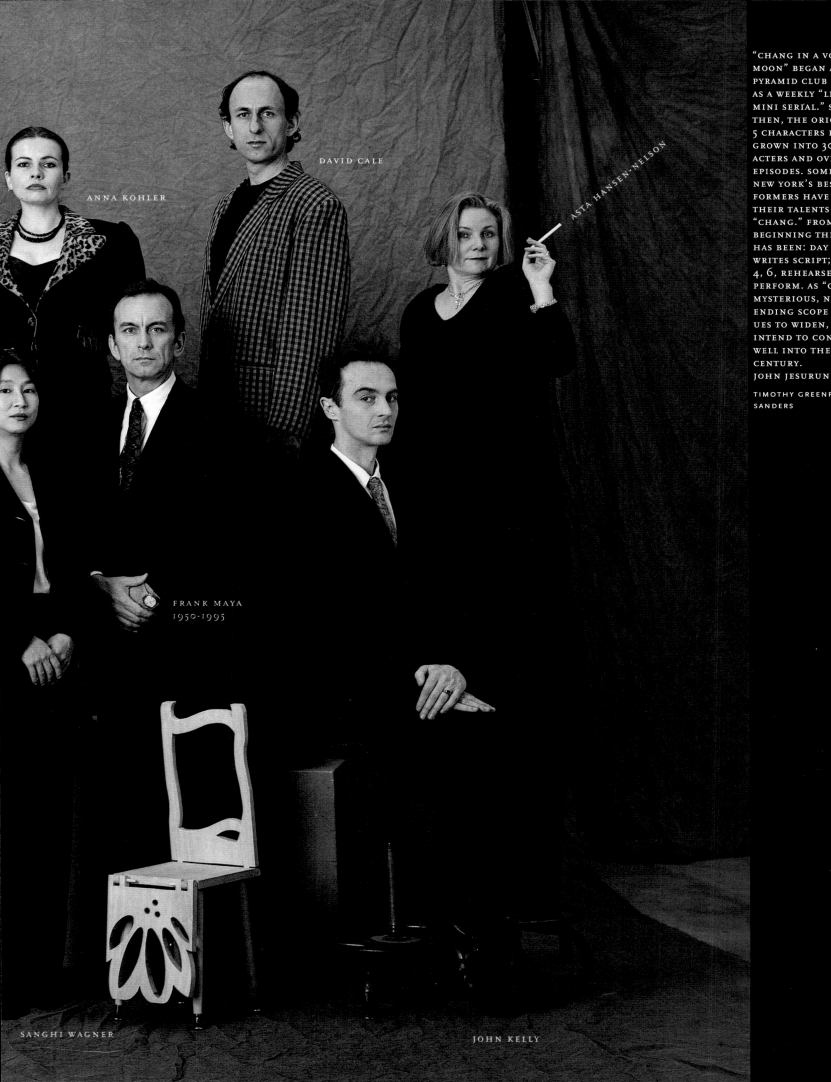

ANNA KOHLER

DAVID CALE

ASTA HANSEN·NELSON

FRANK MAYA
1950·1995

SANGHI WAGNER

JOHN KELLY

"CHANG IN A VOID MOON" BEGAN AT THE PYRAMID CLUB IN 1982 AS A WEEKLY "LIVING MINI SERIAL." SINCE THEN, THE ORIGINAL 5 CHARACTERS HAVE GROWN INTO 30 CHARACTERS AND OVER 50 EPISODES. SOME OF NEW YORK'S BEST PERFORMERS HAVE LENT THEIR TALENTS TO "CHANG." FROM THE BEGINNING THE FORMAT HAS BEEN: DAY 1, JOHN WRITES SCRIPT; DAYS 2, 4, 6, REHEARSE; DAY 7, PERFORM. AS "CHANG'S MYSTERIOUS, NEVER-ENDING SCOPE CONTINUES TO WIDEN, WE INTEND TO CONTINUE WELL INTO THE 21ST CENTURY.
JOHN JESURUN

TIMOTHY GREENFIELD-SANDERS

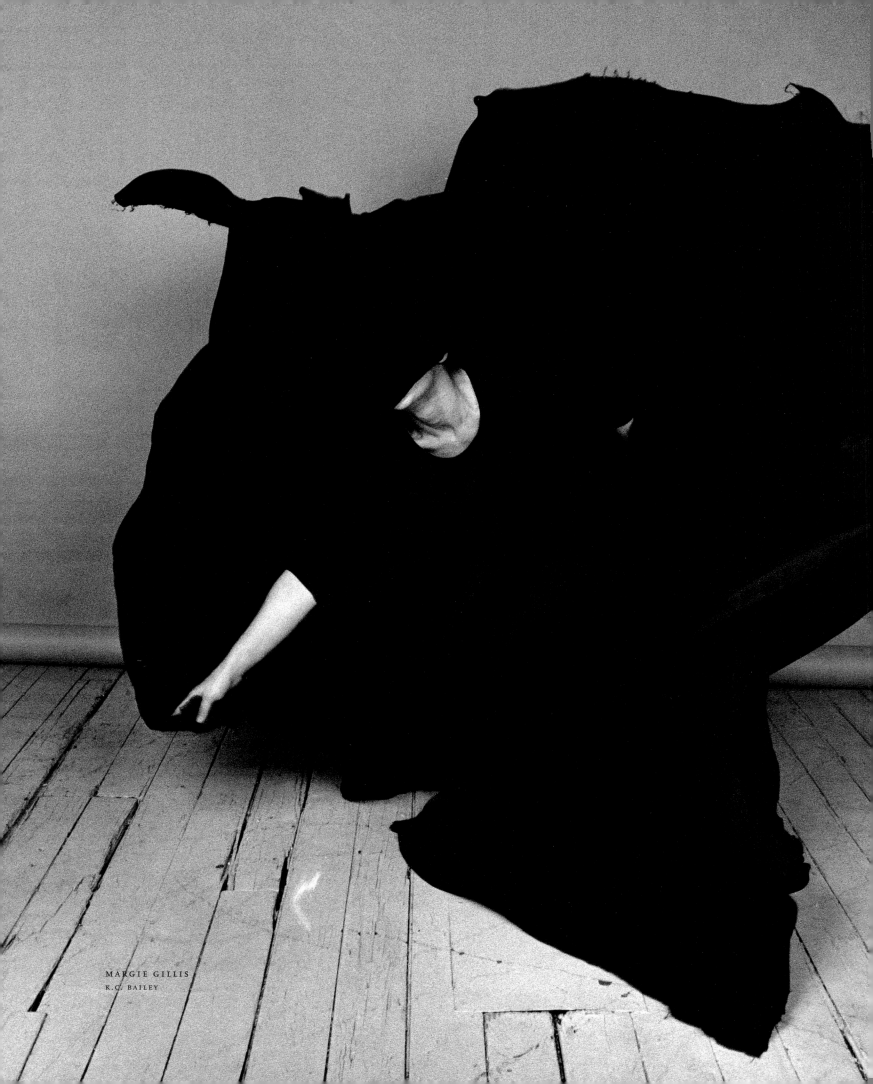

MARGIE GILLIS
K.C. BAILEY

AFTERWORD

Dance Ink was intended by its founder and publisher, Patsy
Tarr, as a gift to the dance world, which had never before had a
magazine as beautiful as its denizens. Even after the quarterly's
closing, she continued her dual mission, both acquiring
photographs for her private collection, and matching dancers
and photographers in commissioned shoots intended for publica-
tion. These latter efforts have yielded not so much a reporting,
as a revealing. Unmediated by directors or choreographers or
stylists, and outside the presence of an audience, the dancers in
these pictures were free to show themselves as they wanted to be
seen. Sometimes the photographers were collaborators, some-
times *agents provocateurs*. On rare occasions, they worked out-
doors, but most of these photographs emerged from the intimate
and controlled environments of the photographers' studios.

The exceptions to these collaborative alliances are the unobtrusive site visits made by the master photographer Duane Michals: one to the classroom of Alexandra Danilova, *prima ballerina assoluta*; and one to Merce Cunningham's light-filled aerie at Westbeth, near the Hudson River. Michals also traveled to Long Island to photograph Paul Taylor at home in the country. As you can see, Taylor is happy there. His pictures look like snapshots in a family album—as indeed, in a sense, they are.

All dance companies are families, their members spread out over generations yet occupying the same house. The five choreographers whose profiles you find in this book, tucked between the photographs, all have long-standing companies of their own, made in their own images. They are indisputably individualists. They are *paters* and *maters familias*, and yet they are siblings.

Merce Cunningham, Paul Taylor, Trisha Brown, Twyla Tharp, and Mark Morris are the offspring of Martha Graham and George Balanchine—as unlikely as such a union at first seems, given that their separate dominions were as different as night and day. The American-born Graham was given to archaic tales and iconic roles. Her modern dance technique is grounded, barefoot, centered on the abdominal contraction, the polar opposite of traditional ballet. She was a dramatist, and a dramatizer. The Russian-born Balanchine invented modern ballet—nonnarrative, streamlined, speedy, and sublime. The only title he ever gave himself was Ballet Master. Nonetheless, they have heirs in common.

MERCE CUNNINGHAM not only danced with the Martha Graham Dance Company when he first came to New York ("Merce was made for the air," she once said), but also studied and taught at Balanchine's School of American Ballet. He made dances for the New York City Ballet and its precursor, Ballet Society. Cunningham's own work rebels against both Graham's dramatics and Balanchine's (and everyone else's) use of music, yet it combines elements of both ballet and barefoot.

PAUL TAYLOR danced with Graham, had a role made for him by Balanchine (who asked him to join his company; Taylor declined), and danced with the company Cunningham founded. From Balanchine, Taylor takes certain architectural devices, but he is truly Martha's boy: he sat at her feet, he made love to her on stage (actually she made love to him, Jocasta that she was), and then he ran off to found a company of his own, incidentally rejecting the methodology of older brother Merce.

TRISHA BROWN, the black sheep, rejected it all and took (quite literally, by means of a harness) to climbing walls and noodling around with a bunch of improvisors, all the while keeping a keen eye on Cunningham. Like Cunningham and Taylor, in time Brown asked contemporary artists to devise decor for her work. All three hung around with Robert Rauschenberg at one time or another.

TWYLA THARP, as vigorous as Trisha Brown was languid, danced with the Paul Taylor Dance Company and studied at the Cunningham studio, where she poached dancers for her own early efforts. Somewhere along the way, she absorbed a great

deal of Balanchine and Graham. Unlike the others, she turned toward ballet—as a choreographer, she has a soft shoe on one foot and a toe shoe on the other.

Last in line, MARK MORRIS danced in none of these companies, but he reveres Balanchine, possesses certain temperamental similarities to Graham, often can be seen cheering Cunningham, would prefer not to be compared to Taylor, and once, in his earliest days on the scene, heckled the Tharp company during a performance. For a while, he was the *enfant terrible* of the clan.

These five choreographers—the major moderns of our day—are joined in these pages by the galaxy of performers and dance makers who agreed to be caught by the camera.

This book belongs to them all. It is their album.

ACKNOWLEDGMENTS

The photographs in this book were commissioned between
1990 and 1996 for publication in *Dance Ink* magazine and
more recently, specifically for inclusion in this volume.
The exception is the work by Annie Leibovitz, which has been
collected privately. *Dance Ink*'s staff during the life of the
magazine included: Lise Friedman, editor; J. Abbott Miller,
art director; Katherine Schlesinger, photography editor;
Rika Burnham and William Harris, consulting editors.
My deepest thanks to them and to all of the choreographers,
dancers, playwrights, performers, and photographers who
made this book possible. My thanks also to James Danziger
and Etheleen Staley for their help with my personal collection.

Patsy Tarr

PRESIDENT, DANCE INK FOUNDATION

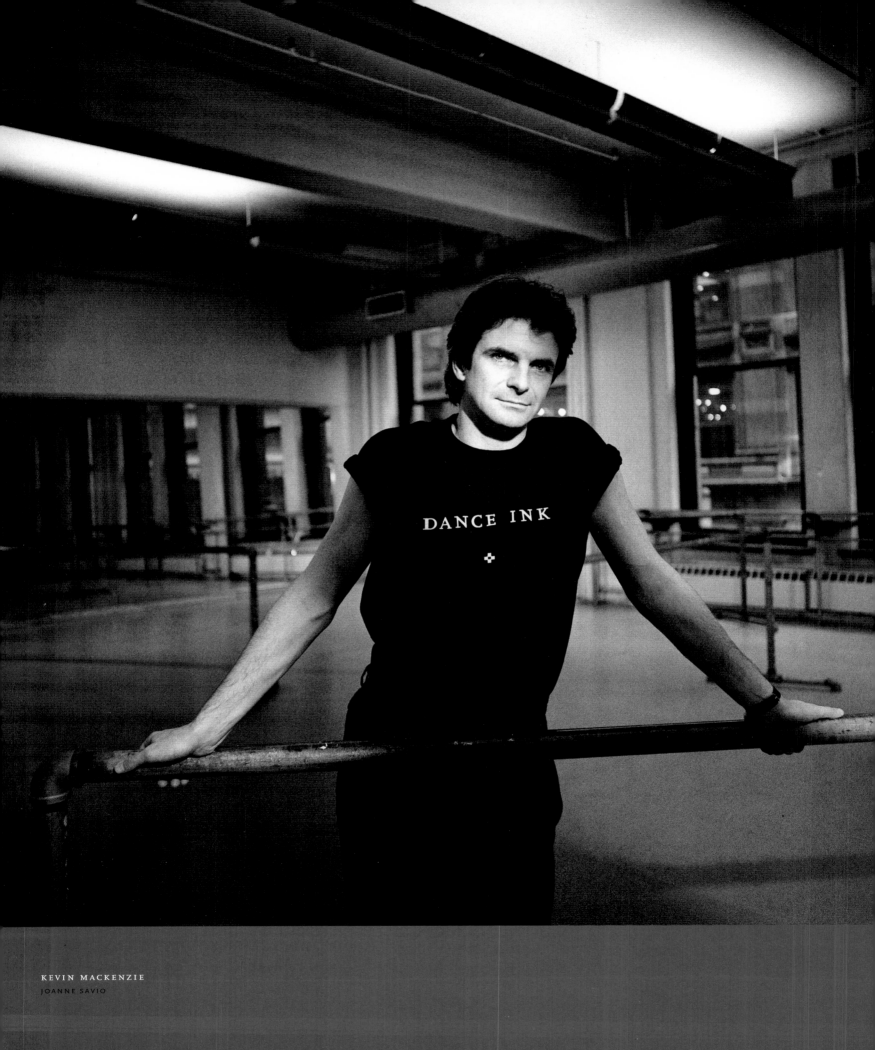

KEVIN MACKENZIE
JOANNE SAVIO

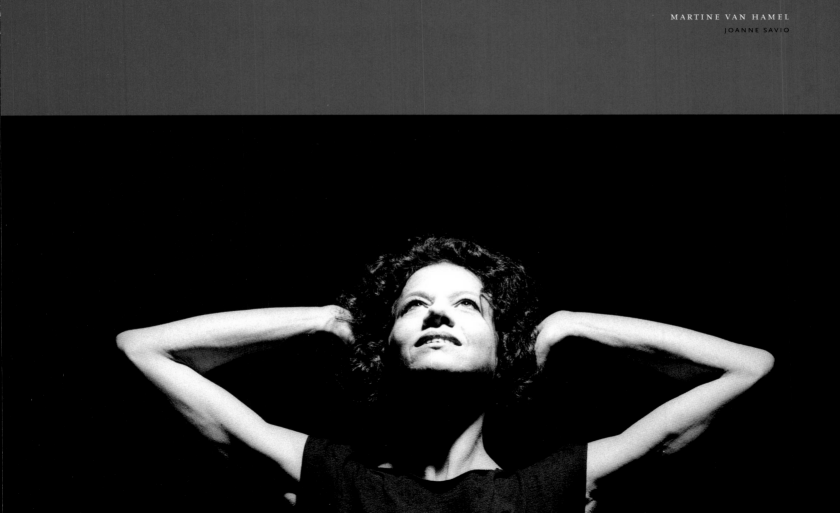

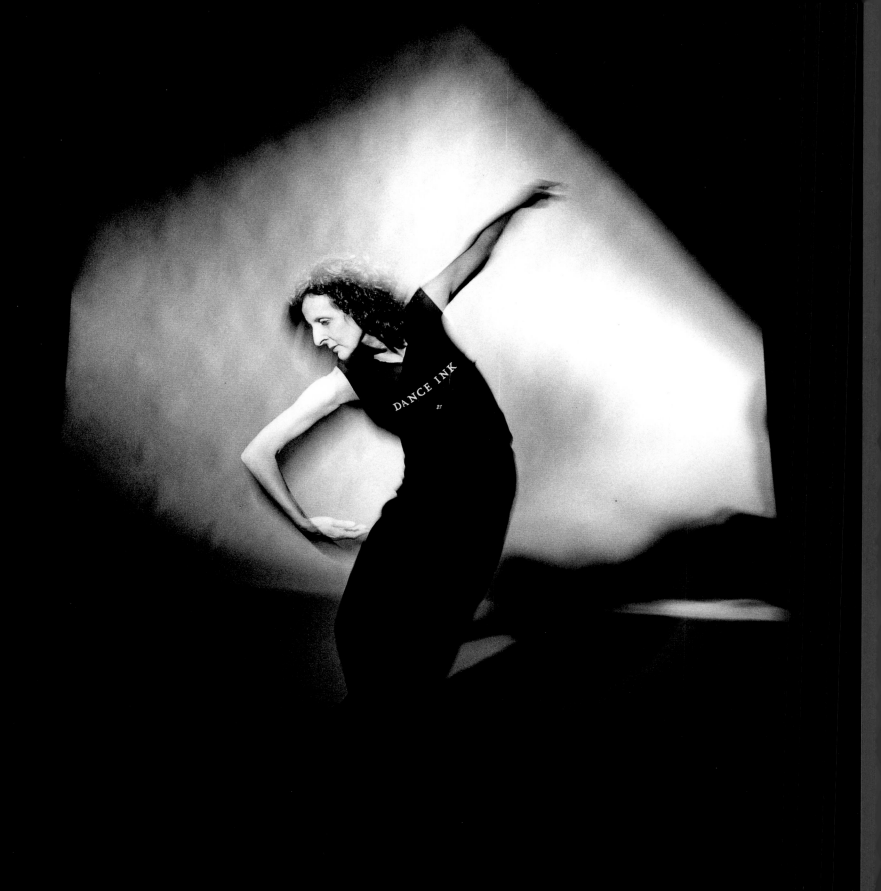

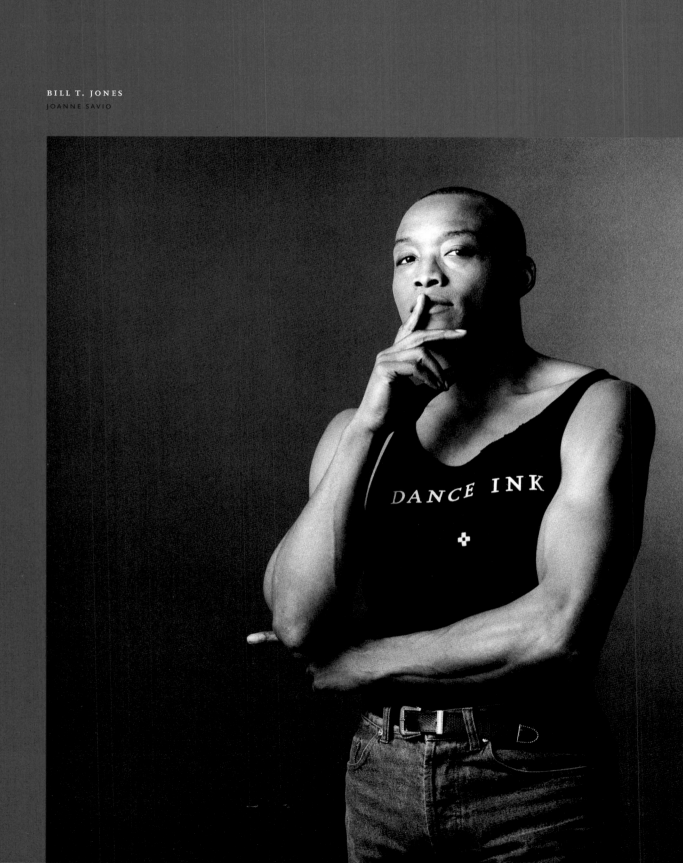

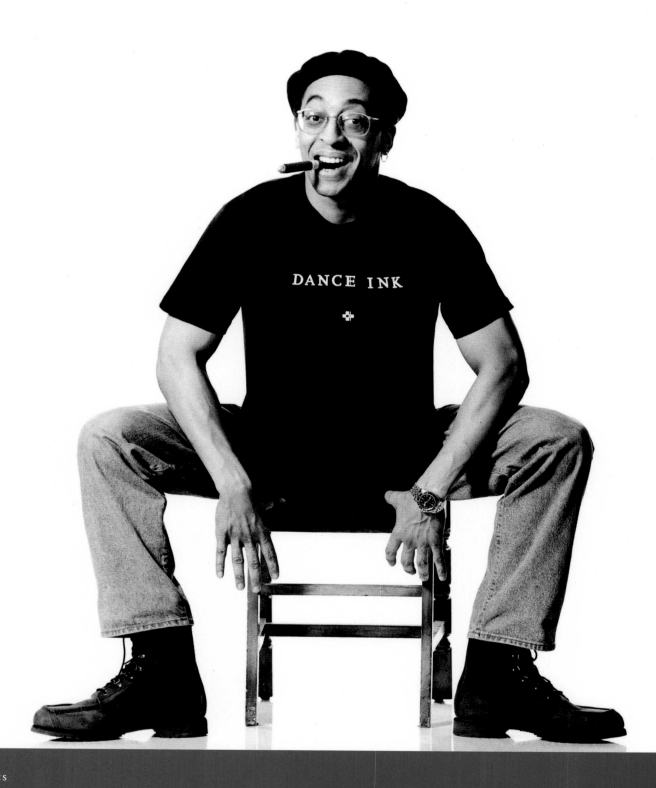

GREGORY HINES
JOANNE SAVIO

BILL IRWIN
DAVID SHINER

JOANNE SAVIO

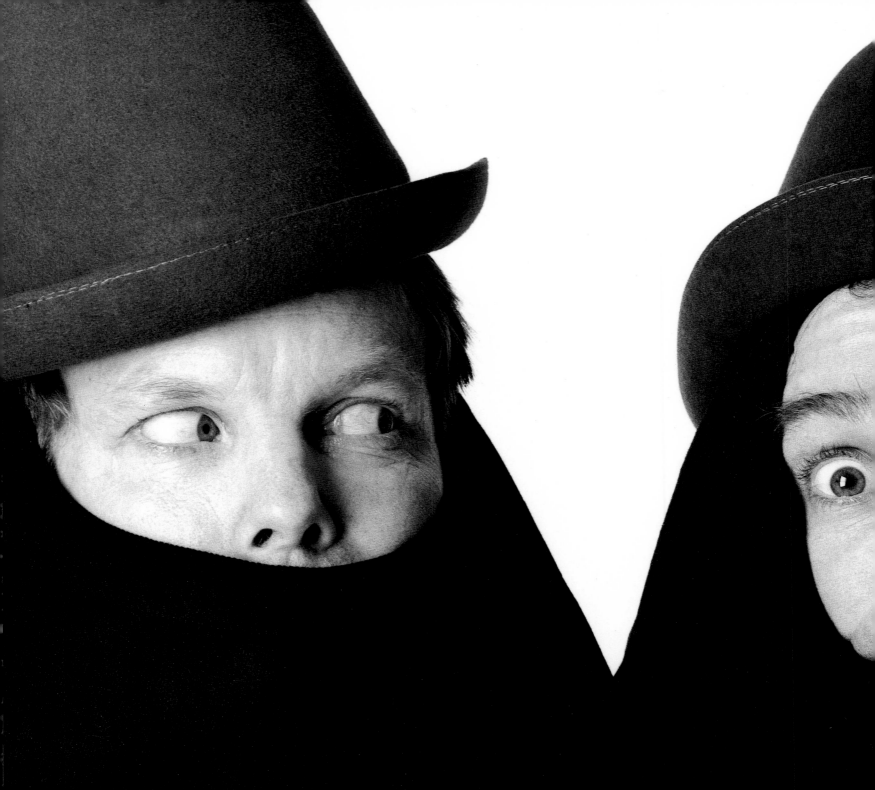

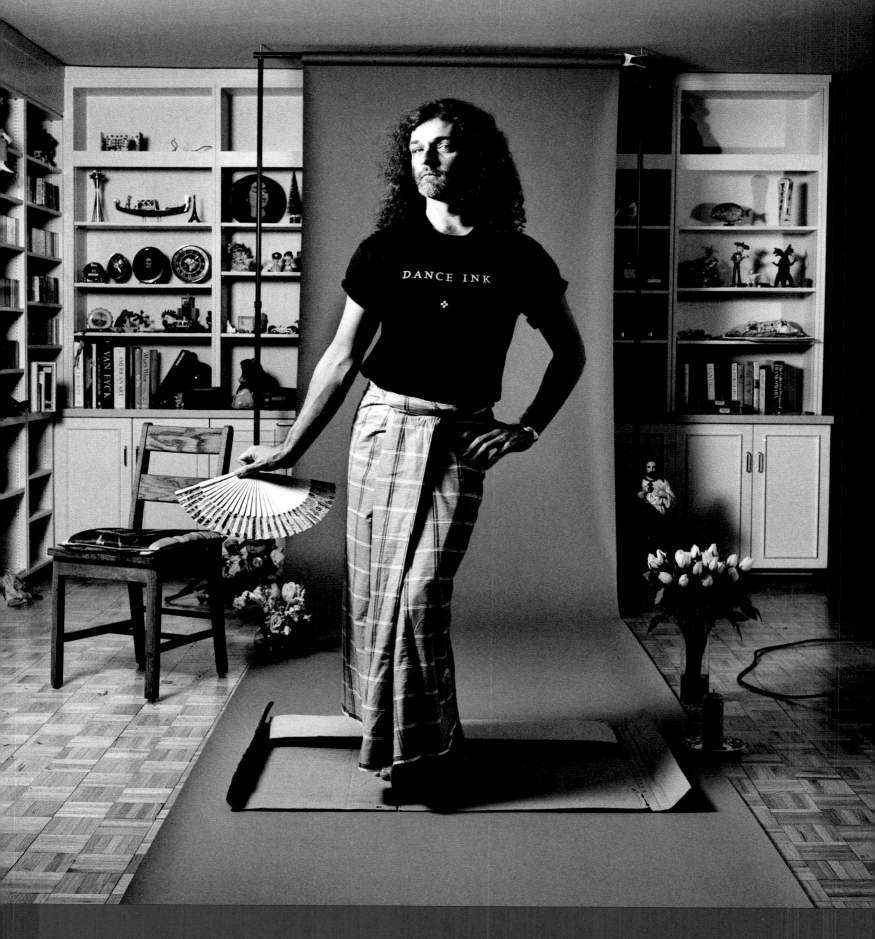

MARK MORRIS
JOANNE SAVIO

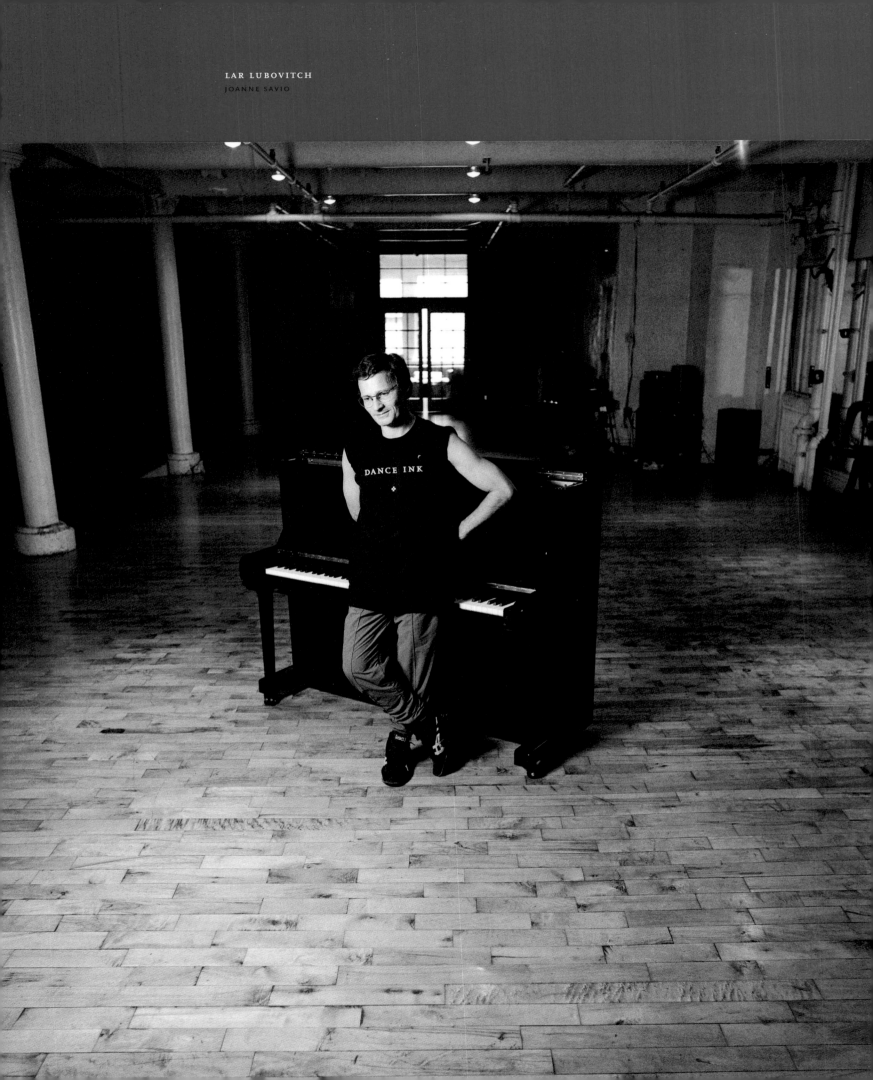

INDEX

THIS BOOK IS DEDICATED TO JEFF TARR

COLOPHON

Book design by J. Abbott Miller of Design/Writing/Research, New York.
This book is set in Scala and Scala Sans, designed by
Martin Majoor in 1988–90 and 1993, respectively.

The paper is Japanese Matte Art.

All photographs are reproduced as duotones,
using a palette of nine different colors.

DANCE INK : PHOTOGRAPHS

COPYRIGHT © 1997 BY DANCE INK, INC.

photographs copyright © 1990–1996 Ruven Afanador: pages 137–43; photographs copyright © 1990–1996 Josef Astor: pages 2–3, 5, 18–19, 70–71, 150–51; photographs copyright © 1990–1996 K.C. Bailey: pages 120–21, 123–29, 152–53, 176; photograph of Twyla Tharp copyright © 1996 Chris Callis, for *The New Yorker*: page 98; essays copyright © 1997 Nancy Dalva: pages 13–14, 16, 43–46, 75–77, 99–102, 131–133, 177–180; photographs copyright © 1990–1996 Richard Dunkley: pages 72–73, 114–15; photographs copyright © 1990–1996 Andrew Eccles: pages 1, 8, 9, 20–25, 28–33, 38–41, 60–61, 82–85, 92–95, 106–09, 110–11, 148–49, 155–57, 160; photographs copyright © 1990–1996 Alice Garik: pages 26–27, 56–57; photographs copyright © 1990–1996 Timothy Greenfield-Sanders: pages 86–89, 168–73, 174–75; photographs copyright © 1990–1996 Guzman: pages 158–59, 161; photograph copyright © 1995 Hugh Hales-Tooke: page 122; photographs copyright © 1990–1996 Mark Hanauer: pages 6, 7, 58–59; photographs copyright © 1990–1996 Jesse Huot: pages 100, 101; photographs copyright © 1990–1996 Annie Leibovitz: pages 62, 63, 67, 96–97, 103, 105, 113, 130, 133–35; photographs copyright © 1990–1996 Marcia Lippman: pages 48–55, 162–63; photographs copyright © 1990–1996 Duane Michals: pages 12, 14, 15, 17, 35–37, 42, 44, 45, 47, 68–69, 164–65; photographs copyright © 1990–1996 Joanne Savio: pages 10–11, 64–65, 74, 77, 144–47, 166–67, 182–89; photographs copyright © 1990–1996 Stewart Shining: pages 79–81, 118–19; photographs copyright © 1990–1996 Alberto Tolot: pages 116–17

Printed in Singapore

Library of Congress Cataloging-in-Publication Data
Dance ink photographs / edited by J. Abbott Miller and Patsy Tarr;
essays by Nancy Dalva; afterword by Patsy Tarr
192 p. 25 x 30.5 cm.
ISBN 0-8118-1855-1
1. Dancers—Biography. 2. Dancers—Pictorial works.
I. Miller, J. Abbott. II. Dalva, Nancy.
GV1785.A1D285 1997
792.8'022'2-dc21
97–11244 CIP

Distributed in Canada by
Raincoast Books
8680 Cambie Street
Vancouver, B.C. V6P 6M9

10 9 8 7 6 5 4 3 2

Chronicle Books
85 Second Street
San Francisco, CA 94105

Web site: www.chronbooks.com

DANCE INK
PHOTOGRAPHS

EDITED BY J. ABBOTT MILLER AND PATSY TARR

DESIGNED BY J. ABBOTT MILLER

ESSAYS BY NANCY DALVA

CHRONICLE BOOKS

SAN FRANCISCO